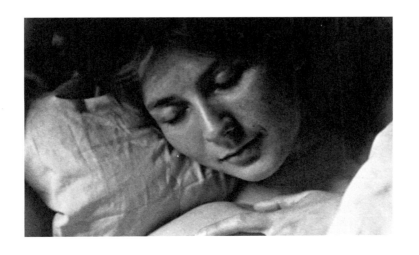

BLACK AND BLUE

# Black and Blue

The Bruising Passion

of *Camera Lucida, La Jetée, Sans soleil,*

and *Hiroshima mon amour*

CAROL MAVOR

Duke University Press

DURHAM AND LONDON

2012

Designed by Amy Ruth Buchanan
Typeset in Trinité by Tseng
Information Systems, Inc.
Library of Congress Cataloging-
in-Publication Data appear on the
last printed page of this book.

DUKE UNIVERSITY PRESS GRATEFULLY
ACKNOWLEDGES THE SUPPORT OF
THE UNIVERSITY OF MANCHESTER,
WHICH PROVIDED FUNDS TOWARD THE
PUBLICATION OF THIS BOOK.

For Manny Farber
and Patricia Patterson,
who first schooled me
in black and blue.

# CONTENTS

# ACKNOWLEDGMENTS

With gratitude to the following people and institutions for their knowledge and for their help in making this book possible:

The Leverhulme Trust, the British Academy, Hayden White, Mara West, Andrew Hennlich, the University of Manchester, Esther Teichmann, Olivier Richon, Marina Warner, Sally Mann, Ranji Khanna, Lynda Hartigan, Victor Burgin, Allison Connolly, Nora Alter, Tom Rasmussen, Steve McCabe, Ishiuchi Miyako, Francette Pacteau, Deborah Cherry, Sarah Jones, James Kincaid, Patricia Patterson, Manny Farber, Amelia Jones, Olga Smith, Anna Magdalena Elsner, Lara Weibgen, Janet Wolff, Veronica Smith, Michael Hoppen, Margaret Iverson, Helene Moglen, the Royal College of Art, Jim Clifford, Page duBois, Geoffrey Batchen, Jason Edwards, Griselda Pollock, Fredric Jameson, Jean-Pierre Gorin, Alice Kaplan, Wiebke Leister, Deborah Willis, Elizabeth Howie, Tsuchida Hiromi, Leigh Barnwell, and Alison Criddle.

Special thanks to Libby May for copyediting the manuscript and to Mark Mastromarino for overseeing the book's production as project editor.

In addition, more special thanks to the two anonymous readers of the book for their attentive and astute commentary.

Fullest gratitude to:

Ken Wissoker, my radiant editor.
Amy Ruth Buchanan, shining designer of Black and Blue.
elin o'Hara slavick, for making her eyes mine.
Augie, Ambie, and Ollie, lustrous loves of my life.
My mother and father.
And for all time, Kevin Parker.

ABBREVIATIONS

Page references for the three texts cited most often in this book observe the following conventions:

1. Roland Barthes's *La Chambre claire: Note sur la photographie*, translated as *Camera Lucida*, will be referred to as *La Chambre claire*. Parenthetical citations are to Richard Howard's English translation of the text, with an H, followed by the page number, and to the Seuil edition of the French text, with an S, followed by the page number. The full citations are as follows:

   > Roland Barthes, *Camera Lucida: Reflections on Photography*, translated by Richard Howard (New York: Hill and Wang, 1981).
   > Roland Barthes, *La Chambre claire: Note sur la photographie* (Paris: Éditions de l'Etoile, Gallimard, le Seuil, 1980).

2. For the screenplay for *Hiroshima mon amour*, by Marguerite Duras, parenthetical citations are to Richard Seaver's translation of the text, with an S, followed by the page number, and to the Gallimard edition of the French text, with a G, followed by the page number. The full citations are as follows:

   > Marguerite Duras, *Hiroshima mon amour; Text by Marguerite Duras, for the Film by Alain Resnais*, translated by Richard Seaver (New York: Grove Press, 1961).
   > Marguerite Duras, *Hiroshima mon amour, scénario et dialogue* (Paris: Éditions Gallimard, 1960).

3. Marcel Proust's *À la recherche du temps perdu*, translated as *In Search of Lost Time*, will be referred to as the *Recherche*. Parenthetical citations are to C. K. Moncrieff's and Terence Kilmartin's translation of the *Recherche*, with a K, followed by volume and page numbers, and to the Pléiade edi-

tion of the French text, with a P, followed by volume and page numbers. The full citations are as follows:

> Marcel Proust, *In Search of Lost Time*, translated by C. K. Moncrieff and Terence Kilmartin, revised by D. J. Enright, 6 vols. (New York: Modern Library, 1992). Note: the pagination of the British edition is different from that of the American edition.
>
> Marcel Proust, *À la recherche du temps perdu*, edited by Jean-Yves Tadié, 4 vols. (Paris: Bibliothèque de la Pleiade, 1987–89).

# First Things:

# Two Black and

# Blue Thoughts

..........................................

This is the story of
a man marked by an
image from his
childhood.

*Ceci est l'histoire d'un
homme marqué par une
image d'enfance.*

—Chris Marker, *La Jetée*

I was once an infant, without speech, marked by (a black and blue) image from the womb. (*Infant:* "from the Latin *infans;* from *in* (not) and *fari* (to speak): the one who does not speak."[1])

## PERHAPS MY FIRST
## BLACK (AND BLUE) MEMORY

Hailing the womb, black can be archaic.[2]

I feel more or less certain that I remember being inside the body of my mother, inside this first home, a "dark continent" (Freud)[3] in which no more could be seen than saturated blue-blacks, violet blue-blacks, and crimson blue-blacks, despite the fact that my not-yet born eyes were wide open. To be inside is to be blind. Likewise, my fetal ears heard the shallow breath of my mother. I heard the sound of her heartbeat: a crushing, cushioning thumping, not unlike the sonorous palpitation which pounds its way through the black underground cavern of *La Jetée*, Chris Marker's film of 1962.

I remember the darkness, the amniotic semiotics of the velvetized, waterized sounds. I heard the gentle crackling of my mother's bones. In the words of Jean-Luc Nancy: "it is always in the belly that we – man or woman – end up listening, or start listening. The ear opens onto the sonorous cave that we then become."[4]

My mother and I, we were a couple tied by an umbilicus.

We were lovers.

I kicked my mother's ribs.

My memory is bruising.

My memory is black (and blue).

Perhaps . . . I am still there, meditating in the uterus of my mother. Perhaps . . . I am an old child, waiting, resisting what Roland Barthes describes as the "Western frenzy to become adult quickly and for a long time."[5]

Today, my mother remembers nothing, not even me, just like the mother plagued by Alzheimer's in *Three Colors: Blue*, Krzysztof Kieślowski's film of 1993. (The demented mother is played by Emmanuelle Riva, the gor-

geous actress who came to fame as the star of *Hiroshima mon amour*, Marguerite Duras's and Alain Resnais's film of 1959.)

My mother has lost herself. My mother has forgotten herself. My mother no longer fears forgetting. There is nothing to remember.

The casting of Riva as the mother in *Blue*, after her starring role as the very beautiful French actress in *Hiroshima mon amour*, is the kind of thing film connoisseurs can smile over. In *Hiroshima mon amour*, Riva is the *unnamed* young woman who has come to star in a film about peace. In Duras's script the woman is referred to as SHE (or ELLE in the French). ELLE is falling in love with a Japanese man. She fears that falling so deeply in love with a new man will cause her to forget her former German lover, with whom she illicitly fell in love during the German occupation of France. ELLE fears forgetting her German lover, now dead, more than she fears any other thing in her life. Her biggest fear is forgetting.

"What terrifies us about death is not the loss of the future, but the loss of the past. Forgetting is a form of death ever present within life" (Milan Kundera).[6]

My mother, like *Blue* Riva, now rests in that place, far beyond the fear of forgetting.

My mother, like *Blue* Riva, is the symbol of love's forgetfulness. To quote the male lover, also unnamed, in *Hiroshima mon amour* (HE, or LUI in the French), "I'll remember you as the symbol of love's forgetfulness. I'll think of this adventure as the horror of oblivion" (S, 68; G, 105).

I seek Riva inside a film on forgetting and inside a film on memory, but I am not sure which is which. For, "memories come to us as something, well forgotten" (Tobias Hill).[7] Similarly, Chris Marker claims in *Sans soleil*, his film of 1982, "I will have spent my life trying to understand the function of remembering, which is not the opposite of forgetting, but rather its lining."[8]

It was quite by chance that I was sick at home one afternoon and found myself watching *A Patch of Blue* (1965). It was a long time ago. I was a little girl.

*A Patch of Blue* is a heart-wrenching, civil rights era melodrama starring Sidney Poitier, and directed by Guy Green. The character of Selina (played by Elizabeth Hartman) is helpless, white, blind, and adolescent, with a terrible mother who caused her blindness during a drunken scuffle. (The very awful mother is played by Shelley Winters.) The only color memory that Selina has from her world before blindness is a "patch of blue" (Plate 1). Blind Selina, with this bit of blue sky or blue ocean or blue cardigan or blue cup or blue nothing at all, falls in love with Gordon, Poitier's character: a gorgeous "man of color." Green could have made the film in color, but he was emphatic that it be in black and white.

This patch of blue produced a tiny, if violent, affect on me, what Walter Benjamin describes as "a little shock."[9] The affect of my patch of blue is not unlike the affect of Marcel Proust's famed little patch of yellow wall (*petit pan de mur jaune*), only in reverse. My blue is nostalgic; Proust's yellow is nostologic. (*Nostology* is a word for gerontology: it is from the Greek *nostos*, a return home, with reference to aging or a state of second childhood.[10]) In *À la recherche du temps perdu* (1913–27), Bergotte, Marcel Proust's famed character, who happens to be a writer, who shares much with the real author of the long novel, famously goes to see Jan Vermeer's painting *The View of Delft* and gets all stirred up by a tiny patch of yellow. This happens on the last day of the old man's life, at the end of his life, not at the start of his life.

> At last he came to the Vermeer which he remembered as more striking, more different from anything else that he knew, but in which, thanks to the critic's article, he remarked for the first time some small figures in blue, that the ground was pink, and finally the precious substance of the tiny patch of yellow wall. His giddiness increased; he fixed his eyes, like a child upon a yellow butterfly which it is trying to catch, upon the precious little patch of wall. "That is how I ought to have written," he said. "My last books are too dry, I ought to have gone over them with several coats of

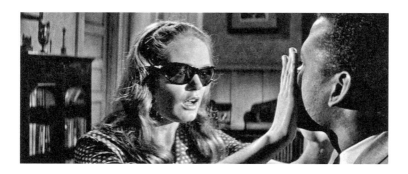

*It was quite by chance that I was sick at home one afternoon
and found myself watching* A Patch of Blue *(1965).*

........................................

paint, made my language exquisite in itself, like this little patch of yellow wall." (K, V, 244; P, III, 692)

In the case of *this* book, my eyes are fixed on a blue butterfly "upon the precious little patch of wall" that I am trying to catch. I have a case of "Nabokov's Blues."[11] (Nabokov, author and lepidopterist, was an expert on a large group of butterflies known as Blues.[12])

When I first watched *A Patch of Blue* I was a nine-year-old white girl enjoying the freedom of being just a little sick, of missing school, of drinking ginger ale in the morning and sucking on red, triangular-shaped, deliciously artificially flavored cough drops.

My age was the same as Claudia's, the little black narrator-girl in *The Bluest Eye* (1970), Toni Morrison's wounding novel (set in Ohio in the grim year of 1941, the beginning of the Second World War). Same age, but different colors, classes, geographies. Claudia hated all the white things I loved, including Shirley Temple and those big glassy blue-eyed, pink-skinned, yellow-haired dolls of my childhood. Claudia destroyed the latter with a "disinterested violence,"[13] not unlike Shelley Winters's own blinding of her child.

Claudia, wise and sympathetic (whose voice mimics those of adult black women spilling their souls, and those of family and friends on the porch or in the backyard),[14] tells the story of another little black girl, who is her binarism: eleven-year-old Pecola, incredibly woundable Pecola.

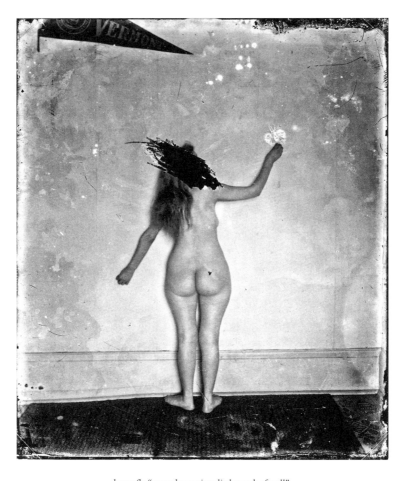

butterfly "upon the precious little patch of wall"
...........................................

*Claudia hated all the white things I loved, including Shirley Temple
and those big glassy blue-eyed, pink-skinned, yellow-haired dolls of my childhood.*

........................................

Pecola wants nothing more than "Morning-glory-blue-eyes . . . Alice-and-Jerry-blue-storybook-eyes."[15] Her vision is as skewed as Kiki Smith's upside-down *Lilith* (1994) (Plate 2). With each page that I turn, Pecola (like Coca-Cola), who is too brown, too sweet for this world, pecks and pecks at my own brown eyes, as if I were one of Cinderella's wicked stepsisters.

Unloved, emotionally malnourished: Pecola (like black coal) feeds her starving girlhood with milky whiteness, even consuming "three quarts of milk" in one sitting, just to take advantage of using the Shirley Temple cup that obsessed her.[16] The cup is clear blue, like a fantasy of the little starlet's glass-blue eyes. Pecola similarly nurtures her wounded self with Mary Jane candies, sweets with the taste of molasses and peanut butter, not unlike a Peanut Butter Kiss or a Squirrel Nut Zipper or a Bit-O-Honey:

> Each pale yellow wrapper has a picture on it. A picture of little Mary Jane,
> for whom the candy is named. Smiling white face. Blond hair in gentle dis-

array, blue eyes looking at her out of a world of clean comfort. The eyes are petulant, mischievous. To Pecola they are simply pretty. She eats the candy, and its sweetness is good. To eat the candy is somehow to eat the eyes, eat Mary Jane. Love Mary Jane. Be Mary Jane.

Three pennies had brought her nine lovely orgasms with Mary Jane.[17]

But these little girls with blue eyes wrapped in yellow paper did not heal Pecola.

It was *by chance* that I watched *A Patch of Blue* by myself while my mother did household things. As a little girl, I saw many afternoon movies on television starring my favorite movie stars: Shirley Temple and Sidney Poitier. My adult memory of my childhood viewing of *A Patch of Blue*, where Poitier feeds the viewer and the blind girl with seen and unseen blackness, is hued blue and taboo. The memory is still sorely felt: it is bruising, is black and blue.

This recollection of seeing *A Patch of Blue* is not horrifically bruising like my adolescent memories of seeing documentary footage of Hiroshima and Nagasaki, or of discovering photographs of Bergen-Belsen and Dachau. To quote Susan Sontag's recollections of seeing pictures of the concentration camps in 1945, when she was twelve years old: "When I looked at those photographs, something broke."[18] No, my *Patch of Blue* did not break me: my memory is much more *neutral* than that. But it is precisely this neutrality that will dirty this book black and blue. As Roland Barthes claims in *The Neutral* (*Le Neutre*), a landmark series of lectures delivered at the Collège de France in 1978, twenty-three little chapters or dandelion seeds or twinklings, under the shadow of the recent death of his *maman*, "the Neutral is colorful (and it stains!)"[19]

Long ago, that little film starring a black man held by a patch of blue went inside me and made a home for itself. Like a marble from my childhood, it has always been there. Intermittently, I have held this black and blue cat's-eye again: looking through it, rolling it in my mouth. But it was not until recently that I realized how special this marble was. It was my first black and blue thought.

Like Pecola drinking whiteness in a Shirley Temple cup, I tasted Poitier's blackness in a wrapper of sweet blindness, like Selina herself.

I find black and blue everywhere. It abstractly brushes and stains me in

the black and blue paint of Barnett Newman and Mark Rothko. It figures in Francis Bacon. It sings to me in the voice of Louis Armstrong in his recording, in 1929, of "What Did I Do to Be So Black and Blue?"

Black is the color of the darkroom, of desire, "of the black milk of the nocturnal goat" (Rilke),[20] of cinema, of being underground, of a fall through the hole of the pupil of the eye, of a bomb shelter, of a cellar, of a pile of coal, of dirt, of sweet, thick, dark molasses, of bad-luck cats, of the velvet dress of John Singer Sergeant's *Madame X*, of the mourning coat, lined in fur, with matching skull cap, worn by Hans Holbein's *Christina of Denmark*, of Laurence Sterne's famous all-black page in *Tristam Shandy*, of rare tulips, of the paintings of Ad Reinhardt, of night, of caves, of melancholia, of the black sun, of the sunless sky (after a volcanic eruption or after the dropping of a nuclear bomb) and of beauty.

Black is the color of cinema itself. As Barthes writes, the cocooning blackness of the movie theater is "the 'color' of a diffused eroticism . . . it is because I am enclosed that I work and glow with all my desire."[21] When leaving the movie theater, Barthes mews, in a feline way, that "his body has become something soporific, soft, peaceful: limp as a sleeping cat."[22] The nocturnal cat is the moviegoer of the animal kingdom; it is the totem animal of Chris Marker, Alain Resnais, and Agnes Varda.

Black is the womb-like bedroom where Proust wrote most of the *Recherche*, covering the windows to suppress all light, lining the walls with soundproofing cork, reversing his hours so as to turn day into night: in sum, living in a darkroom, developing his detailed pictures of life in blackness. Walled in, *uterinized*, Proust wrote not only the blue parts of the *Recherche* (more on azure words soon) but also the beautiful black bits, like "the story of the pearls": Madame Verdurin's once-white pearls that "had become black as the result of a fire," which indeed made them that much more exquisite (K, VI, 35; P, IV, 293).

Blue is the color of the blues, "the ink that I use is the blue blood of the swan" (Cocteau),[23] of the sea, of the cyanotype, of memory, of the eyes of my youngest son, of the gray-blue of my mother's eyes, of hope, of Yves Klein, of Thomas Gainsborough's *Blue Boy*, of Giotto's joy, of Derek Jarman's blank film titled *Blue*, of Helmut Newton's Polaroids, of "blue pencils, blue noses, blue movies, laws, blue legs and stockings . . . examination booklets

Ten times in a day has *Yorick*'s ghost the consolation to hear his monumental inscription read over with such a variety of plaintive tones, as denote a general pity and esteem for him;——a foot-way crossing the church-yard close by the side of his grave,—not a passenger goes by without stopping to cast a look upon it,—and sighing as he walks on,

Alas, poor YORICK!

C H A P.

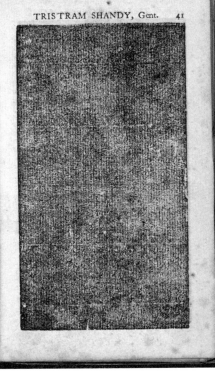

of Laurence Sterne's famous all-black page in Tristam Shandy, of rare tulips, of the paintings of Ad Reinhardt, of night, of caves, of melancholia, of the black sun, of the sunless sky (after a volcanic eruption or after the dropping of a nuclear bomb) and of beauty.

.......................................

. . . and cheese,"[24] of baby boys, stillborn babies, of glaciers, of cocktails, of Marina Warner's *Indigo*, of desire, of distance, of longing "of the light that got lost,"[25] of not being warm, of beauty "of the aster or the iris or the air a fist has bruised."[26] Thomas Becket (claims William Gass) "is a very blue man."[27]

"The air a fist has bruised": that's a rustle, a murmur, a buzz, a humming.[28]

...........................................................................................

While blueness (as in blue eyes) and blackness (as in dark skin) are unequivocally about race, the two colors flower into other ever-expanding tropes as they shade, highlight, tint, dye and bruise my book: *Black and Blue*. After all, blue is not only a color of whiteness, as in Morrison's *The Bluest Eye*, it is also the color of nostalgia.

One only needs to drift nostalgically *Toward the Blue Peninsula* with the shadow-box artist Joseph Cornell, whose favorite colors were blue and white.[29]

One only needs to sink into the wistful longings of Proust: unalloyed blues of the azure sky, beryl blues of the ocean, and melancholic dusky sapphires of the midnight hours.

In the *Recherche*, the Narrator's obsessive desire for his love interests (first Gilberte and then Albertine) is propelled by a black and blue (indigo) liquidness. In his imagining of both Gilberte and Albertine, the colors black and blue contain molecules of Jewishness (in the period's air of the Dreyfus affair). Most poignant, in this regard, is the Narrator's confession of painting over Gilberte's black "Jewish" eyes with an envisioned blue:[30]

> Her black eyes gleamed, and since I did not at that time know, and indeed have never since learned, how to reduce a strong impression to its objective elements, since I had not, as they say, enough "power of observation" to isolate the notion of their colour, for a long time afterwards, whenever I thought of her, the memory of those bright eyes would at once present itself to me as a vivid azure, since her complexion was fair; so much so that, perhaps if her eyes had not been quite so black – which was what struck

one most forcibly on first seeing her – I should not have been, as I was so especially enamoured of their imagined blue. (K, I, 198; P, I, 139)

And, of course, Proust, whose mother was Jewish, had his own famous eyes that looked like "Japanese lacquer."[31]

But Albertine has true blue eyes. She is an inversion of Gilberte. Likewise, she is an *invert*, a lesbian (in a book where the homosexual is likened to the Jew, by an author who was both). The blue eyes of this unknowable, close-minded, anti-Semitic Albertine are a surprise:[32] for her hair is nightly, like "black violets" (K, V, 14; P, III, 528). So, just as the black eyes of fair-skinned, red-haired Gilberte come as a shock, Albertine's "blues" are unexpected and unnerving. Relentlessly associated with the ungraspable liquid of the sea, Albertine's eyes are impossible to hold captive, are always already fugitive. Her eyes are the blue ocean: "So much so that when she shut them it was as though a pair of curtains had been drawn to shut out a view of the sea" (K, V, 14; P, III, 528).

Black and blue are racial markers.

Blue is longing.

Black is melancholia.

Black is the true color of Gilberte's blue eyes.

## BLACK (AND BLUE) BEAUTY

The beautiful person or thing incites in us the longing for truth.

– Elaine Scarry, *On Beauty and Being Just*

At the heart of *Black and Blue* are one book and three films: Roland Barthes's *La Chambre claire: Note sur la photographie* (1980); Chris Marker's *La Jetée* (1962); Chris Marker's *Sans soleil* (1982); and Alain Resnais's and Marguerite Duras's *Hiroshima mon amour* (1959). All four of these works are French and postwar. All four are guilty of *beauty* and can be read (as a result of their culpability) as unjust. *La Chambre claire* touches us with the crystalline language of "the delayed rays of a star" (H, 81; S, 126). *La Jetée* caresses us with the tranquil (if confident) narration of a father's bedtime story, with images so still that

you believe you can enter them.[33] *Sans soleil* does business with lush voice-overs and unceasing rushes of exhilarating footage that pop into our eyes-as-mouths "to be eaten on the spot like fresh doughnuts."[34] *Hiroshima mon amour* cashes in on a rhapsodic soundtrack and seamless cinematography.

Blue, black, and beauty are all *colored* duplicitously (from an acknowl-edged Anglo-American-European schematic vision). Blue is joy *and* sadness. Black is evil *and* sophistication, reverence and knowledge. Black is the color of the first engravings and type. Elaine Scarry emphasizes beauty's deceit when she astutely claims: "Berated for its power, beauty is simultaneously belittled for its powerlessness."[35]

Both blue and black are intensely connected to beauty. Given the punch of black *and* blue, it is no coincidence that Michel Pastoureau's first books on color began with these entwined colors.[36] The punch, according to Pastoureau, is not just metaphorical, it is also historical: "For a long time, blue, an unobtrusive and unpopular color, remained a sort of 'sub-black' in the West or a black of a particular kind. Thus the histories of these two colors can hardly be separated."[37]

By marrying beauty with the political, my subjects aggressively (if subtly) break the rules. They use beauty (through the colors black and blue, the touching of *colored* skin, the enchanting structure of the fairy tale, and the erotics of love) as a serious political tool for unveiling truths.

........................................................................

In *La Chambre claire*, the reader confronts Barthes's desire for the black body as nourishing and taboo. He gives us a story of race that causes us to shake our heads: up and down, side to side, yes and no. He is wrong. He is right. Barthes's wrong-and-right moves are visible, forever in process, forever cor-rections marked black and blue (Plate 3), not unlike the appealing page of amended type that we discover in *Roland Barthes by Roland Barthes*: "Correc-tions? More for the pleasure of studding the text."[38] It is as if the text were a garment, and the corrections buttons, snaps, grommets, tucks, and pleats.

In *La Jetée*, Marker dreams the fairy tale and the political film as strange bedfellows. How might the structure of the fairy tale provide meaningful hope in the blackness of this imagined World War Three?

In *Sans soleil*, black is the color of transport, as Marker migrates from island to island, from place to place, from Guinea-Bissau to Japan to Iceland to Cape Verde, from the past to the future. Is it possible to speak of terror, of colonialism, of annihilation, of natural disaster, of bombs, of prejudice through this black mobility cut with the hope of blue?

In *Hiroshima mon amour*, the impossible representation of the dropping of the atomic bomb is understood through sacrilegious love. Can one understand impossible suffering and loss through the erotics of love?

........................................................

Proust, who was not sure if he was an *unaesthetic* philosopher or a full-on *aesthetic* novelist, is in the air of all four of my subjects. *Black and Blue's* three films and one book, it seems, took a few beauty lessons from Proust.

Barthes, who often references the *Recherche*, taught his last seminar on writing a novel, and he left fragments of his own Proustified novel behind.

In 1945, one of Alain Resnais's first professional assignments was as a cameraman and editor on a 16mm short film, directed by Jean Leduc, called *Le Sommeil d'Albertine* (or *Les Yeaux d'Albertine*), which was based on an incident from the *Recherche*.

Chris Marker pays homage to Proust in *Immemory* (1998), an interactive CD-ROM that includes a photograph of a bakery that sells madeleine cakes (taken in Illiers-Combray, the town where the famous author spent his boyhood holidays[39]); a meditation on the Proustian significance of the character of Madeleine (as played by Kim Novak) in Alfred Hitchcock's *Vertigo*; and these words – "I want to claim for the image the humility and powers of a madeleine."[40]

........................................................

*Black and Blue* seeks to tell stories. Like a historical novel, its function is not to correct history, but rather to make history appear (Fredric Jameson).[41]

"Is History not simply that time when we were not born?" (H, 64; S, 100).

This black and blue book is sad and short. Sadness is new to me. But sadness is not the opposite of pleasure: it is its lining. My earlier books were a mix of things: the heft of nostalgia, the clouds of flight, girlish excess, boyish unstoppability. They were more blue than black. My relatively happy books (medium sized and, even, quite fat) certainly have endpapers of sadness. But this book is sparser with its ingredients.

Barthes remarks that a text on pleasure cannot be anything but short: "(as we say: *is that all? It's a bit short*); since pleasure can only be spoken through the indirection of a demand."[42] I claim the same brevity for *la tristesse du texte*, the sadness of *Black and Blue*. Books on pleasure and books on sadness are always in danger of not getting the affect right *and* of self-indulgence. Better to keep it thin. (I fear this book is not thin enough.)

## LIKE A BRUISE

Black is not the opposite of blue: it is its lining. Both are sad colors.

All four of my "tender buttons" (*La Chambre claire, La Jetée, Sans soleil,* and *Hiroshima mon amour*) feel the hurt of war, of love, of time like a bruise. (One meaning of *bleu* in French is bruise.) After watching *La Jetée, Sans soleil,* and *Hiroshima mon amour*, a tenderness remains, though we may have forgotten how the bruise got there. If our skin is black, the bruises may not show at all. Invisible pain is often the most impossible to reconcile.

The affect of these texts is akin to my memory of *A Patch of Blue*. The ridiculous, but moving, melodrama of my childhood, in the microcosm and macrocosm of time, is like one of Proust's "exquisite small-scale contrivances":[43] the tiny chance-taste of a madeleine, the tiny chance-sound of a spoon on a plate, the tiny chance-touch of a starched napkin, all miniscule things which loom with large significance. It is a wound from yesterday that is felt today. *La Chambre claire*, along with my three films (as fed by *A Patch of Blue*), ring time, just as a bruise circles and fills a bodily insult with its injurious colors. (But in this book there is little yellow: the color that appears when a bruise begins to heal.)

Sometimes, between the time of the pain and when the bruise presents itself, we forget the injury. I am trying to not forget. Bruises are the before-time wounds of always-falling childhood and the after-time of growing old. (It takes so little to bruise the elderly.)

A bruise is an injury that is "neither inside, nor outside."[44]

I am sitting in the bathtub counting all the bruises on my legs: a child caught in the body of a woman.

In an echo of Marker's *La Jetée*, "this is the story of *a woman* marked by an image from her childhood."[45]

This is the story of a woman marked by a patch of blue.

A bruise is an injury that is "neither inside, nor outside."

........................................

A Sewing Needle

inside a Plastic and

Rubber Suction Cup

Sitting on a

Watch Spring; or,

An Object for Seeing

*Nothing*

..............................

This is a sad book, in part, because it stems from my mother's devastating illness. It is through her Alzheimer's that the personal begins to prick, punch, snip, and bump against more public and more collective sufferings. Like *Hiroshima mon amour*, this book provocatively (and hopefully effectively) combines catastrophe with frivolity as the text moves between the public and the private, in an effort to make sense.

This book necessarily echoes the condition of the French lover of *Hiroshima mon amour*, a character who is public in her namelessness, yet personal in her subjectivity. ELLE tries to *not forget*; and she also tries to see Hiroshima. Seeing (another word for understanding) is impossible. "You saw nothing in Hiroshima," LUI, her new Japanese lover, informs her, over and over.

My mother, she too, sees nothing.

My mother looks at me without knowing (without seeing) me.

In the *Recherche*, the Narrator's beloved grandmother suffers a devastating stroke. She, too, no longer recognizes him: "But alas, when, a moment later, I bent over her to kiss that beloved forehead . . . she looked up at me with a puzzled, distrustful, shocked expression: she had not recognized me" (K, III, 455; P, II, 629-30). This moment in Proust's text, for the reader and for the Narrator, is arguably more painful, more meaningful, than the grandmother's actual death.

To become unseen by a mother (or grandmother), by one so loved, by one so previously known, by the person who taught us our first words, by the person to whom we first spoke "Mama" (or "Nana" or "Baba" or a host of other reduplicating infant babbles for the other mother) is to "descend into the untranslatable, to experience its shock without ever muffling, until everything Occidental [known, understood] in us totters" (Barthes).[1]

How does one mourn someone who is still alive, yet who is not of this world?

Personal discoveries, whose "Kernel" is the death of a mother who lives, punctuate *Black and Blue*.[2] Though I have but little control of how my first-person accounts will take seed, may I at least lend these words of caution. My anecdotes are not meant as revelation; rather, they are "glimpses of a specific path among others."[3] In the spirit of James Clifford, "I include them

in the belief that a degree of self-location is possible and valuable, particularly when it points beyond the individual towards ongoing webs of relationship."[4] My intimate accounts are attempts to situate, not resolve, a *struggle*: between inside and outside, the private and the public, the Kernel and the shell.

For the "analyst-poet-translator"[5] Nicholas Abraham, the Kernel is a meaning that we *sense*, but cannot write *sensibly*. "The effect of capitalization invokes a mystery."[6] The fact that sense means "meaning" and also "sense," as in the five senses, as in feeling, and as in intuition, is of special interest to Abraham's approach to psychoanalysis, as well as to this book's struggle with personal and public meanings.[7]

The shell reveals the shape of the Kernel it holds, from which it is also inseparable.

The shell is "simultaneously concealing and revealing."[8] The Kernel is "invisible but active," as it "confers its meaning upon the whole construction."[9]

To better understand Abraham's philosophical poetics, one might think of the seashell, which grows according to the shape and size of the animal housed and bounded inside. Or, one might imagine the "walnut that becomes round in its shell."[10] We must approach it, this *"Nucleo-Peripheral"*[11] Kernel-shell, through Abraham's coinage of "anasemia," an analytical tool, which enables a "search for the meaning of phenomena in something that is by nature inaccessible to direct apprehension."[12]

*Black and Blue* is a search for the meaning of a catastrophe like Hiroshima. Out of reach, it is impossible to represent, especially for someone so historically and culturally removed as this author. One can only bump up against it, come into collision with it. The affect is black and blue.

As a partial and free echo of Abraham's essay "The Shell and the Kernel" (1968), this book is a "shell . . . marked by what it shelters":[13] racism; the threat of nuclear annihilation; things that quicken the heart; Hiroshima; love; loss; the Holocaust; happiness; blackness.

My project, like Abraham's, is also one of "scandalous antisemantics":[14] *Black and Blue* is full of concepts that are so horrible they have no choice but to be "designified."[15]

Proust offers the *Recherche* to his readers as a metaphoric magnifying glass to see more closely that which lies within oneself: perhaps something

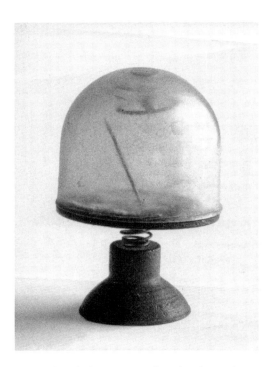

*I offer my book as a sewing needle inside a plastic and
rubber suction cup sitting on a watch spring.*

......................................

akin to Abraham's Kerrnel. As Proust's Narrator explains: "my book being
merely a sort of magnifying glass like those which the optician at Combray
used to offer his customers – it would be my book, but with its help I would
furnish them with the means of reading what lay inside themselves" (K, VI,
508; P, IV, 610).

In a Surrealist-inflected, postwar reverberation of Proust's effort, I offer
my book as a sewing needle inside a plastic and rubber suction cup sitting
on a watch spring. This Kernel enveloped by a shell (as constructed by the
American artist Robert Rauschenberg, circa 1952) is an anasemic tool for
furnishing my readers with what lies inside themselves, as well as what
lies outside. It "alludes to the unknowable by means of the unknown."[16] As
an apparatus for translating personal and more public and collective suf-

ferings, this odd mushroom (vegetal and atomic), uses its watch spring to provide miniscule seismic quivers through time; likewise, its sewing needle is prepared to prick the amnion of rubber and plastic. It is not easy to use. Its findings are hard to read.

Like a sewing needle, my mother is lodged in me. I am beginning to forget her. She tries to speak to me, her mouth a black hole hungry for words.

*a black hole hungry for words.*

........................................

# Elegy of Milk,

# in Black and Blue:

# The Bruising of

# *La Chambre claire*

......................................

A photograph's *punctum* is that accident
which pricks me (but also bruises me . . .)

*Le punctum d'une photo, c'est ce hazard qui, en elle,
me point (mais aussi me meutrit . . .)*

– Roland Barthes, *La Chambre claire*

An open armpit of "marten and beechnut" and "Midsummer night / Of privet and the nests of angel fish" (Plate 4) gives way to fingers of "chance and the ace of hearts," which clench a muscular breast, a molehill "under the sea" (André Breton,).[1] A second frame, smaller and even darker, shows the same man's head asleep or dead, with lips like a "rosette bouquet of stars of the highest magnitude."[2] The exuberant darkness of his skin sinks so deep that it becomes, at times, violet-marine blue. His veins show through, also blue: turquoise blue. His "sex is swordily / Is placer and platypus / Algae and sweets of yore / Is mirror."[3] (It matters, and it does not matter, that the artist, Esther Teichmann, is German, is white, has loved this man.) The diptych (*Untitled*, 2006) is from Teichmann's series *Stillend Gespiegelt*. The German word *stillend* means both breastfeeding and quieting or making still. (Every photograph is a moment held still, not unlike a mother quieting her infant, holding her child still.) The German word *gespiegelt* means mirrored, and it suggests the physical stillness of both mother and child in the act of nursing, as the two become one another.

Photography was once referred to as Daguerre's mirror.

This picture has the "sex" of a "mirror."

Also within the series of seven photographs that make up *Stillend Gespiegelt* is a photograph of the torso of an older white woman in the bathtub. (It matters, and it does not matter, that Teichmann is daughter to this woman.) Every image in *Stillend Gespiegelt* is either of the loved man or loved mother. The bathtub is a fitting place for "mother": for, it is the womb of the house. She holds a washcloth that is the color of the veins of her white breasts: the milky blue of a Polaroid picture (Plate 5).[4] Her nipples give way to the hues of a faint bruise. We are seeing the breasts that nourished the artist.

The black man of *Stillend Gespiegelt*, he, too, holds an essence of nursing by clenching his own breast. The image, with its strong-tender-sad-male erotics, pierces with a Saint Sebastian arrow doused in a little black milk.

The darkness that holds this man of color (asleep or dead) resonates, quietly *and* dramatically, with Paul Celan's poem "Todesfuge" ("Deathfugue," 1945): "Black milk of daybreak we drink you at night / we drink you at midday and morning we drink you at evening / we drink and we drink."[5]

The first page of Roland Barthes's sorrowful *La Chambre claire* (1980) is a color Polaroid, entitled *Polaroïd* (1979), by Daniel Boudinet.[6] The colors are limited: mostly cyan and black. Daylight leaks in around a peek at a fraction of a bed, crowned with a fluffy pillow. The curtains are closed, but daylight shines through the weave of the fabric and the gap where the curtains do not quite meet.

Barthes's *mourning-glory* book, written as an elegy to his recently deceased mother, is seen not through rose-colored glasses but rather through "the photographic trace of a color, the blue-green of her pupils" (H, 66; S, 104). (A point movingly highlighted by Diana Knight.[7]) Barthes and his mother were like old, Russian nesting dolls: one inside the other, inside the other, inside the other. Each one the other's child. Each one the other's mother. "I experienced her, strong as she had been, my inner law, as my feminine child" (H, 72; S, 113).

*Polaroïd* starts Barthes's photo-book and takes flight in the medium's "'throw away' spirit" (Helmet Newton).[8]

*Polaroïd* is blue mother, blue lover, blue birth, thin blue wartime milk, blue death, blue sex (pornographic films are sometimes called *blue films*).

*Polaroïd* suggests day sex. To have sex in the day, when children are playing outside, birds are singing, people are working, when you can hear all the sounds of waking life, is a reversal of the order of things. Likewise, Polaroids are at odds with the traditional photograph developed from a negative. Polaroids develop illegitimately before our eyes in broad daylight.[9]

There is a raw erotics to the particularly startling, exciting, cheap blues of the Polaroid picture. (When Helmut Newton and Guy Bourdin turn to the instant gratification of the negativeless, less-focused, pocket-sized Polaroid, their high-fashion erotics are coated in shoddy, if appealing, blueness.) Polaroid film cools white skin porno-blue. Polaroid film coats true blues in dishonorable cyan. (Think swimming pools and satin sheets.)

Boudinet's bed is sheathed with the illicit Pola-blues (Plate 6).

*Polaroïd* is the condensed sum of Proust's very blue *Recherche* (from the eyes of Albertine to the sea at Balbec to the sky of an unalloyed blue to a love of Giotto's Arena Chapel). The *Recherche* is a blue book, written almost

entirely during the night in bed.: "For a long time, I would go to bed early," reads the book's famous first line, (K, I, 1; S, I, 3).

*Polaroïd* is the blue of staying in bed and not getting up, not going out. (I used to nurse my children in bed, for long hours of near force-feeding. A slightly monstrous mother, I did not want to leave the comfort of my pillows and blankets. I engorged children and time, like a photograph. In Barthes's words: "In the Photograph, Time's immobilization assumes only an excessive, monstrous mode: Time is engorged" (H, 87; S, 142).

Those of you who know my work well may bemoan: "When will she wean herself from Barthes?" It seems, at least, not yet. As Barthes writes in *A Lover's Discourse*: "I behave as a well-weaned subject. I can feed myself, *meanwhile*, on other things besides the maternal breast."[10] Nevertheless, I *am not a well-weaned subject*. His texts fill me with satisfying pleasure (bliss, even). He feeds me his milk, his white ink.

In *The Pleasure of the Text*, Barthes aligns the language of the unpleasurable text with the suckles of the infant who feeds in his sleep in the *absence* of the breast. "The writer of this text takes the language of the nursing infant: imperative, automatic, ineffectual, little rout clicks (those milky phonemes of the marvelous Jesuit, [Jacques] van Ginneken, placed between writing and language: sucking movements without an object, cut from the pleasures of the gastronomy of language)."[11] As van Ginneken notes, in regards to this archaic language of infants: "In the absence of the mother, every normal child, in the second or third month of his existence, feels the desire to suck and begins to have imaginary meals."[12] "Milky phonemes," then, are dry, fantastical phonemes, indifferent speech.

*La Chambre claire* is *wet* with "the pleasures of the gastronomy of language."

To reverse the gender (from female to male) of the famed words of Hélène Cixous: "There is always within *him* at least a little of that good mother's milk. *He writes* in white ink."[13]

With him, I am unweaned.

Barthes's story of looking for his recently deceased maman in boxes of old photographs is famously told in *La Chambre claire*. In the sheets between the covers of his book, Barthes's stumbles upon his lost mother in a photograph from 1898 that he famously calls the Winter Garden Photograph. In

the glass house, the winter garden, his maman, his Henriette, is pictured in all of her essence, at the tender age of five. Although a smaller version of what she would become, maman is there. Gone she is here. Fort/da. So precious. Barthes, in fear of our indifference to this cherished photograph, never reproduces this image that he talks most about. It remains an empty (but full) illustration, not unlike Sterne's bare page in *Tristam Shandy* ("here's paper ready to your hand . . . paint her to your own mind"),[14] or Monique Wittig's empty page written in white ink for Sappho, or the unstained bed sheet in Isak Dinesen's story "The Blank Page," or the unmarked Ocean-Chart of Lewis Carroll's poem "The Hunting of the Snark." Barthes was, of course, not the first to play the trick of the power of non-representation.

Barthes soaks the Winter Garden Photograph in so much white milk, because its *punctum* wounds him, stings him, pricks him, bruises him. (Inversely, Barthes reproduces but never says a word about Boudinet's blue Polaroïd.)

Punctum is Latin for point. According to the *Oxford English Dictionary*, *punctum* is "a very small division of time, an instant"; "a point used as a punctuation mark"; and, under the anatomical term *lacrimal punctum*, the "tiny circular orifice" from which tears emerge. With Barthesian precision, brevity, and style, punctum is at once a second of time, a non-alphabetical mark in writing, and the tiny place from which tears come into view.

Punctum awakens Barthes. Punctum is not unlike the Proustian chance of a bit of madeleine, or a spoon knocking on a plate, or a trip upon uneven paving stones. Such a taste, such a sound, and such a stumble: all are sensations that aroused Barthes's beloved Proust with involuntary memory. As Barthes writes: "A photograph's punctum is that accident which pricks me (but also bruises me . . .)" (H, 27; S, 49).

But it is not only the Winter Garden Photograph that is a significant keeper and feeder of what Barthes famously names as punctum, that detail (often a part-object) that gets him all stirred up.

Barthes is also taken by a 1926 family portrait, by the famed Harlem Renaissance photographer James Van der Zee (1886–1983).[15]

Between the wars, Van der Zee took thousands of studio portraits of the black community, including pictures of children, celebrities, brides, grooms, and leaders, and memorial images of the dead. Barthes's chosen

*not unlike Sterne's bare page in Tristam Shandy ("here's paper ready to your hand . . . paint her to your own mind"),*

..........................................

family portrait (or the one that chose to wound him) is an image of some members of of Van der Zee's own family: "Marie, Estelle and David Oster-hout – the maternal aunts and uncle" of the photographer.[16] This "black" photo, like the Winter Garden Photograph, cuts Barthes's heart with punctum.

Van der Zee's rich images were, as Deborah Willis notes, "originally intended as gifts to intimates or for personal reflection" adorning "fireplace

OCEAN-CHART.

*unmarked Ocean-Chart*

........................................

mantels in parlors and dressing tables and vanities in bedrooms."[17] His work gained a new reputation when it was exhibited in 1969 in the Metropolitan Museum of Art's exhibition, Harlem on My Mind. But Barthes sidesteps the complex history of Van der Zee and his subjects and goes intimate.

In Barthes's hands (stained with white ink), the standing "auntie" in the Van der Zee portrait finds herself bumping up against the famed Winter Garden Photograph. In fact, Barthes sings a little song, splashed with a little volatile milk, to this auntie who stands, hailing her as "ô négresse nourricière" (S, 74).

Both mother and blackness nourish *La Chambre claire*.

For a long time, I dwelt on the *studium* of Barthes's reading of the Van der Zee portrait – his seemingly obvious, erroneous readings of race:

> Here is a family of American blacks, photographed in 1926 by James Van der Zee. The studium is clear: I am sympathetically interested, as a docile cultural subject, in what the photograph has to say, for it speaks (it is a "good" photograph): it utters respectability, family life, conformism, Sunday best, an effort of social advancement in order to assume the White Man's attributes (an effort touching by reason of its naïveté). The spectacle interests me but does not prick me. What does, strange to say, is the belt worn low by the sister (or daughter) – the "solacing Mammy" – whose arms are crossed behind her back like a schoolgirl, and above all her *strapped pumps* (Mary Janes – why does this dated fashion touch me? I mean: to what date does it refer me?) This particular punctum arouses great sympathy in me, almost a kind of tenderness.

> [Voici une famille noire américaine, photographiée en 1926 par James Van der Zee. Le *studium* est clair: je m'intéresse avec sympathie, en bon sujet culturel, à ce que dit la photo, car elle parle (c'est une « bonne » photo): elle dit la respectabilité, le familialisme, le conformisme, l'endimanchement, un effort de promotion sociale pour se parer des attributs du Blanc (effort touchant, tant il est naïf ). Le spectacle m'intéresse, mais il ne me « point » pas. Ce qui me point, chose curieuse à dire, c'est la large ceinture de la soeur (ou de la fille) – ô négresse nourricière – ses bras croisés derrière le dos, à la façon d'une écolière, et surtout *ses souliers à brides* (pourquoi un démodé aussi daté me touche-t-il? Je veux dire: à quelle date me renvoie-t-il?) Ce *punctum*-là remue en moi une grande bienveillance, presque un attendrissement. (H, 43; S, 73-74)

Barthes's claims that the photograph "utters respectability, family life, conformism, Sunday best, an effort of social advancement in order to assume the White Man's attributes (an effort touching by reason of its naïveté)" makes it easy enough to "out" what, at first, reads like patronizing racism. And, in translation, I, especially, cannot get past that "solacing Mammy."[18] My mouth falls open.

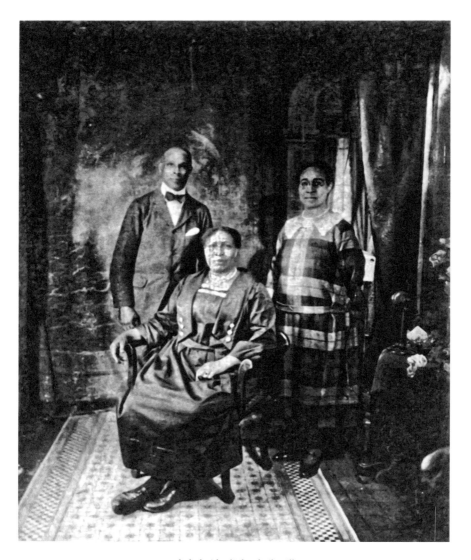

*splashed with a little volatile milk,*

.......................................

Barthes's friend and expert translator Richard Howard has rendered "ô négresse nourricière" as "the 'solacing Mammy,'" with the careful addition of scare quotes so as to pad it with irony and sympathy. But "Mammy" (solacing or not) is dirtied with American racist connotations. The extra punctuation hardly softens the blow, but it does secure Howard's own bafflement. Missing, however, is the sense of honor, surprise, and emotion of the old French ô that begins Barthes's odelet. Barthes's ô is held there in a bluesy song: its little mouth, too, is wide open. The reader cannot help but stumble and fall into the little song hole, into that little tear hole.

Fallen and inside, one can hear the tender-aggressive snipping of the contemporary African American artist Kara Walker. In *Untitled* (1996–98), a disturbing literalism of the birth of the blues, Walker scissors a life-size black silhouette that pictures a squatting woman giving birth to a trumpet: the instrument dangles from between her legs, like a baby being born. Mouths open (in shock or hunger, it is hard to say which), we wait for the blue note, the worried note, the slurred note, the cutting of the chord. No music is heard, save for the click-click of scissors. "She's a black hole."[19]

One definition in the *Oxford English Dictionary* for race is "a cut, mark, scratch."[20] Race was once (and still is) muddled with "raze" (the fact of being scratched or cut). Walker shears race as raze.

Walker, who looks a bit like Mary Poppins in her self-portrait, *Cut*, uses the silhouette (an early form of photography, of shadow play) to give us a baleful of sugar to make the medicine go down. In the words of Gwendolyn DuBois Shaw: "she kicks up her heels while dressed as a high-style servant. She becomes a latter-day Mary Poppins [just a spoonful of sugar makes the medicine go away], part artist/magician and part nanny/mammy."[21] The effect is at first sweet, and then violent. Walker embraces the fairy tale as sugary violence. She draws us in with sweet desirable images and punches back. She makes viewers black and blue, no matter what the color of their skin. Fairy-tale-like, Walker's cut-outs evoke the silhouettes of Arthur Rackham, the children's book illustrator; but, on closer look (to quote Shaw), they make us "see the unspeakable."[22]

In Walker's black and blue-grey panorama entitled *No mere words can Adequately reflect the Remorse this Negress feels at having been Cast into such a lovely state by her former Masters and so it is with a Humble heart that she brings about their physical ruin and earthly Demise* (1999), Hans Christian Andersenesque

*"She's a black hole."*

..............................

swans, "dazzling white, with long, supple necks,"[23] sport, carry, and drop decapitated black cotton-wool heads, as if retelling "The Ugly Duckling" in a whole new scene: the dusky shadows of the antebellum South. Abused for what people perceived as his unattractiveness, Andersen wrote fairy tales of beauty and ugliness that share an intimacy with Walker's own cut-outs: both cut out the "happily ever after" part. (Andersen's "Little Match Girl" freezes to death on New Year's Day; the "Little Mermaid" throws herself into the sea and her body turns to foam.)

In keeping with the magical qualities of Andersen, Rackham, *and* Walker, William Henry Fox Talbot called the images thrown upon paper by his little camera obscuras "fairy pictures," an enchantment that led him to photography, what he would call "the art of fixing a shadow."[24] Likewise, the sil-

*A baleful of sugar*

........................................

houette's history is associated with shadows of racism, magic, and the invention of photography. John Caspar Lavater's late eighteenth-century silhouette machine (used for physiognomy) was a seed of the evils of the *racing* of photography.[25]

The fact that Andersen made his own Walkeresque paper silhouettes brings a smile to the historian's face. Both Andersen and Walker *cut* with words and paper. Andersen's self-portrait with a broad Pinocchio nose plays (like Walker) with physiognomy. In another cut-out, Andersen scissors a clown (his alter-ego) holding the heaviness of the world on his paper head. Andersen "always cut with an enormous pair of paper scissors – and it was a mystery . . . how he could cut such dainty delicate things with those big hands and those enormous scissors."[26]

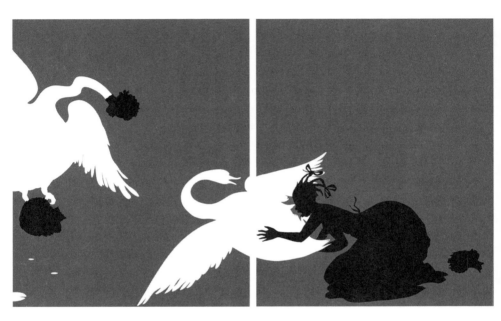

Hans Christian Andersenesque swans, "dazzling white, with long, supple necks," sport, carry, and drop decapitated black cotton-wool heads, as if retelling "The Ugly Duckling" in a whole new scene: the dusky shadows of the antebellum South.

........................................

*Andersen's self-portrait with a broad Pinocchio nose plays
(like Walker) with physiognomy.*

*In another cut-out, Andersen scissors a clown (his alter ego)
holding the heaviness of the world on his paper head.*

........................................

Barthes claims the photograph's punctum as a "prick, little hole, little spot, little cut."[27] (In French, the clicking, puckering alliteration is inescapable: "piqûre, petit trou, petite tache, petite coupure" [S, 49]).

Walker gives us all prick, all hole, all spot, all cut. It is impossible to romanticize an image that is all punctum. Walker causes us to fall into her hole made with big scissors (her particular punctum): a cellar of darkness that we want to forget. In total blackness, you confront your darkest fears, thoughts, and memories. You are in isolation with yourself.

## MILK TURNS

In *Consume* (1998), Walker pictures the impolite parts of Barthes's "ô négresse nourricière." Milky whiteness turns poison.

In Alfred Hitchcock's *Suspicion* (1941), handsome Cary Grant carries a lethal-looking glass of milk up the stairs to a cowering Joan Fontaine. The

*Milky whiteness turns poison.*

*a lethal-looking glass of milk*

....................................

famous director put a light inside the glass of milk because he wanted it
to be "luminous," which curiously made it seem "poisonous."[28] As a result,
"Hitchcock . . . produced a kind of anti-light, with properties normally asso-
ciated with darkness. A cold, wet, colorless light, which hid more than it
made visible" (Peter Blegvad).[29] Or, as Luce Irigaray put it, in a rather differ-
ent context, milk can be as paralyzing as it is nourishing: "With your milk,
Mother, I swallowed ice . . . you flowed into me, and that hot liquid became
poison, paralyzing me." ("Avec ton lait, ma mère, j'ai bu la *glace* . . . Tu as
coulé en moi, et ce liquide chaud est devenu poison qui me paralyse.")[30] In
French, Irigaray's *glace* means not only ice, but also mirror and ice cream,
so as to suggest a range of meanings, from Jacques Lacan's "mirror stage" to
gastronomical milky pleasures.

While I can offer no accurate translation for *ô négresse nourricière*, let it
suffice to say that Howard's scare quotes and his qualifying adjective –
"solacing" – hardly soften the blow, especially with the missing *ô*. But per-
haps that was Howard's intention.[31] We might understand the quotation
marks as Abraham's shell, holding the Kernel of what cannot be translated,

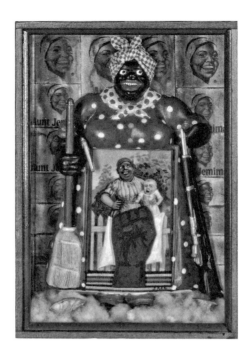

I am fed and shot.
....................................

not only in terms of the differences between two languages and two cultures but also, most importantly, in terms of the unspeakable violence of the history of slavery that "Mammy" holds.

And Betye Saar's "Mammy," her *Liberation of Aunt Jemima* (1972), is in my "image repertoire," if not in Barthes's: Saar's "Mammy" not only nourishes me with my own childhood memories of pancakes with Aunt Jemima's syrup but she also carries a gun. I am taken aback. I am fed and shot. I stumble here on Barthes, on Van der Zee, on the maternal, on race, on myself. And, as you can see, already I am finding something that verges on my own punctum, that pricks me, if on a mixed-up and delayed route through Barthes, through Van der Zee, through Walker, through Saar, through my own mother pouring syrup onto my Saturday morning pancakes.

Reading this passage of Barthes's and looking at the Van der Zee photograph, I feel bruised. "The *punctum* could accommodate a certain latency

(but never any scrutiny)" (H, 53; S, 88). This is Barthes's claim. Nevertheless, he does scrutinize punctum, and so will I, as it accommodates a "certain latency" of this book.[32]

## BLACK SUGAR

*La Chambre claire* is Barthes's book on desire (punctum) and "the art of fixing a shadow" (photography).

When race meets the photograph, desire (punctum) resides in the shadows.

As Barthes knows, "the punctum shows no preference for morality or good taste" (H, 43; S, 74).

I have never not noticed the four black figures in *La Chambre claire*: the three of African Americans (two portraits by Avedon and a family photograph by Van der Zee), and the Félix Nadar image of the young black sailors who bookend the Italian-turned-French Pierre Savorgnan de Brazza, the famed "bloodless conqueror," who became one of France's greatest legends.[33] How could I not notice these black bodies? According to Barthes, the fact of the photograph's connection to the Real "suggests the gesture of the child pointing his finger at something and saying: that, there it is, lo!" (H, 5; S, 15). Likewise, Frantz Fanon starts "The Fact of Blackness" with "'Dirty nigger [nègre]!' Or simply, 'Look, a Negro!'"[34] The fact of blackness is as stubborn as the photograph's link to the referent.

Barthes's novel(esque) *La Chambre claire* is a story of a desire for the maternal that is nurtured by photographs whose very texture tells the story of the nourishment of race. (Carrie Mae Weems has both swallowed it up and chewed it into a thousand little pieces in her photograph entitled "Chocolate Colored Man" (1987), from her series *Colored People*.[35]) Looking at Weems's "Chocolate Colored Man," I taste the voice of Poland, one of the sweet whores in Morrison's *The Bluest Eye*, who was fond of calling Pecola an epithet derived from a menu or dish, like "dumplin," whose bluesy voice was "sweet and hard like new strawberries," who sings of "blues" in her "mealbarrel," whose "sweet strawberry voice" coos: "I know a boy who is sky-soft brown / I know a boy who is sky-soft brown . . . His smile is sorghum syrup drippin slow-sweet to the last."[36] Weems's man is not a boy

*stained, with chocolate.*

...................................

drippin in sorghum (sweet syrup eaten in the American South with biscuits and pancakes); but, he is coated, even stained, with chocolate.

The skin of Barthes's treatment of the photograph is glazed with what Fanon has termed a "racial epidermal schema."[37] Honoré de Balzac meta-phorically proposed that a thin layer of skin is taken with each photo-graph; it turns out that the racial epidermis of the photograph's ghostlike membrane is something to consume, to eat, to feed off of. Weems's choco-late man, caught in strict profile, is shot with the distanced attention of medico-anthropology, so as to mimic those photographs of the nineteenth century, the sole purpose of which was to prove through racist physiog-nomy that the black was lower, more animal-like, on a Darwinian evolu-

tionary model. He is Br'er Rabbit, as in Joel Chandler Harris's troubling tar-baby tale, but rather than being fixed in sticky black tar he is fixed in desirable chocolate. The 1850s have been appropriately labeled "the culinary period of photography" because, during this period, photographers held their stolen images in "sugar, caramel, treacle, malt, raspberry syrup, ginger wine, sherry, beer . . . vinegar and skimmed milk."[38]

As Barthes has written, both the photograph and sugar overfill. As he puts it in *La Chambre claire*:

> The Photograph is violent: not because it shows violent things, but because on each occasion it *fills the sight by force*, and because in it nothing can be refused or transformed (that we can sometimes call it mild does not contradict its violence: many say that sugar is mild, but to me sugar is violent, and I call it so). (H, 91; S, 143)

In the vast collection of the British Museum in London is a blue sugar bowl bearing this gilt inscription: "EAST INDIA SUGAR not made by SLAVES." It encouraged the boycotting of sugar from West Indian slave plantations.

Sugar is violent, is black with history and blue with sorrow (Plate 7).

The anti-slavery sugar bowl shares the materiality of clear, cobalt blue glass with the Shirley Temple cup, from which Pecola gulped up myths of whiteness, and which featured the face of the famed "sweet" starlet who is known for singing "The Good Ship Lollipop" in the film *Bright Eyes* (1934).

Sugar *and* milk are not mild, they are violent and blue.

When Pecola's mother is in the movie theater, sugar becomes the end of her hopes for a better life: it destroys her sense of pride, her beauty. While fantasizing on screen with Clark Gable and Jean Harlow, she recalls: "*I taken a big bite of that candy, and it pulled a tooth right out of my mouth. I could of cried. I had good teeth, not a rotten one in my head. I don't believe I ever did get over that. There I was, five months pregnant, trying to look like Jean Harlow, and a front tooth gone. Everything went then. Look like I just didn't care no more after that. I let my hair go back, plaited it up, and settled down to just being ugly. I still went to the pictures, though, but the meanness got worse. I wanted my tooth back.*"[39]

Sugar, non-nutritive, hedonistic, excessive, bound to childhood, stained with slavery: sugar is bloody. A photograph shoots, takes, and overfills our sight.

(In his essay "Wine and Milk," Barthes finds the production of wine to be bloodied like the sugar of history: "the big settlers in Algeria impose on the Muslims, on the very land of which they have been dispossessed, a crop of which they have no need, while they lack even bread."[40] To which Barthes stings the reader further: "wine cannot be an unalloyedly blissful substance, except if we wrongfully forget that it is also the product of an expropriation."[41])

## BLACK ART

In the early days, photography was called "the black art": the collodion would stain your fingers with evidence of what you had been up to (perhaps a key to photographer-writer Lewis Carroll and his obsession with white gloves and even his White Rabbit who wears them). Even after photography grew out of its sepia days of "the black art," and even after it outgrew the slickness of black and white, photography would become "colored."

It is obvious (nevertheless it is important, difficult, troubling): photography (light writing) has always been struck by racial adjectives and metaphors. "The Black art" was "colored," long before the first color photograph of a tartan ribbon was presented by James Clerk Maxwell in 1861. Again, I am touched by Weems's *Colored People*, from "Chocolate Covered Man," to "High Yella Girl," and especially, for the purposes of this book, I feel the punch of "Blue Black Boy" (Plate 8).

Punctum at times may be just a little sting; but when it is coupled with some hard-hitting studium (like the fact of blackness, like the racing of photography, like color and women as nourishing), it is affectively bruising. It makes you black and blue.

In a graduate seminar devoted to Barthes, which I taught years ago at the University of North Carolina, Thu-Mai Christian (who, as a child, had moved to the United States from Viet Nam) told us a memory, a recollection stained by her own recollections of being different. Here is her story,

as prompted by my comparison of the blue Boudinet with the black Van der Zee:

> My high school French teacher told us this story about a trip she took to Japan. She was on a train traveling through the Japanese countryside. Across from her, a little boy and an elderly woman were obviously looking at her as they spoke to one another in their native Japanese. For a blonde-haired American woman, a rare sight in this part of Japan, the attention was not unusual. After more discussion with the old woman, the little boy finally approached my teacher and said, "My grandmother wants to know if you see blue through your blue eyes."

This story of Barthes and photography is not black and white; it is a Barthesian third language of black and blue.

Playing upon the French production of those real tourist guides – the famed *Guide bleu*, which are picturesque to a fault, and are demythologized by Barthes in his essay "The *Blue Guide*,"[42] and the not so familiar *Guide noir*, which began in the 1960s, as a pun on the typical tourist guide, providing the reader with a more irrational and illicit pilgrimage – my story is more black than blue.

### LA CRITIQUE NI-NI

Punctum is intimate, it keeps you coming back, like it kept Barthes coming back to the Van der Zee photograph (at first it was "the belt worn low," then the "strapped pumps," that touched him, and then, finally, he landed on the "necklace").

Barthes is, to hail Toni Morrison's brilliant book, "playing in the dark."[43] Punctum forecloses closure, because desire itself can never be fully attained. Punctum, unlike studium, cannot be shellacked and immobilized. Whether intentional or not, Barthes's impolite parts demand a criticism that is not "too polite or too fearful to notice a disrupting darkness" before our "eyes": no matter what color the eyes of the object or its reader.[44] When looking at Barthes's fateful page, riddled with "White Man's attributes" and "ô négresse nourricière," I had only acknowledged what I had understood as "the

politically correct": what was easy, straightforward to read. You could say that I saw only the studium of Barthes's work on punctum. I needed to be more *neutral*.

Neither racist nor not racist, Barthes's reading of the Van der Zee photograph plays out the critic's famed neither-nor methodology: *la critique ni-ni*. Barthes's neither-norism resists categorization, but he did helplessly label it as *le neutre*, which, of course, it was anything but.

Given his preference for the structure of "neither-norisms," of his raptures over binarisms, which give him "erotic" pleasure, it is no wonder that Barthes is so fascinated by the Photograph, whose essence is entirely "ni-ni": neither Art nor Science — neither Fiction nor Real — neither Death nor Life, and on and on, like nesting dolls.

Indeed, as Rosalind Krauss and Denis Hollier have so thoughtfully pointed out, Barthes's penultimate course at the Collège de France, "*Le Neutre*," is evidence of a steady conjecture, an obedience to this "third language" (as played out by the neutral) from his early book *Writing Degree Zero* to his final teachings.[45]

### FIRST SHADOWS: THE HEART OF THE PROBLEM

> The Tarzan stories, the sagas of twelve-year-old explorers,
> the adventures of Mickey Mouse, and all those "comic books"
> serve actually as a release for collective aggression. The
> magazines are all put together by white men for little
> white men. This is the heart of the problem.
>
> — Frantz Fanon, *Black Skin White Masks*

There is one poem that my mother always recited to me: Robert Louis Stevenson's "My Shadow."[46] I believe that she memorized it in school (learning a poem by rote was at the center of her backward, Depression-era education in the American South). Stevenson's poem is at the center of the singular book that I remember from my childhood, a volume that I still have, tattered and worn, it sticks with me: *The Gateway to Storyland*, first published in 1925, edited by Watty Piper. (Mine was a deluxe, oversized edi-

tion from the 1960s.) The poem, one could say, is where it all began for me (as perhaps my only literary memory), my Mnemosyne.

But "My Shadow" was, of course, not the only story in my beloved storybook. It, too, like *La Chambre claire*, had its own stories of desire spelled out through other "shadows" of blackness that I tucked into my bed with me, into the corners of my sheets, into the wrinkles of my memory. (As Peter Stallybrass has taught me: in the technical jargon of sewing, wrinkles are called memory.[47]) As my father read, I made rabbit shadows on my white, white wall: my index and middle fingers as ears, my ring finger as a delightful wiggly nose, an eye out of a hole made from my thumb and my pinky. And there I heard not only "My Shadow" but also "Little Black Sambo" and "The Little Tar Man" (the latter a whitened-up version without the black dialect of a Br'er Rabbit story).[48]

Now, when I look into the milky eyes of Richard Avedon's portrait, William Casby, born in slavery, Algiers, Louisiana, March 24, 1963, stuck in between the sheets of *La Chambre claire*, I remember myself as a little girl in bed listening to racist stories. Slavery is part of my life(time). Casby, born a slave, was walking the earth while I was being doused in drops of black milk. The photograph of William Casby slaps me in the face twice, with the present as past and with the past as present.

"Not only is the Photograph never, in essence, a memory (whose grammatical expression would be the perfect tense, whereas the tense of the Photograph is aorist), but it actually blocks memory, quickly becomes a counter memory" (H, 91; S, 142).

I am sure that it is in bed that most of us begin our long apprenticeship on the intricacies of desire and its claims on race (and on gender and class). It all happens, long before we lose our milk teeth, perhaps from too much sugar, while we make shadows on the wall.

## BLACK AND WHITE PEARLS

As Margaret Olin has demonstrated, one needs to ask a whole series of questions that turn on Barthes's use of the word *naïf* when describing the Van der Zee photograph:

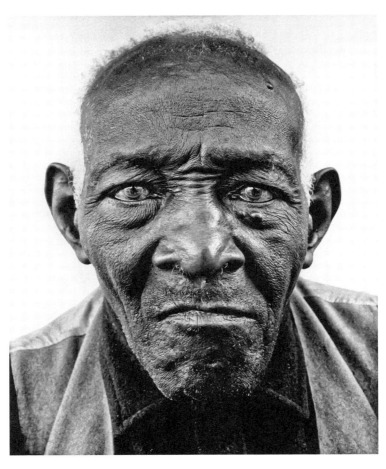

*William Casby, born in slavery, Algiers, Louisiana*
*(photograph by Richard Avedon, taken March 24, 1963)*

........................................

Why are the sitters naïve? To think that the acquisition of "Sunday best" and jewelry (or to have themselves photographed in such costumes), will make them like whites? Or are they naïve to think that whites will treat them better if they see them in such garb? Which attributes does Barthes mean: Why does Barthes take the "American Way of Life" to mean "attributes du Blanc," rather than attributes of the middle class, surely an aspiration of many of Van der Zee's sitters, an entry into which a portrait by Van der Zee may already have certified?[49]

Yet as Olin points out, Barthes elsewhere has more clearly taken to task the myths that white people held of black people, as in "Bichon and the Blacks," which appeared in the original French edition of *Mythologies*.[50] Or what about Barthes's careful and powerful analysis of the photograph of a young black soldier wearing a French uniform on the cover of *Paris Match*, in which Barthes shows how *the myth of France* as a great empire without discrimination works through the signifiers of this picture?

Rather than revealing himself to be the contradictions he is setting at play, Barthes instead seems to be casting the Van der Zee picture into a shadow among shadows (in his own magic lantern show), where, to quote the gorgeous essay by Tanizaki Junichirō's, *In Praise of Shadows* (1933–34), "a phosphorescent jewel gives off its glow and color in the dark and loses its beauty in the light of day."[51] Shaded by Tanizaki's shadow, Barthes's punctum is a bluesy shadow in a dark place.

As Barthes tells his readers: "in order to see a photograph well, it is best to look away or close your eyes" (H, 66; S, 88). A real necessity here, given that the "négresse nourricière" is adorned with no "slender ribbon of braided gold," as Barthes claims; she seems, instead, to be adorned with pearls (as Olin suggests in her brilliant essay). Nevertheless, in Barthes's mind, the African American woman is wearing "this same necklace (a slender ribbon [*cordon*] of braided gold)" (H, 53; S, 88), which had been worn by his cherished Aunt Alice, a woman important to him. Alice, his paternal aunt, had taught him to play piano. Alice had shown him an *other* kind of love. She never married. Barthes's caption for a sad-looking photograph of Aunt Alice as a young girl in his *Roland Barthes by Roland Barthes* reads: "The father's sister: she was alone all her life."[52]

Aunt Alice lived with her mother as an old maid, not unlike the gold

necklace that had "remained shut up in a family box of old jewelry" (H, 53; S, 88).

There is another photograph of Aunt Alice in *Roland Barthes by Roland Barthes*: she stands, as Olin cleverly unveils, in a family portrait in the same position as the "négresse nourricière." Barthes "adheres" to this aunt, like the Photograph and its Referent, like the boy and his shadow in Stevenson's "My Shadow," whose boy narrator claims: "I'd think shame to stick to nursie as that shadow sticks to me!" Such shame, of course, was not unbeknownst to Barthes's beloved Proust, who stuck to his own Maman. Such shame is familiar to all boys and "boyish men" who love their mothers in a culture of what Eve Kosofsky Sedgwick calls "effiminiphobia."[53]

Barthes was nursed, nourished by the blackness of Van der Zee's own maternal aunt, sister (at least in his mind) to Aunt Alice: they are doubles in Barthes's desirous mind, not unlike the sister-twins named "Chicken and Pie" in *The Bluest Eye*.[54]

In *A Lover's Discourse*, Barthes confesses that only "sometimes" is he "normal": "a well-weaned subject" who can feed himself on other things besides the "maternal breast."[55] Like an adolescent, Barthes recklessly unveils desire as raced, as queered. He sticks to this black woman, like Maman, like Aunt Alice, as if he were her. Barthes understands his desire in terms of "the neutral" and it is a "scandal," and he performs it as such.[56]

Barthes colors his auntie as a black and blue nancy, a black and blue pansy.

Barthes was at times mockingly referred to by the students of the Collège de France as a *tante* (which in French is not only "aunt" but also slang for nancy-boy). Barthes identified himself with Aunt Alice and the Auntie of the Van der Zee photograph.

Barthes colors himself and his Aunt Alice under the darkness of the woman he sings as "ô négresse nourricière," who is, indeed, the most shadowed figure, allegorically and formally in Van der Zee's family portrait. Likewise, Barthes is redoubled as *nurse* when he cares for his mother at the end of her life. "During her illness, I nursed her, held the bowl of tea she liked because it was easier to drink from than from a cup: she had become my little girl, uniting for me with that essential child she was in her first photograph" (H, 72; S, 112).

Undoubtedly it was Jules Michelet who first fed Barthes (at least intel-

Barthes "adheres" to this aunt, like the Photograph and its Referent, like the boy and his shadow in Stevenson's "My Shadow," whose boy narrator claims: "I'd think shame to stick to nursie as that shadow sticks to me!" Such shame, of course, was not unbeknownst to Barthes's beloved Proust, who stuck to his own Maman.

..........................................

lectually speaking) with metaphors of the nurse. In a small section of his book *Michelet*, devoted to "Michelet's Lesbianism," Barthes comments: "Michelet turns himself into a woman, mother, nurse, the bride's companion."[57]

Further on in *Michelet*, we find a portion entitled "Language-As-Nurse" ("Le langage-nourrice"). Here we learn that Michelet took great pleasure in speaking as "Woman." Indeed, Michelet, the self-claimed "artist-historian"[58] made his own novelesque history through the language of female heroines: Joan of Arc and the black Virgin of the Song of Songs, to name but two. As head of the nursing staff, as "matron," Barthes tells us, "the masterly historian, the enormous vorator of all human history, voluptuously entrusts himself to language-as-nurse."[59]

Sedgwick's proclamation of herself as a gay man trapped in a woman's body is a ventriloquist echo of Barthes's and Michelet's bedside "nurse" talk.

Barthes splashes his *négresse nourricière* with milk so as to undo what is and would always be "the essential enemy" for Barthes: "the bourgeois norm."[60] It is a gesture of reparative work. As Barthes writes in his little essay "Wine and Milk": "milk is cosmetic, it joins, it covers, restores. Moreover, its purity, associated with the innocence of the child, is a token of strength, of a strength which is not revulsive, not congestive, but calm, white, lucid, the equal of reality."[61]

Likewise, in *A Patch of Blue* milk seems strong and calm when Selina sits down to eat with Gordon, each with a glass of "Golden" brand milk. Gordon has just sung his own song to her in French; the two are eating dismal food (cottage cheese and canned peaches) made happy by the act of sharing. They are discussing interracial friendships (Selina had a black girlfriend named Pearl when she was nine) and grown-up affairs (Gordon's grandmother, it seems, also named Pearl, had a relationship with a white man). Something unknown but tragic seems to have happened to Gordon's black grandmother named Pearl. Selina's mother put an end to her daughter's friendship with a little black girl named Pearl.

This chapter is joined, covered, and restored by milk, but it is held together by a string of black pearls. The first pearl can be found in this book's introduction. Recall that in Proust's "story of the pearls," Madame

*Barthes splashes his négresse nourricière with milk*

........................................

Verdurin's once-white pearls "had become black as the result of a fire," which indeed made them that much more exquisite.

Barthes turned a black woman's pearls into gold, perhaps in defense of his own "auntie" nature.

Blind Selina did not see the blackness of her "pearls" (not only her nine-year-old friend, but also Gordon himself).

Gordon deeply understands the blackness of his grandmother named Pearl.

A pearl is a metaphor for something rare, admirable, and valuable. To make a pearl is the mollusk's way of defending against an irritant.

When discussing their love of their Pearls, Gordon's face fills with sorrow

*She dips her finger in the tall glass of milk and sucks it.*

........................................

and concern as Selina naïvely carries on in ignorance of the blackness that is nourishing her. Nevertheless, she blindly responds. Selina blindly repairs, if erotically so. She dips her finger in the tall glass of milk and sucks it. It is a little gesture that is not so little. (Blind, her finger is reading the glass for fullness, but the gesture is as erotic as it is pure.) It is a knowing gesture.

It's "the air a fist has bruised" (Gass).

For Barthes (because he was French), milk is an "anti-wine," an "American" substance, the very opposite of wine.[62]

A similar metonymic pleasure causes us to giggle when Selina gets her first taste ever of pineapple juice from Gordon. (Poitier's family is from the Caribbean, which is a great provider of this exotic fruit.) As with the milk, Selina first dips her finger into the container of pineapple juice and then takes an enthusiastic gulp off the fresh, tart, sweet taste and exclaims, "What is this delicious drink?" This mise-en-scène of the worldly black Gordon giving the naïve white Selina a sip of pineapple juice (unbelievably *her first*) is a stereotype so deep, we fear that it is not ironic. It is a little like *ô négresse nourricière*.

It's "the air a fist has bruised."

"A" Is for Alice,

for Amnesia,

for Anamnesis:

A Fairy Tale

(Almost Blue)

Called *La Jetée*

.........................................

# FAIRY TALE

<div style="text-align: center">

They are without memories, without plans. Time builds itself
painlessly around them. Their only landmarks are the flavor of
the moment they are living and the markings on the walls.

— Chris Marker, *La Jetée*

</div>

These lines, from Chris Marker's twenty-eight-minute-long film *La Jetée*
(1962),[1] encircle me like the coiled hair of Hélène Chatelain (the star of the
film): like the coiled hair of Madeleine in *Vertigo* (Marker's favorite film);
like a porthole around a face staring back; like the round, wound, "wounds"
around Greta Garbo's eyes; like the unmemory hole that begins *Alice in Won-
derland* (when underground, Alice forgets everything, save for her beloved
cat Dinah); like the ornamental, oversized "O," which begins every Once-
upon-a-time fairy tale.

Like "Snow White," like "Briar Rose," *La Jetée* is a fairy tale. It begins as
a story of impossible courtly love. A young boy, still in shorts, falls in love
with a woman at the end of the pier at Orly airport. She is very beautiful
in her 1960s heels and black suit. They will never meet again, at least not in
this lifetime. He will wish for her beyond his death, even when floating in
the stars. It is a wishing story for the one he loves, hoping that she will find
him again.

The boy loves this woman's magical face.

"Magic Marker" made a *blue* fairy tale for adults, called *La Jetée*. As André
Breton wrote in his "Manifesto of Surrealism" (1924): "There are fairy tales
to be written for adults, fairy tales still almost blue."[2] What *blue* means
here remains a mystery. Perhaps Breton is suggesting "blue films," or "blue
laws," or perhaps nothing at all. Or perhaps, some forty years before, Breton
had in mind something like the back-to-the-future telling of a tale like *La
Jetée*. Let it suffice to say that Marker admires Breton, whom he believes "has
the perfect eye the way some people have the perfect pitch."[3]

"Magic Marker" is one of many pseudonyms for Chris Marker. Reading
the list of collaborators for Alain Resnais's film *All the Memory of the World*

like the coiled hair of Hélène Chatelain

like the coiled hair of Madeleine

......................................

*like the unmemory hole that begins Alice in Wonderland (when underground, Alice forgets everything, save for her beloved cat Dinah);*

........................................

*The boy loves this woman's magical face.*

........................................

(*Toute la mémoire du monde*, 1956), one finds the names "Chris and Magic Marker."[4]

Magic Marker's fairy tale takes place after World War Three. It is a little like "Rip Van Winkle." Rip, like Marker's unnamed protagonist, whom I am calling "Jet-man" (after Barthes),[5] relishes living in the moment. Likewise, both characters have animal affinities. Just as Rip is beloved by all the animals of the village, especially his true friend (a dog named Wolf), Jet-man is touched by **"real cats"** and **"real birds,"** as well as the creatures of Paris's museum of natural history. Cruising the gallery of zoology at Le Jardin des Plantes in Paris, stuffed full with animals, with his woman-as-kitten friend, Jet-man is licked in contentment. Furthermore, sleep affords both Jet-man and Rip with the pleasures and nightmares of time travel. Rip wakes up only twenty years later. Jet-man finds himself far into the future, sleep traveling farther even than Briar Rose's (or Sleeping Beauty's)[6] one-hundred-year-long bed-rest journey. (A bed is a boat in so many fairy tales.)

The child-woman-kitten-philter of *La Jetée* sleeps like a science-fiction Briar Rose all the way into the distant future, all the way to the aftermath of World War Three, only to be awoken by the man she calls her "Ghost." **"She welcomes him in a simple way. She calls him her Ghost."** This ghost, this

*Cruising the gallery of zoology at Le Jardin des Plantes in Paris, stuffed full with animals, with his woman-as-kitten friend, Jet-man is licked in contentment.*

.........................................

prince, "he is caught in the briars [of Time]. The gnarled branches entwine him like a vindictive lover, the thorns lacerate his flesh."[7] He is wearing a necklace, neither of gold nor pearls. Rather, Jet-man wears **"the combat necklace he wore at the start of the war that is yet to come."** But like the gold necklace in the photograph by Van der Zee, which gave Barthes so much punctum, this necklace also pricks with time travel. With its mysterious metal charms – jagged, pointed and threatening (appearing variously as a roofing staple, a miniature spade, a tiny hatchet, a fishing lure) – Jet-man's beautiful, mêlée-chain is an impossible souvenir. It echoes the fearsome briar barricade, behind which Briar Rose slept.

## FÉES (FAIRIES)

Hidden in the electronic density of the forest of *Immemory*, Marker's interactive CD-ROM, Marker has a special album entitled *Star Fairies*: click on it and you will find the faces of beautiful women from the movies. Among these electric fées from the big screen is Alexandra Stewart. Her face circled with the O of Once-upon-a-time, of Alice's memory hole, of wishing wells, of film reels. She looks through a porthole of glass: transparently walled off. Like Snow White in her glass coffin, she is near and unreachable, in two zones at once.

Joseph Cornell famously had his own fées. Cornell had an appetite for movie stars (Lauren Bacall, Greta Garbo, and the B-movie star Rose Hobart, to name but a few), for shopgirls (like the "*feé aux lapins*"[8]), and for ballerinas. As a gift for the French dancer Renée (Zizi) Jeanmaire, Cornell placed a naked, sapphire Beauty, slumbering in a black and blue forest, in a black coffer, after one of Zizi's famous dances: *La Belle au bois dormant* (Sleeping Beauty in the Wood). Like Briar Rose, like Alexandra Stewart behind a circle of glass, like the woman of La Jetée, this black and blue Beauty is also near, but unreachable (Plate 9).

*La Jetée* uses time in the spirit of the fairy tales of the Brothers Grimm and Charles Perrault. Overtly political, the time of *La Jetée* also ticks with the back-to-the-future fairy-tale socialist utopianism of William Morris's *News from Nowhere (or, An Epoch of Rest)*. Morris's mise en scène is the medi-

*Among these electric fées from the big screen is Alexandra Stewart. Her face circled with*
*the O of Once-upon-a-time, of Alice's memory hole, of wishing wells, of film reels.*

........................................

eval past and future at once, while Marker's is the 1960s *and* the after-time of a future apocalyptic war, at once.

*La Jetée* takes place in a no-place (u-topia) in no-time (u-chronia): the time and place of the fairy tale. It is dystopia, with the hope of utopia. Or, it is utopia cut by the threat of dystopia. Even the sound of the title of the film resonates with the fairy-tale surprise of finding oneself in another world: *La Jetée* evokes "*là j'étais*" (there, I was).[9]

*La Jetée* is a political fairy tale.

But just read the work of Ernst Bloch, Walter Benjamin, and Jack Zipes and you will understand that the original fairy tales of the Brothers Grimm and Perrault were always already "radical theory."[10] A fairy tale like "Hansel and Gretel" is a lesson in the right to freedom and happiness. In the words of Bloch ("The Fairy Tale Moves on Its Own in Time"): "you are born free and entitled to be totally happy, dare to make use of your power or reasoning, look upon the outcome of things as friendly."[11]

Throughout *La Jétee*, Jet-man wears a strange, tight, v-neck shirt, featuring the popular comic book character El Santo, who is based on a real Mexican wrestling legend (Rodolfo Guzmán).[12] El Santo, a media icon of

the 1950s, '60s, and '70s, was a wrestling star in the ring, and a hero in films and in comic books. He wore a silver lamé mask, white tights, and a cape. "El Santo represented the future and often battled with dangerous figures of a storybook past: ageless witches or aristocratic vampires or werewolves from the 'old country.'"[13]

El Santo, like Jet-man, is a time traveler. Both wear masks. El Santo is a Mexican saint, a mysterious macho hero, and a *storybook* character at once: he is a Mexican *Jet-man*.

In his essay "Jet-man," Barthes describes a new kind of aeronautics, so fast as to be optically traceless, "a motionless crisis of bodily consciousness":

> Mythology abandons here a whole imagery of exterior friction and enters pure coenaesthesis: motion is no longer the optical perception of points and surfaces; it has become a kind of vertical disorder, made of contractions, black-outs, terrors and faints; it is no longer a gliding but an inner devastation, an unnatural perturbation, a motionless crisis of bodily consciousness.[14]

Barthes's jet-man lives a paradox that resonates with *La Jetée*'s Jet-man. For both voyagers "an excess of speed turns into repose."[15] Speed-turned-repose is a paradox that resonates with the conditions of the imageless Cold War, a war beyond imagery. (Jean Baudrillard has suggested that imageless abstract expressionism, in fact, represents the possible annihilation of the world.)[16] Speed-turned-repose is a paradox also, not unlike the soundless hypocenter of Hiroshima's atomic bomb. (Such complete silence is an excess of sound.) The Cold War, Hiroshima, Nagasaki, the Cuban Missile Crisis, and the Holocaust are all linked *beyonds* (in that they are beyond figuration, sound, and comprehension). All are echoed in *La Jetée*'s mythical, devastatingly quiet terror. Likewise, Marker's Jet-man (who spiritually speaks for peace) and Barthes's jet-man (who represents the loss of humanity) are *both* (if differently so) invested with "a sacerdotal significance."[17] Both are sacrificed "to the glamorous singularity of an inhuman condition."[18]

*La Jetée* is a post-apocalyptic fairy tale "that moves on its own in time." A boy who becomes a man witnesses his own death (not just once, but twice, as the film comes full circle).

The boy-as-man and the man-as-boy, they grapple to understand *one-self* in *two* time zones (that of pre-conflict and that of post-conflict) at once.

*El Santo,*

*El Santo, like Jet-man, is a time traveler. Both wear masks.*

........................................

Jet-man is in what Marker will specifically and utopically name, in his later film *Sans soleil,* "the Zone" (in homage to Andrei Tarkovsky.) Jet-man looks back to the future, to a place of no-time and discovers that: *là j'étais.*

## CHESHIRE CAT
........................................

The hero of *La Jetée* (like Marker's beloved time traveler Marcel Proust) **"wanted to be returned to the world of his childhood, and to this woman who was perhaps waiting for him."** He wanted to see again the places and

animals that he knew as a child, real places that Marker *reels* to us: "A peace-time bedroom, a real bedroom. **Real children. Real birds. Real cats.**" The cat, of course, is Marker's totem image, appearing in many of Marker's films (with the flair of Lewis Carroll's Cheshire Cat), including *Immemory, A Grin without a Cat* (1977),[19] his gorgeous *Sans soleil* and *Chats perchés* (2004). The last of these films focuses on a series of bright yellow graffiti paintings of *grinning* cats that mysteriously appeared all over Paris, in response to the political climate of George Bush announcing the war on Iraq. The voice-over in *Chats perchés* informs the viewer that the sunny cats get their beaming, if menacing, smile from the Cheshire Cat.

It is worth noting that as a child Marker made his first film with a small tin box called a Pathéorama (a modest version of the magic lanterns that so inspired the boyhood imaginations of Proust and Ingmar Bergman). Marker's first film starred, of course, a cat: his beloved Riri. With glue, scissors, and tracing paper, Marker made his own pictures for his Pathéorama. Primitive in nature, the end result was more like a handheld slide show than cinema. Nevertheless, the effect was magical for Marker. As Marker writes in his little essay on the Pathéorama: "I had gone through the looking-glass."[20] Even then, although the golden egg would not hatch for decades, filmmaking was, for Marker, already *Alicious*: a Lewis Carrollesque portmanteau of "Alice" and "delicious."[21] But Marker's childhood playmate, Jonathan, could hardly share the enthusiasm. After viewing the pictures, Jonathan quipped: "Movies are supposed to move, stupid. . . . Nobody can do a movie with still images."[22] That was what Jonathan thought. Thirty years later, Marker would make the celebrated *La Jetée*: a film made almost entirely of still images. *La Jetée* is almost as immobile as the taxidermied, unblinking animals that the couple visits in the gallery of zoology.

The nocturnal cat, like the owl (another favorite in Marker's menagerie of loved animals), is a lover of night, of black, is a natural moviegoer. (Is it any wonder, then, that Barthes feels good, like a cat, when he leaves the darkness of the cinema, and finds that "his body has become something soporific, soft, peaceful: limp as a sleeping cat"?[23]) Marker's fellow nouvelle vague film pals Agnes Varda and Alain Resnais also made the cat their revered cinematic animal. Aficionados of Varda, Resnais, and Marker search for the signature "cat," like one seeks a glimpse of Hitchcock's own image in his films.

*"I had gone through the looking-glass."*

......................................

Marker's films are political, but if he had been born in a different time, he might have been happy enough making films of women and cats. As he writes in *Staring Back*, his recent book of photographs: "During those years [the tumultuous 1960s], I came to the conclusion that the only sensible weapon against the cops could be a film camera . . . In another time, I guess I would have been content with filming girls and cats. But you don't choose your time."[24]

But let us part ways (if only temporarily) with Marker's beloved beast and return to the filmmaker's treasured Proust: author of *anamnesis*.

In a recent volume on the topic of anamnesis in French culture, the editors usefully define anamnesis as "a dynamic and creative process, which includes remembering as much as forgetting, concealment as much as imagination."[25] The madeleine is, perhaps, anamnesis's most perfected trope.

The woman at the end of the Orly pier is a madeleine memory. She is a filmic version of the Proustian mother-figure that we all await. (It is she who holds that life-affirming fairy-tale kiss.) As Proust writes of the mother, only moments before the first and only time the mother will stay with her son in his room for the night: "I saw in the well of the stair a light coming upwards, from Mamma's candle. Then I saw Mamma herself and I threw myself upon her. For an instant she looked at me in astonishment, not realizing what could have happened" (K, I, 46; P, I, 35).

Both the woman's beautiful face at the end of the pier (seen by Jet-man as both an adult and as a boy) and Mamma's face at the top of the stairs in the *Recherche* (seen by the Narrator as a boy on the cusp of becoming a man) inhabit the conflicted descriptive territory of the erotic, maternal, scallop-shell-shaped madeleine cake: "si grassement sensuel, sous son plissage sévère et dévot" (P, I, 46). The famed and contested C. K. Scott Montcrieff and Terence Kilmartin translate this passage as "so richly sensual under its severe, religious folds" (K, 1, 63). The newer, often-praised translation by Lydia Davis describes the "little shell made of cake" as "so fatly sensual within its severe and pious pleating."[26] Either way, the rather ordinary, everyday madeleine cake figures as entirely sensual, despite her disciplinary pleats. Again, I highlight these words from Marker's *Immemory*: "I want to claim for the image the humility and powers of a madeleine."

This woman of *La Jetée*, her face, like Proust's madeleine, derives its power and its humility from gorgeous everyday beauty. Perhaps she is the ghost of an old forgotten-now-remembered friend, or maybe she is a future personification of a woman in an Italian Renaissance painting. (There is something in her face and in her sleep of Giorgione or Titian or Botticelli.)

And, like Proust, Jet-man follows his "madeleine." One marvels at how the scallop-shell-shaped cakes invoke the badges worn by the medieval pil-

grims who followed Saint Jacques. In Illiers-Combray, there is a church, adorned with scallop-shells, dedicated to this saint. By the same token, Marker marvels further over the Proustian inflection of Scottie's pursuit of Madeleine in Hitchcock's *Vertigo* (1958). As Marker remarks in *Immemory*, under the guise and guidance of his big orange cat, named Guillaume-en-Egypte: "Among a hundred other themes, Alfred Hitchcock's *Vertigo* deals with the extravagant quest to rediscover things past. That its heroine just happens to be called Madeleine is the kind of fluke that connoisseurs can smile over without exaggerating its importance." But, it seems that Marker is overlooking a detail, or is feigning amnesia. Hitchcock based the script for *Vertigo* on Boileau-Narcejac's novel *Sueurs froides* (Cold Sweats, 1954).[27] The madeleine of *Sueurs froides* is the original Madeleine.

*La Jetée* is a remake of *Vertigo*, set in Paris. Its star is a face that is madeleine-Madeleine. In her, Marker rediscovers childhood itself. The Kernel of the Madeleine shell was planted when Marker, at age seven, saw Simone Genevois on screen in the film *La Merveilleuse vie de Jeanne d'Arc* (1928). It was "love at first sight."[28] In *Immemory*, Marker remembers the spectacle of the actress in all her delicious, blossomed, filmic splendor:

> the most precious thing in the world, something that haunted you ceaselessly, that slipped into every nook and instant of your life, until pronouncing its name and describing its traits became the most delicious occupation imaginable — in a word, the image that taught you what is love . . . By petting a cat as early as the second scene, Simone Genevois had obviously won my immediate approval. But nothing prepared me for the shock of a face enlarged to the dimensions of a house, and I am sure that the quasi-divine character of the apparition played its role in the enchantment.

It was as if in a fairy tale.[29]

### A REMEMBERED FAIRY TALE
### SEEN THROUGH A BLUE LENS

Brian Massumi has written a curious essay, "Too-Blue: Color-Patch for an Expanded Empiricism," which highlights the problem of translating color into meaning.[30] In the essay, Massumi discusses the pseudo-scientific ex-

This is the image that taught a child of seven how a face filling the screen was suddenly the most precious thing in the world, something that haunted you ceaselessly, that slipped into every nook and instant of your life, until pronouncing its name and describing its traits became the most necessary and delicious occupation imaginable—in a word, the image that taught you what is love. The deciphering of these bizarre symptoms only came later, along with the discovery of cinema, so that for the child who had grown, cinema and woman became two inseparable notions, and a film without a woman is still as incomprehensible to him as an opera without music. Why this face and this gaze remained unknown for almost sixty years is yet another mystery.

*But nothing prepared me for the shock of a face enlarged to the dimensions of a house, and I am sure that the quasi-divine character of the apparition played its role in the enchantment. It was as if in a fairy tale.*

..................................

periments of the German researcher David Katz, whose work *The World of Colour* was published in 1911. Katz's findings argue an intriguing point: our minds over-stress, over-intensify, the actual "real" color of objects, once they are cast into memory. When asked to match objects from memory, Katz's subjects "'almost always' selected a color that was 'too bright to match a bright object,' 'too dark to match a dark object,' and 'too saturated to match an object which is known to have a distinct hue.' The cofunction-ing of language, memory and affect 'exaggerates' color . . . The memory of the friend's eyes is in some way *too* 'blue': excess."[31]

Although Massumi does not explicitly claim blue as the color most cul-turally associated with memory, his *too blue* title suggests it.

In 1936, while living in his modest house at 3708 Utopia Parkway, in Flushing, New York, Joseph Cornell (who was extremely fond of fairy tales and blue) made an azure film, essentially a "celluloid collage" that he called *Rose Hobart*.[32] Cornell's "classic of experimental cinema," was made by shortening and resequencing the film *East of Borneo* (1931), which stars the "now-forgotten" actress Rose Hobart.[33] Cornell silenced it, intercut it with documentary shots of an eclipse, put it all to music (a "reject-bin" recording

of "Holiday in Brazil"), and then projected his cut-and-taped film at a reduced speed through a blue filter.[34] Cornell dismembered an old forgotten film, in order to project it and remember it as blue.

La Jetée has no color at all; nevertheless, one might say that it is *shelled* in blue. From its lovingly framed nostalgic encounters with life before World War Three to the horrors of a world destroyed by the atomic bomb, La Jetée projects itself through the blues of loss: from the most personal blue to a universal catastrophic blue. La Jetée is a black-and-white fairy tale, whose off-frame color thinks the past and the future as blue.

## THE FACE AS EVENT AND IDEA

A photograph is a trace of the death of the moment held forevermore. Cinema is unstoppable real time, reeled over and over, as if caught in an endless quest forward, even when it is depicting the past. Marker's La Jetée stands apart: it is neither photography nor cinema, and that is part of its arresting innovation. While the film is made up almost entirely of stills (which dissolve one picture into another), it is famous for incorporating a tiny bit of real time (reel time) movement in which Chatelain opens her eyes.

The La Jetée woman is a doll. Although her entire body will never move, she opens and closes her eyes with toylike movement. It is as if she were a doll being put to sleep and reawakened. But shortly before this incredible, if subtle, eye movement, Chatelain as a sleeping porcelain appears, through the careful working of two dissolved stills, to open her mouth for a Once-upon-a-time breath. ("The O is . . . an open mouth and expiration of breath through this opening."[35]) Chatelain as *poupée* (which in French means doll), as pupa (which in Latin means doll),[36] begins her movement from darkness to lightness by first parting her butterfly lips. Breath, here, is a blink before the famed opening of her eyes. The viewer then, as Victor Burgin points out, experiences the "parting of the lips" as "analogous to the opening of the eyes."[37] This brings my text full circle: Madeleine (in Scottie's eye) meets Proust's madeleine (in the Narrator's mouth) in the swallowing spiral of Magic-Marker time.

Chatelain's face in La Jetée is the event of the film, but it was Barthes who

While the film is made up almost entirely of stills (which dissolve one picture into another), it is famous for incorporating a tiny bit of real time (reel time) movement in which Chatelain opens her eyes.

.......................................

started it all. In Barthes's "The Face of Garbo," he proclaims Greta Garbo's face as "Idea" and Audrey Hepburn's face as its opposite, as "Event."[38] Barthes published "Le Visage de Garbo" in *Mythologies* the same year that Audrey Hepburn would appear in *Funny Face* (1957). Fred Astaire plays the photographer who photographs Hepburn's a-little-too-adorable "funny face." (For the part, Astaire was coached by Richard Avedon.) In the film, Hepburn's face is the event: she makes endless, dramatic expressions as a charming "*femme-enfant*."[39] Likewise, she also images herself, to echo Barthes's words again, as a "*femme-chatte*."[40] She is particularly kitten-like when dancing in the dark, underground Paris bar catering to philosophers and Beat poets. Hepburn it seems, like Lewis Carroll's Red Queen, "really was a kitten after all."[41]

Although *Funny Face* — as an outrageous Hollywood film, full of color, song, and dance — could not be more different than Marker's black-and-white politicized cine-poem, the charm of the event of a woman's face is held in both.

But the woman of *La Jetée* is not only like Barthes's Hepburn, she is *also* like Barthes's Garbo. At the end of the jetty, she too, like Garbo, has a face that is magical, that plunges the viewer into deepest ecstasy: a face that can neither be reached nor renounced. In Barthes's exact words: "Garbo still belongs to that moment in cinema when capturing the human face still plunged [*jetait*] audiences into the deepest ecstasy, when one literally lost oneself in a human image as one would in a philtre, when the face represented a kind of absolute state of the flesh, which could be neither reached nor renounced."[42]

Chatelain is at once Hepburnian Event *and* a Garboian Idea.

Garbo's face haunts Barthes, like the face of the woman at the end of the pier haunts Jet-man, like the face of the real Alice, a little girl named Alice Liddell, really haunted Lewis Carroll. You can find Alice's O-val photograph haunting the final page of the original manuscript that would become *Alice in Wonderland*. Alice Liddell also haunts *Through the Looking-Glass's* final poem, with memories of her before she turned away:

Still she haunts me, phantomwise,
Alice moving under skies
Never seen by waking eyes.[43]

Garbo's face haunts Barthes, like the face of the woman at the end of the pier haunts Jet-man, like the face of the real Alice, a little girl named Alice Liddell, really haunted Lewis Carroll. You can find Alice's O-val photograph haunting the final page of the original manuscript that would become Alice in Wonderland.

........................................

Ernst Bloch wrote: "The fairy tale princess is Greta Garbo."[44] Chatelain and Liddell are figures of anamnesis: fairy tale princesses in waiting (not unlike the Proustian mother, not unlike Marker's woman at the end of the pier, not unlike Madeleine, not unlike a madeleine).

## CAT PAWS AND TAXIDERMY

**"Other images appear, merge, in that museum, which is perhaps that of his memory."**

Both *La Jetée* and the gallery of zoology at Le Jardin des Plantes in Paris are over-generous museums, haunted by death. Like a photograph, they are excessively full as they hold not only the loss of the moment, but also the darkroom of development. Photographs, as cousins to taxidermied animals, preserve with not only sawdust and emulsion but also regret.

In *Alice* (1988), Jan Švankmajer's animated film (made with real bottles, tea cups, toys, and dead animals stuffed with sawdust like those you would find in *La Jetée*'s gallery of zoology), the taxidermied White Rabbit becomes animated. Neither dead nor alive, neither asleep nor awake, neither animal nor human, this neither-nor, *ni-ni* creature escapes his Looking-Glass vitrine by breaking the glass with a giant pair of scissors. Resuscitated by childhood, pleasure, and erotics, he is back to life. Like Briar Rose being awoken from her one-hundred-year-long sleep, like the beautiful woman of *La Jetée*, the rabbit, due to the *magical* process of stop-motion animation, has become what Barthes has called in another context "de-windowed" (*dévitriné*).[45] (Perhaps Švankmajer's glass is made of sugar, like the witch's windowpanes in "Hansel and Gretel," or like the sugar glass made for breaking that was once commonly used in Hollywood movies. One also thinks of Carroll's Hatter, who murdered time and bit his china teacup instead of the bread and butter.)

A sawdust trail follows this undead White Rabbit, like the stones and breadcrumbs left behind by Hansel and Gretel. When the White Rabbit pulls out his pocket watch on a chain, he licks off the sawdust like an animal licking the blood of a wound. Perfect, for what is *Alice in Wonderland* (and *La Jetée* for that matter) if not a story of licking time, or trying to lick time. It is a little like Meret Oppenheim's Alicious, mad, *Breakfast in Fur*

*Both La Jetée and the gallery of zoology at Le Jardin des Plantes in Paris are over-generous museums, haunted by death. Like a photograph, they are excessively full as they harken not only the loss of the moment but also the darkroom of development. Photographs, as cousins to taxidermied animals, preserve with not only sawdust and emulsion, but also regret.*

..........................................

(1936): part dormouse and part teacup, it sits nicely in Wonderland where the Hatter knows, "it's always tea-time."[46] But the thought of warm tea and fur is even worse than the thought of a big lick of sawdust. (Oppenheim's unsettling, fairy-tale fur teacup is not for dipping madeleines.)

If "it's always tea-time," then we are always hungry, always wild with desire. We are endlessly chasing the White Rabbit, whom Hélène Cixous rudely and hilariously describes as a "pénis trottinant" ("penis on paws").[47] But for Marker, it would be a madeleine on paws—which is more fitting than you think. Madeleine cakes are sometimes called "cats' paws."

## LA JETÉE IS A REMAKE OF ALICE

Jet-man discovers that he wants to stay with this beautiful woman who wears her hair in an enchanting spiral. He does not want to go to the future as the experimenters had planned. "And then," as Lewis Carroll's Alice remarks at the apocalyptic end of her journey, "all sorts of things happened in

*(Oppenheim's unsettling, fairy-tale fur teacup is not for dipping madeleines.)*

..........................................

a moment. The candles all grew up to the ceiling, looking something like a bed of rushes with fireworks at the top . . . the White Queen . . . disappeared into the soup [tureen]."[48] Not unlike Alice, Marker's Jet-man falls into a memory hole to die (of love). As Harald Weinrich so elegantly writes in his book *Lethe: The Art and Critique of Forgetting:* "Perhaps forgetting is also only, in trivial terms, *a hole in memory* into which something falls or *disappears.*"[49]

By turning to Carroll's stories of Alice, so favored by Marker (because of their falls into memory lapses and for their love of the cat), we discover that when Alice is strolling through the forest of forgetting and forgets her name, she is struck with amnesia and says, "L, I know it begins with L,"[50] confusing herself with her author Lewis Carroll. (And of course, in French, the English letter L sounds like the feminine singular pronoun *elle,* which sounds just the same in its plural form of *elles.* Luce Irigaray knows all about Alice and her multiple *elles.*[51]) This moment in Carroll's story brings to light the fact that Netherlands and Neverlands are the no-places of forgetting.

Like Alice, the *La Jetée* man falls into his own memory hole and remembers the past *and* forgets the future, or vice versa, it is hard to say which. It is a little like living backwards in *Through the Looking-Glass:*

"Living backwards!" Alice repeated in great astonishment. "I never heard of such a thing!"

"— but there's one great advantage in it, that one's memory works both ways."

"I'm sure MINE only works one way," Alice remarked. "I can't remember things before they happen."

"It's a poor sort of memory that only works backwards," the Queen remarked.

"What sort of things do YOU remember best?" Alice ventured to ask.

"Oh, things that happened the week after next," the Queen replied in a careless tone.[52]

As Marker says in *Sans soleil*, "I will have spent my life trying to understand the function of remembering, which is not the opposite of forgetting, but rather its lining." No wonder, then, anamnesis (a recollection of past events) sounds like amnesia (loss of memory): one is the lining of the other.

I discover that the anamnesis of amnesiac fairy tales is the utopian thrust of Marker's desire to escape the hands of time. Marker ponders in *Sans soleil*, "I wonder how people remember things who don't film, don't photograph, don't tape." Utopia for this great photographer and cinematographer is the escape from *both* anamnesis and amnesia by living neither in the past nor in the future, but impossibly in the moment.

"Once upon a time," Bloch tells us in his essay "Better Castles in the Skies," "means in fairy-tale manner . . . a more colorful or easier somewhere else."[53] Fairy tales are the first flights (and subsequent falls down rabbit holes and other places underground) that we alight from as children. In other words, to live happily ever after is to keep falling into the hole of the large O at the start of every "*Once* upon a time."

A bruise is often in the form of a circle. *La Jetée* as a (blue) fairy tale does not start with an ornamental once-upon-a time O. Rather it leaves behind a black and blue trace, a resonating bruising O. This O is not the past, not the future, but the present shelled.

Just as in "Cinderella," where the prince refinds his lost love, my pilgrimage through *La Jetée* is also a kind of refinding, just as Jet-man refinds the woman he saw on the jetty. But unlike the prince's pursuit of Cinderella, when Jet-man chose to refind her on the jetty, he understood that this

decision meant that he would not live into the future, but would die. In fact, it meant the end of the world. Nothing can really be refound, unless you are in a fairy tale. Nevertheless, *La Jetée* gives us that hope, that we too might just find that "there, I was" is a place that just might be found: a black Kernel in a shell of blue.

"This is the story of a man marked by an image from his childhood." So begins the circular *La Jetée*. Not long after these opening words, we see the cropped image of a child's tender legs in schoolboy shorts, his brogues worn soft by running, his stripy socks scrunched. The child is standing on the bottom bar of a rail at the edge of the jetty at Orly. The child is looking at the big jets below. The child is Jet-man, when he was very young. The time is right before the child was marked by "the violent scene that upset him." The child has not yet seen the woman's face. The child has not yet seen "the crumbling body."

A very faint bruise marks the child's right leg.

"This is the story of a man marked [bruised] by an image from his childhood."

*"This is the story of a man marked [bruised] by an image from his childhood."*
.......................................

# Happiness with

# a Long Piece

# of Black Leader:

# Chris Marker's

# *Sans soleil*

....................................

He wrote me: one day I'll have to
put it all alone at the beginning of a film
with a long piece of black leader; if they
don't see the happiness in the picture,
at least they'll see the black.

—Chris Marker, *Sans soleil*

# BLACK

..................

Shut your eyes and see.

— James Joyce, *Ulysses*

*Sans soleil*: its beauty lies within its blackness. But what is its blackness? What is its *sunless* tongue saying?

*Sans soleil* begins in pure black with these words burned in ash white: "Because I know that time is always time / And place is always and only place." The lines are from T. S. Eliot's "Ash Wednesday." (In the French version, the words are from Jean Racine's *Bajazet*, which translate as: "The distance between countries in some way makes up for the too great proximity of epochs.")

Then, the letters slowly dissolve into pure black, as if in a lightless closet, as if in the womb, as if in a bomb shelter, and we hear these words spoken by a woman: **"The first image he spoke to me about was the one of three children on a road in Iceland in 1965."**[1]

This woman will narrate the entire film. In French, it is the voice of the acclaimed author Florence Delay, who also starred in Robert Bresson's *Procès de Jeanne d'Arc* (1962). In the English version, it is the voice of the actress Alexandra Stewart, whom we saw looking through the porthole. The woman's words (whether through the sensuous mesh of Delay or Stewart) envelop the listener throughout the film, as if one were knitted in the looped, tied, trellised, wire vocality of a Ruth Asawa sculpture, as if one were cocooned in what Michel Chion, the experimental composer and film theorist, refers to as "*la toile ombilicale*" (an umbilical web):

> In the beginning, in the uterine darkness, was the voice, the Mother's voice. For the child once born, the mother is more an olfactory and vocal continuum than an image. Her voice originates in all points of space, while her form enters and leaves the visual field. We can imagine the voice of the Mother weaving around the child a network of connections it's tempting to call the umbilical web [*la toile ombilicale*]. A rather horrifying expression to be sure, in its evocation of spiders – and in fact, this original connection will remain ambivalent.[2]

*at least they'll see the black.*

"Because I know that time is always time
And place is always and only place."..

T.S. Eliot - Ash-Wednesday

*Sans soleil begins in pure black with these words burned in ash white:*

*as if in a lightless closet, as if in the womb, as if in a bomb shelter,*
........................................

*as if one were knitted in the looped, tied, trellised, wire vocality of a Ruth Asawa sculpture,*

......................................

(Of note is the fact that Asawa, born in the United States as a child of Japanese immigrants, began her study of drawing and painting as an adolescent in American internment camps during the years 1942–43. She wove something optimistic from horrifying threads.[3])

La Jetée features the father's "voice of bedtime stories": *Sans soleil* echoes with the uterine voice of the mother, ambivalent in its blackness.

And then the viewer is bathed in the first moving image that we will see: three stunning, blond children walking down a road in Iceland in 1965, swathed in the color of 1960s film. The children wear autumn hues: the slate grays and orange-red persimmons of American robins, the browns of twigs, oatmeal, and walnut shells, the dark cadmiums of cranberries, the muted milky greens of lichen. Apples have kissed the cheeks of these healthy chil-

*"We can imagine the voice of the Mother weaving around the child a network of connections it's tempting to call the umbilical web [toile ombilicale]."*

........................................

dren. A luminous, steely, gray-blue ocean is behind them. While holding hands in a twisted childish fashion, as children often do, the smallest child steals a glance; the eldest child silently speaks to the one who is neither the eldest nor the youngest. Watching them move in perfect silence, we become them. We hold hands with them. We become part of the circle. The child closest to us focuses again on the lichen-colored grass. The verdant land holds them, just as the sky holds the earth. The three children have no idea of the catastrophic, volcanic destruction yet to come.

This moving image of three Icelandic children in 1965 wounds me. It bruises me with that Barthesian black-and-blue feeling of that which has been.

The segment lasts eight seconds.

This moving image of three Icelandic children in 1965 wounds me. It bruises me
with that Barthesian black-and-blue feeling of that which has been.

The Icelandic child who is not me, but is in me, looks a bit like
the "real" girl-child of La Jetée.

......................................

In 1965, I was eight. The Icelandic child, the one whose sweater is cranberry, looks to be the same age. This child echoes with my personal past. We both walked the earth at the same time, both wearing corduroy trousers, both wearing the easy sartorial egos of childhood, both holding hands with other children, both eyeing adults with cameras. The Icelandic child who is not me, but is in me, looks a bit like the "real" girl-child of *La Jeteé*.

*Sans soleil* has hardly begun, but time is already swallowed by the spiral. The viewer is already suffering from vertigo.

The footage of the Icelandic children quickly gives way to pure black leader. And we hear the woman's voice again: **"He said that for him it was the image of happiness and also that he had tried several times to link it to other images but it never worked."** And we are held for just a bit, seeing only the black again.

Moments later, the black leader cuts to fast moving footage of an Army Air Force Hornet. This menace, with its horrific rockets attached to its body, looks like a giant science fiction insect. The Hornet is being moved below deck, to be hidden, like terror itself. Its affect is not "a sting, speck, cut, little hole." It is a blow.

The alarm of seeing the Hornet lowered under the deck of the boat is one of many small jolts throughout the film, all of which cut through the beauty of *Sans soleil*: a long shot of a giraffe being slaughtered; the Japanese ceremony of the burning of broken dolls; a department store that combines a museum, a chapel, and a sex shop on the island of Hokkaido; guerrilla warfare in Guinea-Bissau; drought in the Sahel; postwar exhaustion. The whole film, made of miniscule cine-pieces on moments of splendor, terror, and banality, might be described as a celluloid journal of things that *quicken the heart*. **"[Sei] Shōnagon had a passion for lists: the list of 'elegant things,' 'distressing things,' or even of 'things not worth doing.' One day she got the idea of drawing up a list of 'things that quicken the heart.' Not a bad criterion I realize when I'm filming."** Although written a thousand years ago by a lady at the imperial court of Japan, Sei Shōnagon's precious bundles of papers made great literature out of Markeresque lists, vignettes, anecdotes, and opinions. English readers know her "fire tongs" and "next-morning letters" as *The Pillow Book*.

By the end, of the film, we are left stunned by footage of the same Icelandic town where the beautiful children walked. It is five years later. The

*where the beautiful children walked. It is five years later. The town
is beneath a blanket of pure black suffocating ash,*

...................................

town is beneath a blanket of pure black suffocating ash, the result of an
apocalyptic, volcanic eruption. "And when five years later my friend Haroun
Tazieff sent me the film he had just shot in the same place . . . the island's
volcano had awakened. I looked at those pictures, and it was as if the entire
year '65 had just been covered with ashes."

But I am getting ahead of myself and the film. We are still at the start.
We have seen the black. We have seen the children. We have seen the Hornet.
And then, one more time, the film dissolves into a long piece of black leader.
We see pure blackness, yet again, but this time for even longer: a full ten
seconds, which feels stretched. It is a black pregnant pause of anticipation
and longing. And we hear: "He wrote me: one day I'll have to put it all alone
at the beginning of a film with a long piece of black leader; if they don't see
the happiness in the picture, at least they'll see the black."

The film, then, cuts again to white letters on black: "Anatole Dauman
proposes."[4] And then the film cuts to bold, red letters on pure black: we
meet the title of the film in Cyrillic script, in homage to Modest Mussorg-
sky's song cycle, also called *Sans soleil* (1874). The red (*la rouge*) also echoes
Marker's *Le Fond de l'air est rouge* (1977), and the politics of being red. But the
letters are also, of course, in tribute to Marker's admiration for the Russian

*from the beautiful blue sea and into the suffering blue-gray sky.*

filmmaker Andrei Tarkovsky. Furthermore, the typography invokes one of the many Cold War terror bites yet to come in the film.[5] Soon, we will see the U.S. Navy's Polaris, a nuclear ballistic missile, emerge with its black tip of dread from the beautiful blue sea and into the suffering blue-gray sky.

The mise en scène of *Sans soleil* has been set: the beautiful children have appeared and they have been cut by a long piece of black leader. The black leader has been cut by the Hornet. And the Hornet has been eclipsed, like the Icelandic children, by the black.

## BLUE

The first long takes of *Sans soleil* feature Japanese travelers, sleeping on a ferry (Plate 10), coming from Hokkaido. The water is blue. The upholstery on the seats is blue. We see a ferry passenger's watch moving through the blue

(Plate 11). We hear these words: "He wrote: I'm just back from Hokkaido, the Northern Island. Rich and hurried Japanese take the plane, others take the ferry: waiting, immobility, snatches of sleep. Curiously all of that makes me think of a past or future war: night trains, air raids, fallout shelters, small fragments of war enshrined in everyday life."

## BLACK AND BLUE BEAUTY

*Sans soleil* is black not only with guerrilla warfare in Guinea-Bissau and the drought in the Sahel but also with the ditch where, in 1945, two hundred Japanese girls used grenades to commit suicide rather than fall into the hands of the Americans. **"People have their pictures taken in front of the ditch. Across from it souvenir lighters are sold shaped like grenades."** Indeed, taking Marlon Brando's advice in *Apocalypse Now*, Marker's *Sans soleil* knows that **"you must make a friend of horror."** But the face of horror is not Marker's only friend: he also befriends the face of beauty. **"Absolute beauty also has a name and a face."** Marker gathers glimpses of Her (of Beauty) as dropped from the pockets of everyday life in the spirit of Sei Shōnagon's *Pillow Book*: "a letter of fine green paper tied to a sprig of willow covered in little leaf buds . . . a knotted letter of violet paper, with a long cluster of wisteria blossom attached."[6] They are little signs postponed: perhaps mysterious blue airmail letters or *petits bleus* (pneumatic letters sent through Paris during the Belle Époque), written in black ink, delivered some nine centuries later, so that we might **"draw a sort of melancholy comfort from the contemplation of the tiniest things."**

In *Sans soleil*, one cannot find the same penchant for the color blue as one finds in the indigo, cobalt, cerulean, sapphire, and azure letters of Proust's *Recherche*.[7] Proust's proclivity for blue is easily found in the *Recherche*, especially when the Narrator is on cloud nine, seeing blue through his black lacquer eyes. ("A profound azure intoxicated my eyes" [K, VI, 256; P, IV, 445].) *Sans soleil* is not overridden by blue; it is filled with other colors, especially red. Black is more central than blue.

Nevertheless, *Sans soleil* embraces the black island emerging out of the blue. The film is a film of islands: Japan, and its surrounding islands, Iceland, the archipelagos of Cape Verde and Bijagós, even Marker's home of the

the black island emerging out of the blue.

........................................

Île de France. "Did I write you that there are emus in the Île de France? This name — Island of France — sounds strangely on the island of Sal."

Islands are often places of utopian, social critique. It is in Thomas More's *Utopia* that "the noun 'utopia' appears for the first time."[8] *Utopia*, like Marker's *Sans soleil* is a politicized, island travelogue. The "thalasso-graphic"[9] geography of *Utopia* and *Sans soleil* (real and imaginary — past, present, and future) serves as a no-place in no-time for the "the rejection of commerce and war into utopia."[10] As Ernst Bloch informs us, with a glimmer of his characteristic notion of utopia as a possible, if not-yet reached, place: "At the very beginning, Thomas More designated utopia as a place, an island in the distant South Seas . . . but I am not there."[11] "Not there" means that one *could* get there. As Hayden White has remarked: "the brilliance of More is to have put his utopia in the present, which allows one to see 'the present as history.'"[12]

When a black volcanic island rises out of the Prussian blue sea, it is making a dream. An island is a bed in the sea, a hatchery for dreams, an invitation to daydreams of refuge.[13]

At the very start of *Sans soleil*, we get a glimpse of the three children on the island of Iceland. By the end of the film, viewers are overwhelmed to see the same place covered in a black ash. The volcano is a natural catastrophe

that portends the apocalypse of war, something that had already happened to Marker's beloved Japan. Twenty-five years earlier, at 8:15 am, on August 6, 1945, "Little Boy" was dropped on Hiroshima. On that day, the sky turned black. On that day, ashes were everywhere. On that day, drops of black rain the size of marbles fell.

Hiroshima.

Nagasaki.

*Black sun.*[14]

The Artist (as heralded with a capital A) does not usually migrate between the beautiful (what I figure as a qualified blue) and the political (what I figure as a qualified black): it is taboo. It is outlaw. It is a bit like mixing wine (blood) and milk (oppositions so beautifully stirred by the culinary fingers of Barthes in his essay "Wine and Milk"). It is a bit like mixing the joyful birdlike angels on the blue walls of the Arena Chapel that Proust celebrates in the *Recherche* (a blue also celebrated by Julia Kristeva in her essay "Giotto's Joy") with the terror of a dark, bird-filled sky in Hitchcock's *The Birds*. Looking skyward, then, we might just say, in unison with Marker: **"if they don't see the happiness in the picture, at least they'll see the black."**

Still looking skyward, I see Yves Klein, perhaps the bluest artist of all time, who really believed that he could fly like a bird. ("He was sure he could fly," or so claimed his wife.[15]) And in the same way that Marker made use of beauty, Klein sought to use his famed ultramarine blue "as though it could be an explicit and overtly political tool for ending wars, because if you paint a single color over a relief map of Western Europe and North Africa, you thereby eliminate the boundaries between the countries with a unifying bath of blue" (Plate 12).[16] Likewise, Klein saw his blue anthropometries as a response to the shadows left behind of people evaporated by the radiation of "Little Boy." As he wrote: "Hiroshima, the shadows of Hiroshima. In the desert of atomic catastrophe, they were witness, without doubt terrible, but nevertheless a witness, both for the hope of survival and for permanence – albeit immaterial – of the flesh."[17] Klein found some hope in these terrible images. The bodies of his anthropometries are attempts at being in conversation with the unbearable "photographs on stone"[18] from 1945 (Plate 13).

History only tastes bitter to those who
expected it to be sugar coated.

— *Sans soleil*

*Sans soleil* is an always-moving overfill.[19] Eye-food is constantly piled around us, as if we were Hachiko waiting for sushi and rice cakes:

> "He told me the story of the dog Hachiko: A dog waited every day for his master at the station. The master died, and the dog didn't know it, and he continued to wait all his life. People were moved and brought him food. After his death a statue was erected in his honor, in front of which sushi and rice cakes are still placed so that the faithful soul of Hachiko will never go hungry."

Yet *Sans soleil* — with its rush of images (by Marker and other cameramen) makes one hungry for more, even when it is boring. **"He wrote: I've been round the world several times and now only banality still interests me. On**

*Eye-food is constantly piled around us, as if we were Hachiko*
*waiting for sushi and rice cakes:*

this trip I've tracked it with the relentlessness of a bounty hunter." For what is boredom, if not, as Adam Phillips has argued, the desire for desire?[20]

*Sans soleil* is a long, long list of tiny things from the consummate world traveler: a cat peering over a parapet; a window display of a clarinet that plays itself; a poster with an owl on it; a hotel called Utopia. Proust's *Recherche*, mostly written in a self-imposed soundless, dustless, honey-colored cork-lined room in a *sunless exile*, was also full of a long list of things that **"quicken the heart."** And, of course, there were the lists of Sei Shōnagon herself: "A sparrow with nestlings. Going past a place where tiny children are playing. Lighting some fine incense and then lying down alone to sleep. Looking into the Chinese mirror that's a little clouded."[21]

After the first bite of madeleine cake soaked in lime-blossom tisane, a rush of imagery from the Narrator's childhood sprang from his teacup as film projector (or magic lantern or Pathéorama): all of Combray, "the old grey house . . . like a stage set . . . all weathers . . . streets . . . country roads . . . our garden . . . M. Swann's park . . . the water-lilies on the Vivonne . . . the parish church" (K, 1, 64; P, I, 47).

Like youth, like a nibble of a madeleine, *Sans soleil* is fleeting. My chapter is but a glimpse, because I cannot give you a taste of a fresh doughnut **"to be eaten on the spot,"** because the film is not here: it has already collapsed into memory, like a soufflé. And, like the *Recherche*, *Sans soleil* is very difficult to remember at all. Yet, we take pleasure each time we read through the *Recherche*, and we fall for *Sans soleil* with each viewing. Proust's "good fortune," Barthes reminds us, is that "from one reading to the next, we never skip the same passages."[22]

After the first bite, the tea-soaked madeleine taken with a spoon would never again achieve its on the spot, fresh awakening (its sensation of *involuntary memory*). Further mouthfuls lose "their magic."[23]

The magic turned black.

For Marker, youth holds an untranslatable Kernel (held by living in the moment), which is all but forgotten in *future-oriented* adulthood. As the woman's voice tells us, while we watch Japanese teenagers dancing in Shinjuku (one of the twenty-three wards of the metropolis of Tokyo): **"The youth who get together every weekend at Shinjuku obviously know that they are not on a launching pad toward real life; but they are life, to be eaten on the spot like fresh doughnuts."** (Or, if you are watching *Sans soleil* in French, to

*youth-galaxy,*

........................................

be eaten on the spot like *"les groseilles"* [currants].) We could, as Marker suggests, learn something from these groups of suburban teenagers, known as the *Takenoko-zoku.*

Throughout *Sans soleil,* we witness this strange and "other" youth-galaxy, legendary for convening on the streets in wonderfully garish Arabian-Night clothes for the sole pleasures of dancing to music that boomed out of portable cassette players.[24] While they dance, the voice-over elaborates: **"For the Takenoko, twenty is the age of retirement. They are baby Martians. I go to see them dance every Sunday in the park at Yoyogi."**

Likewise, but this time in despair (like something from Sei Shōnagon's list of "distressing things"), Marker speaks of the lovely twenty-three-year-old women who are celebrated on Japan's Coming of Age Day. They promenade in their fur-trimmed kimonos in Tokyo's beautiful January light. The Kernel will soon be inactive, gone, leaving no trace at all on the shell (the corpus). They are killing time in **"the anteroom of adulthood. The world of**

*January light.*

the Takenoko and of rock singers speeds away like a rocket. Speakers explain what society expects of them. How long will it take to forget the secret?" They, too, like the entire film, are to be "eaten on the spot like fresh dough-nuts."

## COOKING

> In painting, as in cooking, something must be allowed to
> drop somewhere: it is in the fall that matter is transformed
> (deformed): the drop spreads and the foodstuff softens: there is
> a production of a new substance (movement makes matter).
>
> – Roland Barthes, "Réquichot and His Body"

Marker's fast-moving cine-collage can be compared to the experience of watching the difficult art of Japanese "'action cooking,'" as performed by a chef named Mr. Yamada, in a restaurant in Nishi-nippori, that we witness near the start of *Sans soleil*. Like Mr. Yamada's action cooking, *Sans so-*

*audible gusto of an egg*

........................................

leil is also an exhilarating mix of raw ingredients that fly in quickly be-
fore us. Alive with sizzle, Marker's snatches of film surprise us, like the
audible gusto of an egg dropped by Mr. Yamada upon his oiled and hot
grill. Within seconds the egg sizzles into something unknown. Things land
before us, only to be quickly launched, flipped, scooted, pushed, and re-
moved: the cutting is extremely fast. It is impossible to narrativize the ac-
tions. It is cooking that is carefully orchestrated, but for which there is no
recipe. Mr. Yamada grabs ingredients from the everyday world. Likewise,
Marker uses banal footage from television, film clips (both sleep-inducing
and riveting), his own cinematography, bits of cinema shot by friends, and
passages from Hitchcock. Both Marker and Mr. Yamada turn their compo-
nents into cuisine with elegant, unprecedented simplicity. Both defy the
notion of the great auteur, while each possesses his own modest, strong,
no-frills, handsome, truth-seeking style. **"He said that by watching care-
fully Mr. Yamada's gestures and his way of mixing the ingredients one could
meditate usefully on certain fundamental concepts common to painting,
philosophy, and karate."**

Marker respects the cooking of Mr. Yamada as a model for filmmaking,

just as Proust hails the humble (but exquisite) cuisine of Françoise, the family's country cook, in the *Recherche*. Françoise's country table is as full of food as Marker's film is full of images, as Proust's novel is full of, well, everything. In Proust's sinuous hands (turned words), Françoise's Sunday lunch is musically "poured," Jackson-Pollock-like, as if there were no table-canvas edges. Françoise wallpapers the family table with food with the all-over sensibility of an abstract expressionist. And like Marker's rhythmic excessiveness, Françoise's lunch is equally disproportionate, with a mind-blowing tempo in tune with the presentness of life: the luck of being at the right place at the right time, the kindness of friends, historicity, curiosity, beauty, hunger, change, the dearness of an apricot, the limitability of gooseberries and, of course, reciprocity. Allow me to quote Proust's description of Françoise's jam-packed table in full fullness, in order to establish its overload as undeniable:

> Upon the permanent foundation of eggs, cutlets, potatoes, preserves, and biscuits, which she no longer even bothered to announce, Françoise would add—as the labor of fields and orchards, the harvest of tides, the luck of the markets, the kindness of neighbors, and her own genius might provide, so that our bill of fare, like the quatrefoils that were carved on the porches of cathedrals in the thirteenth century, reflected to some extent the rhythm of the seasons and the incidents of daily life—a brill because the fish-woman had guaranteed its freshness, a turkey because she had seen a beauty in the market at Roussainville-le-Pin, cardoons with marrow because she had never done them for us in that way before, a roast leg of mutton because the fresh air made one hungry and there would be plenty of time for it to "settle down" in the seven hours before dinner, spinach by way of a change, apricots because they were still hard to get, gooseberries because in another fortnight there would be none left, raspberries which M. Swann had bought specially, cherries, the first to come from the cherry-tree which had yielded none for the last two years, a cream cheese, of which in those days I was extremely fond, an almond cake because she had ordered one the evening before, a brioche because it was our turn to make them for the church. And when all this was finished, a work composed expressly for ourselves, but dedicated more particularly to my father who had a fondness for such things, a chocolate cream, Françoise's personal

inspiration and specialty would be laid before us, light and fleeting as an "occasional" piece of music into which she had poured the whole of her talent. (K, I, 96–97; P, I, 70)

Françoise (the Michelangelo of the Narrator's kitchen) is an artist in her own right, though comically modern, as she appears to prefigure the dripped and poured painting style of postwar American art. The list of foods is as gluttonous as a huge table-top *Number 1* by Jackson Pollock, famous for painting on horizontally laid, rather than vertically hung, easel-type canvases, in his own humble, work boots, gracefully tossing paint off sticks and paintbrushes, dancing around them, crossing one foot over the other.

Françoise's art maintains its own kind of rhythm, a kind of musicality. Like Marker's visual feast, Françoise's meal is as "light and fleeting as an 'occasional' piece of music." The meal is happy and light-footed, like the footage of the three children from Iceland. Both the meal and the children are hued, at least metaphorically, in blue joy.

In contrast, the food of the black leader, in tune with Mussorgsky's *Sans soleil*, suggests the black meal featured in Joris-Karl Huysmans's *Against Nature* (1884), a lightless, novel-meal cooked up decades before Françoise's musical feast:

> Dining off black-bordered plates, the company had enjoyed turtle soup, Russian rye bread, ripe olives from Turkey, caviare, mullet botargo, black puddings from Frankfurt, game served in sauces the colour of liquorice and boot-polish, truffle jellies, chocolate creams, plum-puddings, nectarines, pears in grape-juice syrup, mulberries and black-heart cherries. From dark-tinted glasses they had drunk the wines of Limagne and Roussillon, of Tenedos, Valdepeñas and Oporto. And after coffee and walnut cordial, they had rounded off the evening with kvass, porters, and stouts.[25]

## MOUTH

*Sans soleil* is an epistolary film, which ends with the line: **"Will there be a last letter?"** A letter comes in an envelope. A letter envelops: encircles, cloaks, swathes, wraps. You lick it closed with a kind of kiss. If kissing is "aim-inhibited eating," as Adam Phillips ascetically remarks, then to eat

black meal

.......................................

the madeleine cake may be more kiss than bite.[26] For, the *petite* madeleine is just that, a little crumb, a small kiss of food: "a morsel of the cake" soaked in but "a spoonful" of tea (K, I, 60; P, I, 44).

*Sans soleil*, too, celebrates the infinitely small, as it chews and kisses its way through space like a tiny insect. With a bug's eye for detail, Marker, the pilgrim-filmmaker, travels and wanders according to his spiritual callings in a kind of "temple tourism": [27] from a temple consecrated to cats in the suburbs of Tokyo — to Josen-kai on the island of Hokkaido, which combines a museum, a chapel, and a sex shop — to the temple of Kiyomitsu where, every 25 September there is a ceremony for the repose of the souls of broken dolls — to the zoo in Ueno, where people cried more for the death of a panda than for the prime minister who left this world at the same time — even to all of the locations of Hitchcock's *Vertigo.* **"In San Francisco . . . he followed Madeleine — as Scotty had done . . . [he] made the pilgrimage of a film that [he] had seen nineteen times."**

To be enveloped in *Sans soleil* is to see parts of the world through the

darkness of Marker's mouth, is to be lost in a sunless fairy tale. "It was as if the entire year '65 had just been covered with ashes."

Marker, like Manny Farber, the film critic and painter extraordinaire, is a bounty hunter of images, if in miniscule bites. (See Farber's chock-full of things paintings and his chock-full of nouns movie reviews. He seems to be allergic to adjectives.) Both filmmaker and critic-painter have an eye for chewing on meaning-laden chance detail, foraging space, so as to make what Farber, the former high-end carpenter, calls "termite art": "Termite art . . . aims at buglike . . . concentration on nailing down one moment without glamorizing it . . . the feeling that all . . . can be chopped up and flung down in a different arrangement without ruin."[28] Marker and Farber avoid "white elephant art," the termite's heavy-handed opposite. White elephant art is useless, meaningless, empty, and prizeworthy. It is "masterpiece art, reminiscent of the enameled tobacco humidors and wooden lawn ponies bought at white elephant auctions decades ago."[29] The termite focuses on the tiny, the ornery, the wasteful, the stubborn. He is metonymically determined.[30] Instead of allying themselves with the usually heroic elephant, Marker and Farber are allied with the not-so-admired termite. The three of them (termite, Marker, and Farber) are tender and inquisitive when it comes to the small, the individualizing detail. In Farber's still-life paintings, he chews his way through Mexican lotto cards, a meaty lamb chop, toy railroad tracks, seed packets, a yellow rubber corncob chew toy for dogs, notebooks, slides of paintings in white paper mounts, miniature toy houses, candy bars (Look, Snickers), a small roast, painted wood watermelon slices, oatmeal boxes, rulers, crowbars, hammers, awls and pliers, even pieces of film leader. Farber gives his paintings titles inspired by films. *Have A Chew on Me* (1983) borrows a line from William Wellman's *Other Men's Women* (1931), and *Rohmer's Knee* (1982) is a reframing of Eric Rohmer's *Claire's Knee* (1970): the latter, a "serving of Hieronymus Bosch" on a black and blue "slice of Ellsworth Kelly pie" (Plate 14).[31] As termites, Marker and Farber find themselves "eating . . . [their] own boundaries," leaving "nothing in . . . [their] path[s] other than the signs of eager, industrious, unkempt activity."[32]

In the Musée national du Moyen Age (Musée du Cluny) in Paris, within walking distance from Le Jardin des Plantes, there is a small collection of scallop-shell badges, worn by pilgrims of Saint Jacques, tiny versions of

Proust's madeleines. These three-centimeter cake-badges of the fifteenth century have small holes in them. As if they had been partially eaten by some recollecting termite who lives not on wood, but on tin and time. They have suffered a tiny nibble of time. (Certainly, on his own pilgrimages, Marker must have walked by these miniscule metal cakes more than once.)

As both pilgrim and termite, Marker and Farber are *pilgrimmites*.

The termite chews around something at the center of the narrative that you cannot say, like Marker's black leader. The termite engages with the void: the house still stands, but migrating mouths have taken all of the brute strength out of the structure. The edifice is still standing, but we can see through it. The termite is victorious.

Gordon Matta-Clark, the "charismatic Pied Piper of experimentalism,"[33] is also heroic for his termite work: not only the bitten-up buildings (most famous is the cut up New Jersey house that he called *Splitting*, 1975) but also his food work, including his "fabled Food, an artist-run, community-spirited restaurant-as-be-in . . . catering to hungry neighborhood artists and pioneering hippie-ish taste for global cuisine, fresh produce and sushi in the days when exotic seasoning in New York still meant salsa and soy sauce."[34] Under the cover of termite darkness, Matta-Clark "pursued his version of tool-belt conceptualism. He chopped up abandoned buildings, making huge, baroque cuts in them with chain saws, slicing and dicing like a chef peeling an orange or devising radish flowers. (The food analogy wasn't lost on him.)"[35] In France, for the ninth Biennale de Paris, he made *Conical Intersect* (1975) by "connecting two seventeenth-century buildings with a spiraling, cone-like cut visible from the street."[36] (Adjacent to the Centre Georges Pompidou, which was under construction at that time, these two his-and-her townhouses were slated for destruction when Matta-Clark chewed them anew.)[37]

The big round cut of *Conical Intersect* recalls, again, the big O of "Once upon a time," as entry once again, in a fairy-tale manner, into a better castle in the sky. His cut out sphere suggests the Blochian "more colorful or easier somewhere else,"[38] where Matta-Clark's Robin Hoodish crusade (shelter and food for all) is possible. In conjunction with the construction of *Conical Intersect* was Matta-Clark's food performance, entitled *Cuisse de boeuf*, in which Matta-Clark roasted "nearly 750 pounds of beef, which he

*who lives not on wood, but on tin and time.*

........................................

made into sandwiches and distributed free to the public."[39] Matta-Clark is the "peoples" version of Proust's Françoise: both chip away at the divide between heroic artist and cook. As Proust writes, *architecturally*, of Françoise's beef building: "The cold spiced beef with carrots made its appearance, couched by the Michelangelo of our kitchen upon enormous crystals of aspic, like transparent quartz" (K, I, 39; P, I, 449).

Hungry with a termite's desire, Marker, a mostly invisible artist, hides behind his Rolleiflex mouth in the photograph from the 1960s that most commonly circulates of him: a "man, with one eye of flesh and two machine eyes."[40] His camera-mouth: an image at once futuristic as if he were a cyborg in *La Jetée*, and yet historically quaint, with all the nostalgic charm of the famous photographers of the past with their beloved Rolleiflexes. For, it is the camera that can hold on to a present moment forever. As it is said in *La Jetée*: "Images appear, merge, in that museum, which is perhaps that of his memory." As in *La Jetée* and *Sans soleil*, perhaps as in all of Marker's work, the world is always-already Proustified, because Marker, like the author of the *Recherche*, makes use of everything. Marker chomps on the world, as often as possible, but it is hard to get much; it is hard to get full. As Marker notes, "William Klein says that, at the speed of 1/50th of a second per shot,

*heroic for his termite work:*

..........................................

the complete work of the most famous photographer lasts less than three minutes."[41]

Marker, with his Rolleiflex, transfers the location of the eye to the mouth, and the mouth to the eye. The shifting dynamics of maw and gaze are inherent to the very workings of the pre-digital still camera, whose mouth *shutters* with smooth metal teeth ("the mechanical shifting of the plates . . . I love these mechanical sounds in an almost voluptuous way," writes Barthes [H, 15; S, 32]). Likewise, the movie camera whirs like a sewing machine, as it feeds on its black tongue of ribbon celluloid. (Such a migration of the senses is one of Proust's greatest literary tricks. The Narrator in the *Recherche* can *hear* the weather, can hear a cloudless "blue," without opening his eyes (K, V; 1, P, III, 519). Or, the *sight* of cream-colored hawthorn blossoms migrates to the *taste* of almond cake and lands on the *murmuring* of life (K, I, 158; P, I, 112). For Proust, touch has a smell, smell has a taste, sight has a sound: all are inseparable and enveloping paramours.

Marker's embracement of the migration of the eye to the mouth and the mouth to the eye manifests itself in his termite-like chews on the iota of seemingly everything. But it is most deeply present in Marker's baffling *sense* of subjectivity: to take a picture or make a movie with one's mouth (if metaphorically) envelops the subject. The "I" wraps and is wrapped by the Other. "I" is not the opposite of Other **"but rather its lining."**

Ann Hamilton has literally made her mouth into a pinhole camera, performing an altered sense of subject consumption that, when collaged with Marker's *Sans soleil*, is different but illuminating. Hamilton's resulting very black photographs emphasize how closely the shape of the mouth resembles the shape of the eye. Her pictures express a wandering "I," as if to say: when I take a picture of *you* with my mouth, *you* become my *eye*, my I, my pupil within.

To take these pictures, Hamilton places the little pinhole apparatus in her mouth and comes face to face with her subject; she exposes the film by holding her mouth open in a pregnant pause. After the exposure, Hamilton gently brings her lips together and the picture is taken as if in a kiss: an act of aim-inhibited eating.

Seeing Hamilton's son Emmet in her mouth illuminates *neither* Hamilton (who would typically be considered the author) *nor* her son (who would typically be considered the subject), but rather the mouth's dark lining.

*an act of aim-inhibited eating.*

........................................

Her act is a curious performance of Emmanuel Levinas's notion of alterity. Face to face with her subject, Hamilton's open mouth makes her vulnerable, literally open. When she *takes* the photograph she is in an *altered* open-mouth state. (When one is immersed in what one is doing, one loses oneself: one's mouth falls open.)

Returning from the mouth as camera (at least metaphorically) to Marker's *sunless* film with a piece of black leader, one sees Hamilton's wrapping of subjectivity in the repetition of the phrase, "**he writes me.**" When the velvety voice-over says, "**he writes me**" or "**he wrote me,**" one feels the "lining" as an undecidable container. Who is "me"? Sandor Krasna (the "fictitious," world-traveling, Marker-like cameraman who is writing the letters to the unnamed woman and making the *sunless* film that we are now watching)?[42] The woman reading? The viewer? Chris Marker? Hitchcock? Madeleine?

## THE TENSE OF THE TREES

By the end of his long, long novel (indeed, in the final paragraph), the Narrator of the *Recherche* has *grown* old and is terrified by the thought that he has become so stretched as to be ready to fall: "as though men spend their

lives perched upon living stilts which never cease to grow until sometimes they become taller than church steeples, making it in the end both difficult and perilous for them to walk and raising them to an eminence from which they suddenly fall" (K, VI, 531; P, IV, 625).

It is here in the last volume, *Time Regained*, that the Narrator experiences the involuntary memory prompted by the famous trip on the uneven paving stones. The Narrator, in a half-awake state, quickly steps out of the way of a moving car and trips on the "uneven paving stones" in front of the coach house in the courtyard of the Guermantes mansion. This trip sends him flying through time to the *other* uneven paving stones of the baptistery of St. Mark's. But the trip also trips (as in to release, to trigger) other body-deep, involuntary memories including the madeleine: "The happiness which I had just felt [as a result of the uneven paving stones] was unquestionably the same as that which I had felt when I tasted the madeleine soaked in tea" (K, VI, 255–256; P, IV, 445).

Involuntary memories (as in the various instant epochs of the Narrator's life, the taste of a madeleine dipped in tea, the sound of a chance knock of a spoon against a plate, the feel of the stiffness of a starched napkin, the loss of footing on uneven paving stones, or the sight of the trees that *he thought* he recognized) are "a fragment of time in the pure state" (K, VI, 264; P, IV, 451). Material signs (like cups of tea, spoons, linen, and trees) are cells for holding the spiritual (the Art). To translate their symbols, their hieroglyphics, is to read, which in Proust's hands (as it is in Barthes's) is to write. But how to write this blackness, this "inner book"? No one, Proust tells us, can help us with the rules.

Such *reading* is an act of creation: a *remembrance of things to come*. Inside these signs is the essence, the secret, of art itself. "As if our finest ideas were like tunes which, as it were, come back to us although we have never heard them before and which we have to make an effort to hear and transcribe" (K, VI, 272; P, IV, 457).

In 2002, Marker, along with Yannick Bellon, made a film about the Surrealist photographer Denise Bellon (focusing on her work between 1935 and 1955) with the telling, Proustian title of *Le Souvenir d'un avenir* (*Remembrance of things to come*).[43] Similarly, the title of Catherine Lupton's detailed history of the filmmaker's work is *Chris Marker: Memories of the Future*.[44] This "future remembering" is the tense of the involuntary nibble-and-trip-and-

sip-and-clang-and-wipe memories of the *Recherche* and of *Sans soleil*'s black leader: representations of memory told without betrayal. (*Hiroshima mon amour*, which Marker worked on for a short time, shares this spotlight on a memory without betrayal, as is discussed in this book's final chapter.)

Marker's black leader is the Narrator's profound happiness that he feels when struck by a view of "three trees" (while on a carriage ride with his grandmother and Madame de Villeparisis). The trees evoke something, someplace, some time, forgotten, but the memory is unlocatable. The trees provide an incredible joy, but the elation cannot be pinned down. They are rootless, roaming, roving, peripatetic, nomadic, wandering, dark, so much so, that the Narrator begins to doubt their very materiality. The Narrator is made dizzy by the three trees: just as Proust's character, the novelist Bergotte, is made giddy by the unlocatable patch of yellow that he seeks in Vermeer's *View of Delft* (where this patch is in the painting, or whether it is there at all, is a dispute among Proustian critics). When facing *View of Delft*, Bergotte wants to grab what cannot be held, what cannot be transcribed (as first described in this book's introduction). "His dizziness increased; he fixed his gaze, like a child upon a yellow butterfly that it wants to catch, on the precious little patch of wall. 'That's how I ought to have written,' he said" (K, V, 244; P, III, 692).

The three trees are a *failed* involuntary memory that cannot and will never be resolved. "I was never to know what they had been trying to give me nor where else I had seen them" (K, II, 407; P, II, 79). Like the image of Marker's three Icelandic children, the image of the three trees is one of unlocatable "profound happiness" (K, II, 404; P, II, 76): "They were phantoms of the past, dear companions of my childhood, vanished friends who were invoking our common memories. Like ghosts they seemed to be appealing to me to take them with me, to bring them back to life" (K, II, 407; P, II, 78).

Without *roots*, the three trees are one step away from the three children from Iceland, from three "dear companions of my childhood." They are not three butterflies, but rather the black void left behind. The three trees will remain forever obscured and that is their power. Their color is not a healing yellow, they are forever blue: a blue so dark, so interiorized, that it is black. "I sprang further forward in the direction of the trees, or rather in that inner direction at the end of which I could see them inside myself"

(K, II, 405; P, II, 77). In fact, the only way to see their happiness is to see "the black," is to cover one's eyes, as the Narrator does in order to understand his vision: "I put my hand for a moment across my eyes" (K, II, 405; P, II, 77).

It is the same interiority (as already taken up in this book's first chapter) that rests behind Barthes's claim that "in order to see a photograph well, it is best to look away or close your eyes" (H, 53; S, 88).

The Narrator's three trees are like Tarkovsky's "Zone," that far-off country of his film *The Stalker* (1979): "a forbidden and deserted but alluring place," which seems to "yield nothing."[45]

This place: What is it? Proust calls it involuntary memory; Barthes waxes it sweetly and darkly as punctum; Tarkovsky calls it the Zone. Marker circles around it with black leader that goes around the reel.

It is tempting to understand the happiness of the three children in Iceland as the success of Marker's film, like the madeleine of the *Recherche*. But Marker is putting the black leader on equal footing. He tells us that the three children **"never worked,"** just as Proust, according to Gilles Deleuze, "cites the madeleine as a case of failure."[46] Both Marker and Proust are focused on a different "stage of interpretation, an ultimate stage."[47]

The failure of the madeleine, of the *three* Icelandic children is the success of the *three* trees, of the black leader.

## THE TREE

In *Sans soleil*, which is a film about making a film, in the spirit of Proust writing a novel about writing a novel, we are dizzyingly presented with the fictitious (but Marker-like) filmmaker named Sandor Krasna. In *Sans soleil*, Krasna goes on a pilgrimage to see all the places that Scotty goes in *Vertigo*, including the cut sequoia tree, which reveals the rings of time, in Muir Woods, California. As we learn from the voice-over: "The small Victorian hotel where Madeline disappeared had disappeared itself; concrete had replaced it, at the corner of Eddy and Gough. On the other hand the sequoia cut was still in Muir Woods. On it Madeline traced the short distance between two of those concentric lines that measured the age of the tree and said, 'Here I was born . . . and here I died.'"

*"He remembered another film in which this passage was quoted.*
*The sequoia was the one in the Jardin des Plantes in Paris, and the*
*hand pointed to a place outside the tree, outside of time."*

..........................................

But also within the circles of *Sans soleil* is a discussion, wrapped and re-wrapped, of *La Jetée*, which features a different sequoia cut, this one in Le Jardin des Plantes in Paris. As we are reminded by the filmmaker in the voice-over in *Sans soleil, La Jetée* is also a remake of *Vertigo*: "He remembered another film in which this passage was quoted. The sequoia was the one in the Jardin des Plantes in Paris, and the hand pointed to a place outside the tree, outside of time."

In *La Jetée*, Jet-man looks at the sequoia in Le Jardin des Plantes and gestures and speaks, as if he were Madeleine, as if he were in a dream: "As is a dream, he shows her a point beyond the tree, hears himself say, 'This is where I come from . . .'"

*La Jetée* is a remake of *Vertigo*, and *Sans soleil* is a remake of *La Jetée*, which is a remake of *Vertigo*. Serpentine is how Barthes describes Marker below a little butterfly-wing painting that he made with colored magic markers. In the few scribbled notes below the image are fragments of text alluding to a certain pleasure, to something overfilled, to a fear of the void. (The image

La Jetée *is a remake of* Vertigo,

..........................................

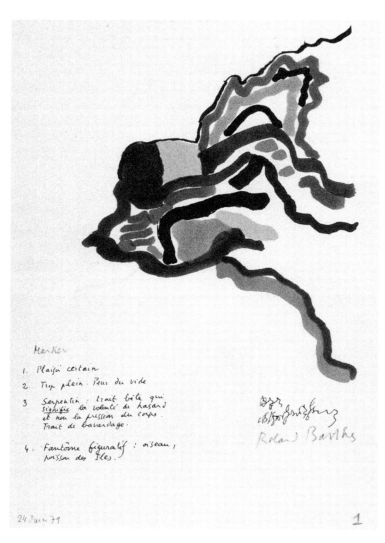

Marker

1. Plaisir certain

2. Trop plein. Peur du vide

3. Serpentin : trait bête qui
   signifie la volonté du hasard
   et non la pression du corps.
   Trait de bavardage.

4. Fantôme figuratif : oiseau,
   poisson des Iles.

Roland Barthes

24 Juin 71                                    1

Serpentine is how Barthes describes Marker below a little butterfly-wing
painting that he made with colored magic markers.

........................................

appears discreetly and without further remarks in *Roland Barthes par Roland Barthes.*[48])

In the spring of 2006, I went on my own pilgrimage to Marker's Paris, in part to find the ringed sequoia in Le Jardin des Plantes, which appears with such enchanted beauty in *La Jetée.* (Marker's *Immemory* bemoans the fact that the tree has been relegated to a basement, but like a good pilgrim, I was determined.[49]) After two days of wandering and questioning numerous employees of the gardens, with my own little sketch of the circles of the ringed sequoia, I finally found it: not in a basement, but certainly destitute and abandoned in a mostly uninhabited building on the premises. A plaque on the tree informs the viewer that it is "a souvenir" and "a gift" of and from the people of California to the people of France. In the spirit of Madeleine's coiled hair and her remark, "here I was born . . . and there I died," little brass plaques mark individual circles on the tree, indicating what happened during particular rings: AD 79, the destruction of Pompeii; 1039, the first Crusade; 1865, the abolition of Slavery; and on and on and on. (A lot could be said about which events in history are highlighted, but that's another story.) In sum, the sequoia is history/memory (*souvenir*) as spiraling vertigo.

Marker's madeleine-filled mouth with its long piece of black leader is wrapped by the ringed sequoia of Hitchcock's *Vertigo*, is wrapped by the ringed sequoia tree that can still be found in Le Jardin des Plantes, is wrapped by its appearance in *La Jetée*, is wrapped again in *Sans soleil* . . .

One spiral leads to another and another. I find myself as a child with yet another giant spiraling tree: the year is 1964. My family is driving our car through a tunnel carved out of northern California's famous Chandelier Tree. Named for its colossal branches on both sides of its mammoth trunk, limbs that are themselves the size of small trees, the Chandelier Tree looks like a candelabrum, hence its name. The Chandelier Tree is older than I can imagine, even now.

I am in a memory hole.

I am eight years old. The Chandelier Tree, with its hidden rings of time and its huge branches, like lamps that light the way to the past, has lived and will live far outside the parameters of my lifetime. Its branches are "waving their despairing arms at me" (K, II, 407; P, II, 79). Its limbs are

AUG 1964

*I am in a memory hole.*

........................................

"phantoms of the past, dear companions of my childhood . . . invoking our common memories" (K, II, 407; P, II, 78).

Perhaps you cannot see the happiness, but can you, at least, see the black?

# She Wrote Me

After I deliver a lecture on *Hiroshima mon amour* at the National Portrait Gallery in London, a beautiful young woman approaches me.

She is full: with "life, to be eaten on the spot like fresh doughnuts," or "les groseilles" (currants).

She is full: with blush.

She tells me.

She tells me that like me, she (too) had been bruised by Hiroshima as a teenage girl.

She tells me that the films and photographs of Hiroshima, 1945, had *also* stung her, had *also* burnt themselves into her brain, when (like me) she was a teenage girl.

She tells me of her Kernel of Hiroshima lodged within her, like a tiny shard of glass, forever. At least, hopefully forever: one sometimes must work at not forgetting.

She tells me that, as a teenage girl, she wrote her bruise as a poem.

Marta Weiss wrote a poem called "1945" when she was just sixteen years old.

She wrote me.

She wrote me a note and tucked "1945" into the envelope and sent it through the post.

She wrote me:

### 1945

Kneel here, eat my rice and pickled plums,
    and take a sip of 1945.
It will sting your eyes and burn your throat,
    but maybe you will taste a fragment of the pain,
    the size of the glass chip embedded in my cheek.
Maybe you will feel one degree of the heat
    that burned the flowers of my mother's kimono,
        that melted my great-grandfather's bones
            with the blue tiles from my roof,
and left only a shadow of my sister on the sidewalk.
        I will only pour one cup of 1945,

and when you have drink it, I will tell you
how beautiful your hair is
and how skilled you are with chopsticks.[1]

# "Summer Was inside the Marble": Alain Resnais's and Marguerite Duras's *Hiroshima mon amour*

.............................

. . . in the young woman's bruised passion.

—Julia Kristeva, "The Malady of Grief: Duras,"
*Black Sun: Depression and Melancholia*

"You saw nothing in Hiroshima. Nothing" (S, 15; G, 22). So goes the first line of *Hiroshima mon amour* (1959), the devastatingly beautiful film by Alain Resnais, with a screenplay by Marguerite Duras.

"You saw nothing in Hiroshima. Nothing." We hear this first line after seeing the artful filming of body parts abstracted: slow moving, tightly framed, and alive with sensuality, so as to evoke Edward Weston's *Nude* of 1934, a body with places for the fingers and eyes to slip into, as if the body were nothing more, nothing less, than a lavishly photographed, sexual/erotic bell pepper, seashell, cabbage, artichoke, or mushroom.

But unlike Weston's touchable *Nude*, which is as still as a bell pepper, seashell, cabbage, artichoke, or mushroom, Resnais's bodies move. They move in tune with Giovanni Fusco's unforgettable nocturne: a melodic night song written especially for *Hiroshima mon amour*. They wear Fusco's sound like skin. And, what we see is less a bird's-eye view than that of a termite or a worm, as if we were one of a certain species of animals who, on the second day after the bombing of Hiroshima, "rose again from the depths of the earth and from the ashes" (S, 18; G, 27). Eating our way up, little by little, bite by bite, nibble by nibble, we see body parts too close, too cropped, yet beautifully so, so as to ensure that we are unsure of what we are seeing: a couple who met by chance.

In Duras's own words:

> As the film opens, two pair of bare shoulders appear, little by little. All we see are these shoulders – cut off from the body at the height of the head and hips – in an embrace, and as if drenched with ashes, rain, dew, or sweat, whichever is preferred. The main thing is that we get the feeling that this dew, this perspiration, has been deposited by the atomic "mushroom" as it moves away and evaporates. It should produce a violent, conflicting feeling of freshness and desire. (S, 15; G, 21)

The bodies seem to be under a rain of ash, recalling Pompeii. These poetic images of arms, backs, and legs twined together, drenched in ashes, were perhaps "inspired by a novel on Pompeii . . . [that Duras] had been reading."[1] Or, they could have come from Proust's *Recherche* (a book of special interest to Resnais). Poetically imagining the gasses of German warfare

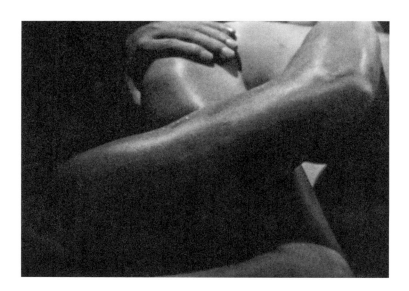

*"You saw nothing in Hiroshima. Nothing"*

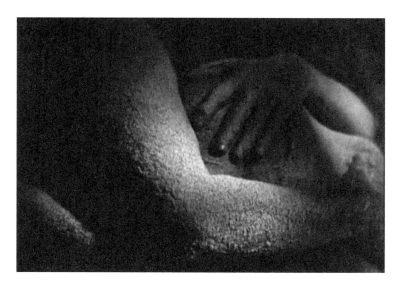

*body parts abstracted:*
......................................

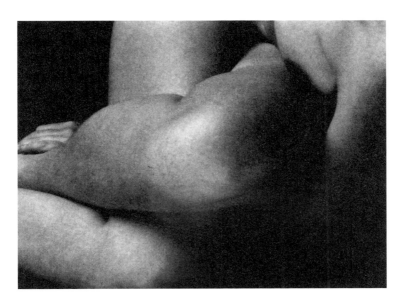

*places for the fingers and eyes to slip into, as if the body were*
*nothing more, nothing less, than a lavishly photographed, sexual/erotic*
*bell pepper, seashell, cabbage, artichoke, or mushroom*

..........................................

NUDE, 1934. PHOTOGRAPH BY EDWARD WESTON.

as able to preserve brief seconds of everyday life, like a photograph, Proust links the asphyxiating fumes of the First World War with the toxic vapors of Vesuvius and the burial of Pompeii. With an emphasis on the frivolity of the bourgeois, Proust writes his own *Le Souvenir d'un avenir*. In Proust's Remembrance of things to come, children of the future will study traces of bodies which were frozen by the Vesuvius-like fumes of the Great War: a woman putting on "a last layer of powder before going out to dine," or a gentleman "adding the final touches to his false eyebrows" (K, VI, 169; P, IV, 385).

Hiroshima contains the ashes of Proust's memory of future war.

The opening scene of *Hiroshima mon amour* is a scene of skin as both pleasure and pain.[2] As Goethe writes of Pompeii in his *Italian Journey*: "There have been many disasters in this world, but few which have given so much delight to posterity, and I have seldom seen anything so interest-

ing" (March 13, 1787).[3] Or, in the words of the French lover in *Hiroshima mon amour*: "You destroy me. You're so good for me" (S, 25; G, 35).

So opens *Hiroshima mon amour*, like the sped up film of a flower bud opening, which, when watched, has the curious effect of slowness. *Hiroshima mon amour* is a double circle, taking place over a period of twenty-four hours: it is the clock going round to twelve o'clock once, and then round again to twelve o'clock one more time. The film moves round and round through one day and one night. As Jacques Rivette has noted: "At the end of the last reel you can easily move back to the first, and so on . . . It is an idea of the infinite but contained within a very short interval, since ultimately the 'time' of Hiroshima can just as well last twenty-four hours as one second."[4]

*Hiroshima mon amour* is ostensibly the story of a love affair between a Japanese architect (or engineer), who lives in Hiroshima, and a French actress, who lives in Nevers, France (S, 8; G, 17). The actress has come to Hiroshima to star in a film about peace. (Just as Proust's *Recherche* is a novel about writing a novel, *Hiroshima mon amour* is a film about making a film.) Never do we get the Japanese architect's actual name. Never do we get the French actress's actual name. He is just LUI from Hiroshima. She is just ELLE from Nevers. "The time is summer, 1957 – August" (S, 8; G, 9). Resnais chose the setting of Nevers because he liked the sound of the name, which, of course, has a special, if foreboding, resonance in English.

The first time, and the only time (until quite recently), that I saw *Hiroshima mon amour* was in 1984 at the Museum of Contemporary Art, in San Diego, California.[5] Stronger than the memory of seeing the film for the first time is my memory of crossing the street to see the horrifyingly beautiful movie in that kind of fog that hugs the coast of California. *Hiroshima mon amour* struck me. It was one of the first serious "art" films that I had ever seen. It gave me a taste of Duras, before I had read Duras. I had remembered the love between the Japanese man and the French woman. Before seeing it for the second time, I had remembered that the film made me cry, which, in turn, had made me think about the sacrilegiousness of imagining a love story in Hiroshima. In the words of Duras: "What is really sacrilegious, if anything is, is Hiroshima itself" (S, 9; G, 10).

But, I had completely forgotten about the film's use of documentary footage.

A few years ago, I saw *Hirsohima mon amour* again.

While rewatching *Hiroshima mon amour* this time around, the film struck me with its coupling of terrifying still images with long, dark, disturbing, overwhelming, blinding passages of documentary footage shot right after the blast by the Japanese filmmaker, Iwasaki Akira. The documentary footage cuts into the artful cinematography of *Hiroshima mon amour*. Japanese mothers, fathers, brothers, and sisters vanish. Some left mere traces of themselves, like the unknown city dweller who sat on the stone steps while waiting for the bank to open. He left behind nothing but a silhouette of himself in the form of a sunless shadow: a primitive photographic print made from the terrible radiation that devoured life on the spot.

Others survived the initial blast only to suffer horrifically from the nuclear fallout. We witness a woman sitting before her mirror combing her hair, which falls out in fistfuls between unbelieving fingers. A mother wanders aimlessly with her child: Where could she go?

Particularly memorable is a woman's kimono burned into her skin in an unnerving pattern. "Atomic light" had seeped through those parts of her kimono that were lightly colored, as if she were clothed, not in cotton or silk, but in the transparency of a photographic negative.[6] On her skin, light areas appear dark. Her strange dermographism is in silent conversation with the "quiet pattern" of the person who disappeared forever while waiting for the bank to open. In his poem "The Shadow," the Hiroshima poet Tōge Sankichi describes what remains of him or her:

Enclosed by a painted fence
on a corner of the bank steps,
stained onto the grain of the dark red stone:
a quiet pattern.
That morning
a flash tens of thousands of degrees hot
burned it all of a sudden onto the thick slab of granite:
someone's trunk.
Burned onto the step, cracked and watery red,
The mark of the blood that flowed as intestines melted to mush:
    a shadow.[7]

Penetratingly and eerily, the woman's *latticed* skin carries with it William Henry Fox Talbot's famed primitive photograph, his *Latticed Window*, made

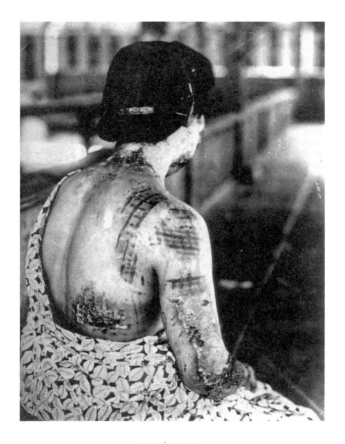

*unnerving pattern.*

......................................

from the earliest camera negative in existence. For Talbot, "the brilliant summer of 1835," as he described it,[8] saw many advances in his pursuit of making spontaneous images "without the aid of an artist's pencil," and "by the agency of light alone." Talbot's photograph of the sunlit window in Lacock Abbey in southern England and the terrifying photograph from Hiroshima (a woman *blueprinted* with the horror of the blast's illumination) crisscross each other. The beginning of "the pencil of light"[9] wove its way into the unspeakable light of Hiroshima when, as is so poignantly described by Akira Mizuta Lippit, "the force of radiation moved beyond closed rooms and cameras, into the world—when the light of atoms exposed the earth and the universe around it."[10]

The footage that Iwasaki shot "burned itself" into his "brain."[11]

The footage burned itself into my brain.

I now remember that I had seen this documentary footage before, which, until recently, remained lodged inside me, like a marble swallowed whole, like an involuntary memory unblossomed. I now remember the film within a film (Iwasaki's documentary inside Resnais's cinema) from which this once-frozen voice of summer was frozen inside me and now emerged.

> At seventeen seconds after 8:15, on the clear bright morning of August 6, 1945, an atomic bomb was dropped on Hiroshima, Japan. The pilots of the United States Air Force's 509th composite group could see flowers in the gardens below. . . .
> Two hours later, drops of black rain the size of marbles began to fall.[12]

These words, in a man's sad, deliberate, slow, and desperately urgent voice, are from the voice-over to a little, explosive documentary film that I first saw in high school. The documentary is entitled *Hiroshima-Nagasaki, August 1945*, and it was released in 1970 by Eric Barnouw. The film contains the Iwasaki footage that is seen at the start of *Hiroshima mon amour*. Not only can I still hear the clear, male American voice-over of Barnouw's documentary as it narrates the incomprehensible facts of Hiroshima in a poetics that moves one, with all the simplicity of the silent blast of a Haiku poem, but I can also hear the voice of a Japanese girl as she gives her personal account of the bombing. The words are those of an unnamed Hiroshima girl who had survived on the edges of the blast. She speaks only once, after the start of the film, after the facts are given. Hers is a beautiful and battered voice. She

*Latticed Window*
*(with the Camera Obscura)*
*August 1835*

*When first made, the squares
of glass about 200 in number
could be counted, with help
of a lens.*

"the brilliant summer of 1835,"

reads in broken English. Hers is the voice of a flower miraculously growing in poisoned soil. This girl's voice haunts this unforgettable documentary and now, especially, haunts me. It will haunt you. She speaks:

> I remember, I remember, a big light comes, a very strong light, I never see so strong.
>
> I did not know what has happened.
>
> My friend, she and I are always together, but I could not find her.
>
> So dark it gets. So red like a fire. Always smoking dark red I cannot see anyone.
>
> Many people run. I just follow.
>
> Pretty soon like fog. Red fog. And gray. And people down all around me.
>
> And people look so awful. Skin comes off. Just awful. Makes me so scared, so afraid. I never knew such hurt on people. Un-human. I think, if I am in hell, it is like this.
>
> No faces. No eyes. Red and burned, all things, like women's hair, dusty and smoking with burning.
>
> Many people going to the river. I watch them. Many people drinking water. But they fall in and die, and they float away. Voices cry, calling names. I cannot hear because so many voices cry, all calling names. So many voices.[13]

I feel her voice to be "filling me with a precious essence" (K, I, 60; P, I, 44) that I cannot translate. What is she saying? It is not the broken English, spo-

ken by a girl broken from the war, that is a problem; it is what she is saying. It is incomprehensible. Unrepresentable. Unclassifiable. Unforgettable.

In the words of the child-narrator of Eliza Minot's remarkable novel *The Tiny One*, a girl who speaks not of the unfathomable Hiroshima but of the death of her mother, a miniscule loss in the scope of things (nevertheless, immeasurable for eight-year-old Via Mahoney Revere): "How can something so big fit into such a little thing like a day? I can't get it . . . the day was just like another day and then something stopped. Something else began."[14]

## FLOWERS

I remember the darkened classroom, the sound of the film moving through the sprockets of the reel, the constellation of bits of dust dancing in the projector's light (like a dandelion blown), the shock of seeing fellow students crying, even boys. Still, I can hear the words from the film, especially the bit about the atomic flowers:

> And by the twentieth day after the bomb, vegetation began to grow wildly in the wreckage of the cities. From charred remnants of plants, lush green weeds and wildflowers sprung again, madly, in extraordinary regeneration, stimulated by atomic radiation. And as people died of radiation sickness, the cities were blanketed with flowers.[15]

In his famed book *Hiroshima* (1946), John Hersey also tells of the blossoming of flowers, the beauty, "the optimistic green" that sprang from the bomb:

> Over everything – up through the wreckage of the city, in gutters, along the riverbanks, tangled among tiles and tin roofing, climbing on charred tree trunks, was a blanket of fresh, vivid, lush, optimistic green; the verdancy rose from the foundations of ruined houses. Weeds already hid the ashes, and wild flowers were in bloom among the city's bones. The bomb had not only left the underground organs of plants intact; it had stimulated them. Everywhere were bluets and Spanish bayonets, goosefoot, morning glories and day lilies, the hairy-fruited bean, purslane and clotbur and sesame and

panic grass and feverfew. Especially in a circle at the center, sickle senna grew in extraordinary regeneration, not only standing among the charred remnants of the same plant but pushing up in new places, among bricks and through cracks in the asphalt. It actually seemed as if a load of sickle-senna seed had been dropped along with the bomb.[16]

Mine is a memory, a screen memory of a remembered film that I saw when I was only sixteen. I thought that I had forgotten all about it, until recently when the memory returned to me involuntarily. Like Abraham's Kernel within the shell, involuntary memory is something untranslatable, what Gilles Deleuze, in his particular reading of Proust, differentiates from a host of other material signs. The madeleine is a material sign, but the joy and pain that is ushered out by the cake is something dematerialized. It is an ideal essence. It is a truth. It is what Deleuze understands as Art.

In Deleuze's circular writing around the Art (the truth) which is offered up by Proust's host of untranslatable, imprisoned, enveloped, wrapped, and boxed signs, we must not only translate the material sign to further material meanings but we must also seek the immaterial, the untranslatable: the Kernel. With work, we will discover "a certain prize in the circling shadows."[17] Yet, this Art (as affect) cannot be transformed, digested, or dissolved. Furthermore, its content is "incommensurable with the container."[18]

*Hiroshima mon amour* offered me a material sign, which gave to me "a strange joy," while at the same time, it transmitted "a kind of imperative."[19] I felt something intense, something bodily, but what was it? I had yet to "develop" this quality, this sensuous impression. Like a "tiny Japanese paper that opens under water and releases the captive form,"[20] the material for flowering was there, but would remain closed, like a Karl Blossfeldt poppy head, if only for a little while.

Now I see Blossfeldt's unreal poppy taking on a surreal post-nuclear shape.

In the words of Proust:

As in the game wherein the Japanese amuse themselves by filling a porcelain bowl with water and steeping in it little pieces of paper which until then are without character or form, but, the moment they become wet, stretch and twist and take on color and distinctive shape, become flowers . . . all the flowers in our garden. (K, I, 64; P, I, 47)

*the material for flowering was there, but would remain closed,*
*like a Karl Blossfeldt poppy head, if only for a little while.*

..........................................

Proust received the Japanese flowers that inspired his novel from his friend Marie Nordlinger (who, curiously, used to live in my now hometown of Manchester, England).[21] As a child, I bought the modern equivalent, akin to Proust's pretty metaphor, in the form of little discs of pressed paper that I found in the shops of San Francisco's Chinatown, stores chock-full of appealingly foreign smells of incense-laden sweetness. Once home, I put the enchanting little paper Jack-in-the-beanstalk magic beans in the bottom of a tall clear glass of water. In the morning I would awaken to a glass-turned-tall pond, full of marvelous paper water flowers: red, blue, yellow, and deep pink, all grown from tender stems of green thread, blossoming from their captive form.

Proust's Japanese paper flowers and those of my childhood were exquisite and immediate, echoing the intense feeling of an involuntary memory, which is more pure, more sincere than the memories we intellectually strive for. They just grow out of nowhere, and the satisfaction in this is not unlike the satisfaction of making cyanotype photograms (cameraless photographs).

I remember making these sun-prints. I remember taking sheets of rich blue light-sensitive paper out into the bright sun and placing objects directly on the paper: lace; a spool of thread with some of its unspooled thread squiggling its way around; a skeleton key; a flower, a black and white negative. I remember waiting the few minutes, during which the blue paper turned almost white. I remember running into the house and *developing* the sheets of paper in a cookie sheet filled with water so that the thread, the lace, the flower, the skeleton key, the black parts of the black-and-white negative magically appeared as exquisite white silhouettes in a sea of blue.

In 1853, Anna Atkins's poppy magically appeared in its own pool of cyan. The enchantment of Atkins's poppy and other flora sun-printed by this botanist are suggestive of Proust's own miraculous "Japanese paper flowers, tightly folded, that blossom and develop in water"[22] (Plate 15). Barthes marks Proust's water-paper-flower passage as "a moment of writing."[23]

In England (red) poppies are for Remembrance Day.[24]

The French remember those who have died in war with a blue corn-flower, a *bleuet*.

From within Atkins's blue poppy of remembering, which looks like an X-ray (the first photographs to go into the body, the first photographs to

*Now I see Blossfeldt's unreal poppy taking on a surreal post-nuclear shape.*

........................................

use radiation derived from uranium), one senses a quietly spoken truth. According to Proust, just as the most significant memories are involuntary, the most important words are also *involuntary*: like an X-ray, they reveal truths beneath the surface. As Proust writes: "These words being of the only kind that is really important, that is to say involuntary, the kind that gives us a sort of X-ray photograph of the unimaginable reality which would be wholly concealed beneath a prepared speech" (K, II, 222; P, I, 577).

## A POPPY, A BLEUET, A SCATTERING OF PANSIES

While doing research for this chapter, I checked out a library copy of *Hiroshima and Nagasaki: The Physical, Medical, and Social Effects of the Atomic Bombings* (written by The Committee for the Compilation of Materials on Damage Caused by the Atomic Bombs in Hiroshima and Nagasaki).[25] Between the pages of the book, I was startled to discover pressed pansies, intermittently spaced throughout the text.

"Pansy" is connected with the French *une pensée* (a thought), as in Ophelia's line from *Hamlet*: "And there is pansies, that's for thoughts."[26] Furthermore, as Harald Wienrich points out in his book *Lethe: The Art and Critique of Forgetting*, pansy is the positive version of a different flower: the forget-me-not, as derived from the French *ne m'oubliez pas*.[27]

Were these flattened flowers placed between the pages of this terrifying study in an effort to evoke *thoughts* of hope amid disaster? Are they thoughts of protest through pacifism?

At worst, they are flowers pressed without thought; they are flowers of indifference.

Why does one feel shame gazing at these flowers?

## MARBLE

Circling round and round *Hiroshima mon amour*, a Deleuzian sign of a different order appears. It is the marble that drops unexpectedly into the cellar in Nevers and into the center of the film. This place, where darkness prevails both day and night, where walls are in touch with the earth, where the

By the end of stage II*b*, patchy figures or islets of cellular regenerati⟨⟩ ppear in the aplastic marrow (figure 8.23). Although Liebow et al. describ⟨⟩ yperplasia of reticulum cells, it is ⟨⟩lear ⟨⟩at is meant by reticulu⟨⟩ ells. Amano attached importance ⟨⟩ ⟨⟩of monocytes precedi⟨⟩ ⟨⟩egeneration of the neutrophili⟨⟩ ⟨⟩of hematopoietic ce⟨⟩ ccurred in small groups of ⟨⟩ site of regenerati⟨⟩ f various cells did not ⟨⟩ pecific structure⟨⟩ bserved in normal ontog⟨⟩ random in cluste⟨⟩

In the bone marrow w⟨⟩ the regenerating ce⟨⟩ id not reach their ultimat⟨⟩ and were not sent in⟨⟩ ⟨⟩e peripheral blood, but acc⟨⟩ow. Suppression of matur⟨⟩ on occurred in all blood c⟨⟩ng neutrophils, erythrocyt⟨⟩ ⟨⟩d platelets. Since regeneration of neutrophils occurred first and was follow⟨⟩ ⟨⟩ter by erythroblasts and megakaryocytes, suppressed maturation of the ne⟨⟩ ⟨⟩ophilic series was the most prominent feature in the marrow. This appea⟨⟩ ⟨⟩ be hyperplasia and focally closely simulates a leukemic change. Repa⟨⟩ f the basic structure of the bone marrow is not complete and shows imperfe⟨⟩ ⟨⟩rmation of sinusoids and admixture of fatty tissue and postnecrotic cicatric⟨⟩ brotic lesions. These were the characteristic features of bone marrow inju⟨⟩ f this type.

*Hemorrhage and Infection of Organ⟨⟩.* Hemorrhage and infection occurr⟨⟩ ⟨⟩ various organs as a result of severe injury to the bone marrow and ⟨⟩ ⟨⟩ccompanying functional insufficienc⟨⟩. These symptoms were most frequent⟨⟩ ⟨⟩countered in stage II and were important causes of death. Hemorrha⟨⟩ ⟨⟩vering a wide area was found in the serosa (pericardium, pleura, peritoneu⟨⟩ ⟨⟩d mucosa (digestive tract, respiratory passage, genitourinary tract). Myoca⟨⟩ ⟨⟩um, lungs, kidneys, and intracranium were also the sites of hemorrhag⟨⟩ hich, depending on its site and amount, sometimes proved fatal.

Among the various infections, oropharyngitis was most frequently see⟨⟩ ⟨⟩ecrotizing tonsillitis occurred in the majority of cases, followed by infecti⟨⟩

*protest*

...........................................

French woman was kept, when she was just nineteen years old, not quite adult, hardly child, by her shameful parents, for sleeping with a German soldier during the German occupation of France, is her unconscious.[28] As a mise en scène of her desire, it brings to mind the movie theater itself, perhaps, even, Resnais's own childhood attic, which as an adolescent he turned into a little cinema, complete with seating. Resnais's attic, then, lit by the illumination of the projector, becomes linked to the cellar of Nevers, radiant with the marble.[29] There, in the cellar, the film takes shape; the film achieves its phenomenal roundness.

Even before being sent to the cellar, where the marble, warm with summer, is discovered, the young woman's head had been shaved by the townspeople of Nevers as a way of shaming her. She slept with the enemy. She was *tondue*, so as to prune her back as victim and "obscene object."[30] Her head mirrors the heads of those left bald by the bomb's atomic radiation, the shaven heads of concentration camps, the smooth head of Joan of Arc (who is from a town not far from Nevers): it mirrors the world, the marble, the circularity of the non-linear story of *Hiroshima mon amour*.

With twisted irony, Duras tells us: "She remained in a cellar in Nevers, with her head shaved. It was only when the bomb was dropped on Hiroshima that she was presentable enough to leave the cellar and join the delirious crowd in the streets" (S, 12; G, 15).

In Duras's memoir *The War* (she claims to have forgotten that she had written it until she discovered it, years later, "in the blue cupboards at Neauphle-le-Château"),[31] we learn of another love rendered illicit by the atomic bomb. After being reunited with her despondent, starving, neardead husband (who had been "sent to Buchenwald, then to Gandersheim in a forced labor kommando," and finally to "Dachaud"), Duras speaks of the summer of Hiroshima as the beginning of a perverse regeneration. Her husband, Robert Antelme (a man who had forgotten her, a man who only remembered hunger), emerges, if only very partially, from the blackness of Dachau at the same time as the huge headline of Hiroshima appears. Duras writes: "Hiroshima is perhaps the first thing outside his own life that he sees or reads about."[32] Eventually Antelme will write a book on "what he thought he had experienced in Germany. It was called *The Human Race*. Once the book was written, finished published, he never spoke of the

*Her head mirrors the heads of those left bald by the bomb's atomic radiation,
the shaven heads of concentration camps, the smooth head of Joan of Arc (who
is from a town not far from Nevers): mirroring the world, the marble, the
circularity of the non-linear story of* Hiroshima mon amour.

..........................................

German concentration camps again. Never uttered the words again. Never again. Nor the title of the book."[33]

Duras writes in the voice of the never-named woman from Nevers: "The marble came toward me, taking its time, like an event. Brightly colored rivers flowed inside it. Summer was inside the marble. And summer had also made it warm" (S, 91; G, 130).

Duras situates this marble, which finds its way down into the cellar (by way of children playing outside), bouncing down the stone stairs until it rolls onto the floor, as a Bachelardian image of pure phenomenology.

In Gaston Bachelard's famed work *The Poetics of Space*, we learn that "images of full roundness help us to collect ourselves, permit us to confer an initial constitution on ourselves, and to confirm our being intimately inside . . . being cannot be otherwise than round."[34] It is the earth, the

pregnant belly, the nest, the pupil of the eye, the open mouth, the circle of time. In a round cry of the round, Bachelard echoes that roundness is "like a walnut that becomes round in its shell."[35] The marble, then, in the hands and eyes of Bachelard's poetics, becomes the image of life itself.

As Duras writes about the marble in *Hiroshima mon amour*: "So much roundness, so much perfection, posed an insoluble problem" (S, 91; G, 130).

The marble rolls on. The marble resists. It carries summer past, present, and future.

In the cellar, the woman from Nevers reflects on this dematerialized non-thing, on the Art whose essence is invoked by a marble warm with summer. "I looked at it with tenderness. I placed it against my mouth, but didn't bite . . . I throw it, but it bounces back toward my hand. I do it again. It doesn't come back. It gets lost" (S, 91; G, 130).

The scene of the marble may have found its way to Hiroshima through Proust.

When the Narrator of the *Recherche* is a boy playing in the Champs-Elysées with his first hopeless crush, the lovely Gilberte Swann, she offers to buy him a marble. Among the "agate marbles, luminous and imprisoned in a bowl," the Narrator points to the one he desires: a marble "that had the same colour of her eyes" (K, I, 572; P, I, 395). Given the emphasis on the "imprisoned" *billes* as looking like "fair" (blonde), "smiling girls," with the "transparency and mellowness of life itself" (K, I, 572; P, I, 395), readers might assume that the chosen marble was blue. That is, unless their memory is serving them well. For, earlier in the *Recherche* (as discussed in this book's introduction), the reader learns that Gilberte's eyes are actually black, stunningly so, despite the fact that the Narrator always remembers them as blue. The marble, then, might best be described as black and blue, not unlike what must have been, for the Narrator, a bruising memory of being held captive by this heartless girl. After paying the marble's "ransom," Gilberte hands the blue, possibly black, *bille* over to the Narrator, while instructing him, with what can only be read as cruel irony, to "keep it as a souvenir" (K, I, 572; P, I, 395).

As readers of the *Recherche*, we understand that this marble, this "souvenir" is impossible to crack. We cannot break it. We can only summon it. Though different in magnitude and scope, involuntary memory, pure love, and Hiroshima, all three are insoluble marbles.

*"So much roundness, so much perfection, posed an insoluble problem"*

.......................................

Hiroshima mon amour is a post-nuclear reading of Proust.

In 1945, the American Surrealist Joseph Cornell, a fan of Proust and of the cinema, put a blue marble at the center of a construction that looks like a book (Plate 16). As noted by Herman Rapaport, the page chosen and glued on the surface, with its "talk about the old Jew," is "not very savory."[36] This blue marble shines with its own black-eyed Jewishness, not unlike the black eyes of Gilberte (which shine blue). Furthermore, because it was made in 1945, Cornell's object is forever under the cloud of the post-nuclear, whether he intended it to be or not. Cornell's marble, it too, is warm with the horrible summer of 1945.

Duras's marble hits Proust's marble hits Cornell's marble, but they do not break.

Hiroshima mon amour calls not for mourning Hiroshima (which would be perversely nourishing), but rather for swallowing Hiroshima whole: not biting into it, not breaking down its insolubility, not betraying its living roundness.

In Resnais's famed earlier Night and Fog (1955), his documentary film

about the concentration camps, the voice-over, quoting the words of the poet Jean Cayrol, remarks: "We can show you but the outer shell."[37] Hiroshima mon amour goes one step further and gives us not only the outer shell (in Abraham's terms) but also the Kernel. The Kernel, the marble, is left intact in order for the memory to exist without betrayal. Duras and Resnais insist on mourning as unfulfilled, as a deep melancholia, necessitated by the demands of representation in the post-nuclear. It seeks the shell and leaves the Kernel intact (unbetrayed).

## BETRAYAL

In the post-nuclear world, when the world is threatened by the most profound form of forgetting – total annihilation – a new technology of memory is rendered necessary: a way to tell the memory, without betraying it, without corrupting it. Victor Burgin has noted that "the telling of the memory, of course, betrays it. Both in the sense of there being something private about the memory that demands it remain untold (secreted), and in the sense that to tell it is to misrepresent, to transform, to diminish it."[38] Yet, Hiroshima is a memory that must be told.

When the woman from Nevers tells her new Japanese lover the story of her past love for the German soldier, a story she has never told a soul before, Duras, with great simplicity and poetic power, unveils this problem of telling as a problem of translation. Betrayal is the poison that consumes ELLE as soon as "their story" is told and is released into the world. Alone in her hotel, with its telling name, The New Hiroshima, ELLE looks into the mirror and speaks not to herself, but to her dead German lover, who is being forgotten, as if dissolving, as if evaporating into the world, right before her eyes:

> SHE:  You were not yet quite dead.
> I told our story.
> It was, you see, a story that could be told.
> I was unfaithful to you tonight with this stranger.
> I told our story.
> It was, you see, a story that could be told.

For fourteen years, I hadn't found . . . the taste of an impossible
   love again.
Since Nevers.
Look how I'm forgetting you . . .
Look how I've forgotten you.
Look at me. (S, 73; G, 110)

## AN INVOLUNTARY MEMORY TURNS (A)ROUND

Before her "betrayal," the woman from Nevers experiences a profound in-
voluntary memory. After she has spent the night with her Japanese lover,
she looks at him asleep on her bed, lying face down, in The New Hiroshima.
His hand trembles slightly. Suddenly and unexpectedly, she is transported
back to the moment of the death of her German lover. The German lover
has been shot. He is dying on the street of Nevers. Duras describes the scene
as follows: "The young man is near death. He too has beautiful hands, strik-
ingly like those of the Japanese. The approach of death makes them jerk
violently. The shot is an extremely brief one" (S, 29; G, 43–44). And like the
mise en abyme of the shorn head of love (and hate), which resonates with
the shaven heads of concentration camps and the smooth skull of radi-
ation sickness, one hand feeds another: the involuntary twitch of the sleep-
ing Japanese lover's hand touches the shudder of the hand of the German
lover at the time of his death, which in turn suggests the photograph of
the burned hand on a large placard carried in the film's Peace Parade and,
perhaps most movingly, speaks to that hand (in the documentary portion
of *Hiroshima mon amour*) forever clutched in that desperate pull characteris-
tic of those foetuses both protected and ruined as a result of being in their
mother's womb at the time of the bomb. (This girl's hand, this Japanese
paper flower will never unfold.)

Shimmering with all these hands is the glow of Wilhelm Conrad Rönt-
gen's X-ray photograph of his wife's hand, taken in 1895. Röntgen not only
discovered the X-ray but he also named it. The "X" signified the unknown
origin of the rays. Unlike the utopian O, X is without hope. As Lippit ex-
plains, Röntgen's X-ray is an image of future death, not only of the bearer

*shudder*

*burned*

*forever clutched*

.........................................

*the lovers' crossed wristwatches.*

................................

of the hand, who saw herself as skeleton, but also as a prophesy of the explosions that would take place in Japan, only fifty years later.

X = "unknown, illicit, secret."[39]

Shortly after the scene of the twitching hands of involuntary memory, we see a shot of the lovers' crossed wristwatches. This is a start of what Deleuze has called "worlding." In Deleuze's concept, of what we might call "roundness," this crossing of place and time through the two watches represents the process of making a "memory for two." In the words of Deleuze, who has written briefly on *Hiroshima mon amour*:

> There are two characters, but each has his or her own memory which is foreign to the other. There is no longer anything at all in common. It is like two incommensurable regions of past, Hiroshima and Nevers. And while the Japanese refuses the woman entry into his own region ("I've seen everything . . . everything . . . You've seen nothing in Hiroshima, nothing"), the woman draws the Japanese into hers, willingly and with his consent, up to a certain point. Is this not a way for each of them to forget his or her own memory, and make a memory for two, as if memory was now becoming world, detaching itself from their persons?[40]

When the contemporary artist Petr Štembera attempted to graft a rose twig into his body (what is the rose, if not the flower of love?), it was an attempt to make a memory of love, of making two into one, without betrayal.

*it was an attempt to make a memory of love, of making two into one, without betrayal.*

..............................................

Štembera's three-dimensional dermographism is a sun-print writ large, trying to take root; it is a life trying to return to the hollowed-out space of the Pompeii cast; it is a living memory that greets the "bluets and Spanish bayonets, goosefoot, morning glories and day lilies, the hairy-fruited bean, purslane and clotbur and sesame and panic grass and feverfew," stimulated by atomic radiation. The graft, as Ashleigh Wells has written, is a masochistic act of impossibility.[41] Like Hiroshima's atomic flowers, it is a wounding colored by hope. Likewise, Štembera's cherished rose reduplicates the French woman's longing for love to grow, even at the cost of annihilation. To circle and re-circle the words of Duras's *Hiroshima*, with the black ink of destruction and the blue ink of longing: "You destroy me. You're so good for me . . . You destroy me. You're so good for me. You destroy me. You're so good for me" (S, 25; G, 35).

And so it was for Štembera whose embedded rose did not take. As Wells notes: "despite following correct arboricultural procedures, Štembera's twig

weakened and died."[42] And the artist who tried to hold the rose without betrayal became infected. As Wells concludes: "There can be no graft between the living and the dead."[43]

## THE BLOSSOMING LONG AFTER

After seeing *Hiroshima mon amour* for a second time, I managed to get my hands on a video copy of *Hiroshima-Nagasaki, August 1945*, the documentary film by Barnouw and Iwasaki. I watched its horrors on my home television, turning it on and off, as my eight-year-old son came in and out of the house. I did not want to scar him, not yet, with Hiroshima's scars.

Since then, my memory of Hiroshima, an event which I cannot imagine, is doubled up with my recollections of high school and my more recent recollections of motherhood, which themselves float on memories of what I might have seen on television, what my uncle who fought in the Second World War might have said, what I might remember about the war from seeing Hollywood films. We can never really be sure how to differentiate what we remember from lived-through experience and those from photographs (which, as Barthes has taught me, cause us to forget by force-feeding).

Allow me to repeat Barthes's poignant words, as first quoted in the first chapter of this book: "The Photograph is violent: not because it shows violent things, but because on each occasion *it fills the sight by force*, and because in it nothing can be refused or transformed (that we can sometimes call it mild does not contradict its violence: many say that sugar is mild, but to me sugar is violent, and I call it so)" (H, 91; S, 143).

Burgin, a dedicated scholar of Barthes, takes off where Barthes left off and reveals how film, like photography, replaces memory. In *The Remembered Film*, Burgin shows how cinema (and for that matter television, on which movies are often replayed) has taken a front seat in the movie house of our memory. As Burgin notes:

> Temporal 'secretions' very often combine memories and fantasies with material from films and other media sources. For example . . . my mother was in an air-raid shelter, and I was in her womb, when her home was severely damaged by a bomb that razed a whole row of houses adjacent to

the bomber's target – a nearby steelworks. I remember my mother's face pale and anxious in the gloom of the bomb shelter, and the dark shapes huddled around her as the bombs crashed outside. This 'memory,' of course, is a fantasy with a décor almost certainly derived from a film."[44]

Watching Iwasaki's footage as an adult gave me a host of peculiar feelings: repulsion and horror at the onset, but also nostalgia, not unlike Proust's description of involuntary memory: "An exquisite pleasure had invaded my senses, something isolated, detached, with no suggestion of its origin" (K, I, 60; P, I, 44). I attribute these feelings (verging on joy), so out of joint with what I saw before me, to thoughts of a journey from high school to adulthood, with all the emotions of seeing the film now as a mother, now as a professor, now in a world that is, miraculously, still here. (Perhaps Fredric Jameson is right: "it is easier to imagine the end of the world than the end of capitalism."[45])

I was not able to trace this perverse elation, perhaps even bliss, until later. I did not yet know, and I would long have to postpone why this film had resided in me, what was at the heart of the exhilarating, transposing, divine feeling that it gave rise to. Interpretation postponed, as I have learned from Deleuze, is a repeated theme of the *Recherche*. Again, I cite Proust on the postponed affect of the madeleine: "I had recognised the taste of the piece of madeleine soaked in her decoction of lime-blossom which my aunt used to give me (although I did not yet know and must long postpone the discovery of why this memory made me so happy)" (P, I, 47; K, I, 64). The blossoming, often, comes long after.

## I REMEMBER

I am looking for summer inside a black marble.

I see raindrops like black marbles, like Talbot's photomicrographs of plant stems.

I see; I hear the calligraphic rain of Guillaume Apollinaire's *Il pleut*:

It's raining women's voices as if they died even in memory.
And it's raining you as well as marvelous encounters of my life O little
    drops [ô gouttelettes].[46]

I taste the black light, like Barthes's drops of black milk, like Apollinaire's drops of black rain.

"The time is summer, 1957 – August" (S, 8; G, 9).

It is the month and the year of the story of *Hiroshima mon amour*.

I remember.

I remember that hot summer of 1957, the season and year of the setting of *Hiroshima mon amour*. I remember my mother's beautiful "modern" floral dress, with its big yellow flowers with orange centers like jelly drops, big blooms stamped like tempera paint potato prints upon a champagne-colored background. I remember my mother's dress with its tight-fitting bodice and voluminous skirt that danced just below her sun-kissed knees, knees that echoed her sun-kissed shoulders. Freckles. Ankles of espadrilles.

I remember my mother's full red 1957 lips, her big gold-button earrings, her incredible beauty, my father's desire for her, her *L'air du temps* scent. I see my mother's dresser with her *L'Air du temps* perfume bottle, its famous bottle crowned with kissing doves of peace and love, made of clear glass. Clear glass like the marbles that occupied my childhood. Coveted marbles that you could look through. They were not cat's-eye marbles. They had nothing inside. Pure emptiness.

Harold Edgerton's post-Hiroshima photographs of an atomic bomb test in the Nevada desert, taken in 1952 with his rapatronic camera, have captured the detonation at the fireball stage, before it explodes into a mushroom. Edgerton's mind-blowing images reveal a huge marble in the dark. (An inverse of Edgerton's violent and explosive drop of milk: the marble looks persuasively tame and hauntingly domesticated.)

Like those clear, colored-glass marbles from my childhood, which we called *clearies* or *puries*, the atomic orb is transparent with light-catching bubbles of air throughout. Its scale almost indeterminable, the ball could be a blown-up photograph of a *purie*, or it could be a telescopic photograph of a distant planet. The circular interiority gathers what looks to be light and precipitation: it is an image of profound round beauty that takes me to Clarence White's *Drops of Rain* (1903).

In the White photograph, the sphere holds springtime showers and the promise of primroses: an Edwardian garden ball, a gazing ball, a garden globe to ensure beauty and ward off evil. The young boy in the photograph has no idea that within forty-two years planes would fly around the globe

*I see raindrops like black marbles, like Talbot's photomicrographs of plant stems.*

......................................

and he would wake up and read the headlines, and the world would never be the same. It would be showered with black rain, black ink loaded with invisible radiation that would become, in the words of Akira Mizuta Lippit, "script."[47]

The words from Barnouw's documentary that I first saw in high school return to me:

> The fireball was 18 thousand feet across. The temperature at the center of the fireball was as hot as the surface of the sun. Near the center people became nothing. Near the center there was no sound . . .
> Eyes turned up to the bomb melted . . . Two hours later, drops of black rain the size of marbles began to fall.[48]

Among the some 6,600 items from the aftermath of the bomb that can be found in the Hiroshima Peace Memorial Museum is a chunk of wall labeled: "'Black Rain' Left Behind on the White Wall."

From 1979–82, Tsuchida Hiromi photographed not only the wall stained with black rain but also many, many of the 1,900 rescued objects that now live at the Hiroshima Peace Memorial Museum. There, one can find melancholic metonymic signs from victims of the blast, most of whom vanished, some of whom suffered terribly only to die later: there are eyeglasses, lunch boxes, shirts, pants, dresses, a handful of hair, watches forever stuck at 8:15.

Overpoweringly sad, and overwhelmingly optimistic (with children as Hope), is the slip worn by a thirty-six-year-old woman who was nursing her child at the time of the blast.

> Aiko Sato (36 at the time) was nursing her baby by the window of her home, 2,000 meters from the hypocenter. She was caught under a fallen chest of drawers together with her baby, and rescued by her two children, ten and twelve years old. Pieces of window glass sent flying by the blast tore holes in her slip. The black spots were made by the black rain, which fell while Mrs. Sato sought refuge.[49]

In the context of this book, the slip's hem of crocheted lace knits its way back into the protective, looped, tied, and trellised wire of Ruth Asawa's umbilical-net sculptures. It was as if Mrs. Sato were within the protective and transparent structure of an Asawa cocoon yet to come. The womb meta-

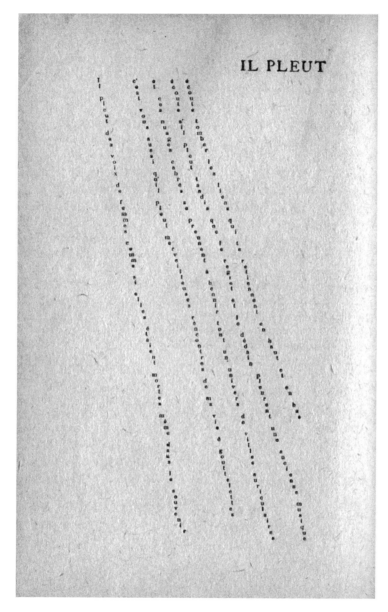

IL PLEUT

like Barthes's drops of black milk, like Apollinaire's drops of black rain.

*a huge marble in the dark.*

..........................................

*It would be showered with black rain, black ink loaded with invisible radiation that would become, in the words of Akira Mizuta Lippit, "script."*

..........................................

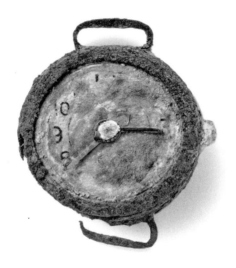

*watches forever stuck at 8:15.*

.......................................

TSUCHIDA HIROMI. *WRISTWATCH*, PART OF THE SERIES *THE HIRSOHIMA COLLECTION*, 1979–82.
"THIS WAS FOUND IN THE WATER, 150 METERS DOWNSTREAM FROM THE MOTOYASU BRIDGE,
EAST OF THE PEACE MEMORIAL MUSEUM. IT SHOWS THE EXACT TIME OF THE BOMBING.
THE OWNER IS NOT KNOWN." COURTESY OF THE ARTIST AND STUDIO EQUIS.

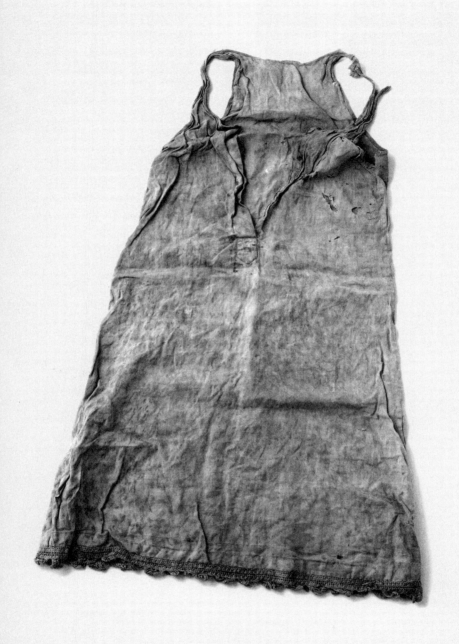

phor is not just added thread: Asawa, who first learned to make art as a way of protecting herself from the hardship of the internment camps, wove her sculptures while giving birth to and tending to her six children.

All of Tscuchida's photographs of objects rescued, but unable to bloom, are impossible souvenirs. (Souvenir in French is, of course, memory.)

In the introduction to his book of photographs of objects from the Hiroshima Peace Memorial Museum (1985), Tsuchida acknowledges that the images are destined for failure:

> I was not at Hiroshima when the bomb exploded. I did not lose any friends or relatives or suffer any injuries. What can someone like me expect to learn by wandering around Hiroshima? I am not sure I would be qualified to say anything about Hiroshima, even if I learned something there. From the beginning, when I started this work, that has bothered me and still does. Then what drove me to Hiroshima? I do not pretend to be so modest as to say I am not qualified to say anything about Hiroshima. Trying to figure out what drove me to Hiroshima, I think it was owing to the darker side of my mind – my egoism as an artist. Even if I were able to empathize with the sufferings of the victims, what on earth could my egoism achieve? All I could do was to recognize the gulf between atomic bomb victims and ordinary people. When I became aware of how great that gulf is, I had to face the fact that I could not bridge it. I have completed my work of portraying Hiroshima, with this collection of photographs. If anything else remains for me to do about Hiroshima, it would be for me to go on honestly admitting my shameful attitude as an artist as I continue to gaze at Hiroshima.[50]

(OPPOSITE) *Overpoweringly sad, and overwhelmingly optimistic
(with children as Hope), is the slip worn by a thirty-six-year-old woman
who was nursing her child at the time of the blast.*

..................................

TSUCHIDA HIROMI. *SLIP*, PART OF THE SERIES THE HIRSOHIMA COLLECTION, 1979–82. "AIKO SATO (36 AT THE TIME WAS NURSING HER BABY BY THE WINDOW OF HER HOME, 2,000 METERS FROM THE HYPOCENTER. SHE WAS CAUGHT UNDER A FALLEN CHEST OF DRAWERS TOGETHER WITH HER BABY, AND RESCUED BY TWO CHILDREN, TEN AND TWELVE YEARS OLD. PIECES OF WINDOW GLASS SENT FLYING BY THE BLAST TORE HOLES IN HER SLIP. THE BLACK SPOTS WERE MADE BY THE BLACK RAIN, WHICH FELL WHILE MRS. SATO SOUGHT REFUGE." COURTESY OF THE ARTIST AND STUDIO EQUIS.

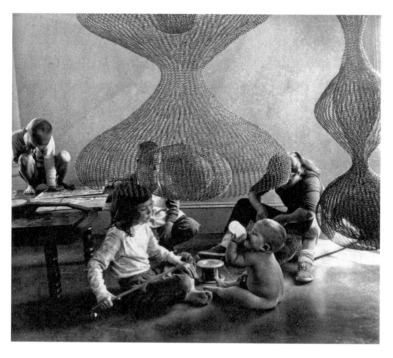

*the slip's hem of crocheted lace knits its way back into the protective, looped, tied, and trellised wire of Ruth Asawa's umbilical-net sculptures.*

..........................................

*But what can the false teeth of Hiroshima swallowed in blue tell us?*

...........................................

Like Tsuchida, other artists have also tried to touch the impossible.

In 2007, Ishiuchi Miyako spent a winter, spring, summer, and autumn photographing the relics of the Hiroshima Peace Memorial Museum. She, too, took objects out of drawers, closets, and boxes, out into the light. Dumbfounded by their presence, she faced them and thought: "All I can do now is focus on the air that I share with the objects lying before me and press the shutter to capture the moment in time."[51] But what can the false teeth of Hiroshima swallowed in blue tell us? There was no sound at the center of the blast. When we listen to these teeth, we hear the loudness of nothing.

A woman's blue dress has faded into the violet and azure shades of an iris flower. The delicate threads, which gather the top of the puffed sleeves, still hold. It seems that not even one wide-eyed white button is missing.

Ishiuchi's photograph contains a barely visible, but perhaps slightly audible, plum-blue pulse. I hear "I am. I am. I am" (Plate 17). The voice of this iris pressed-flower dress "will outlive us all, and never grow old."[52]

In 2008, the American artist elin o'Hara slavick spent a summer making a series of blue, blue cyanotypes of objects left behind after the bomb. Like Tsuchida, like Ishiuchi, slavick worked with objects housed in the Hiroshima Peace Memorial Museum. With the help of the gloved hands of the museum staff, select objects (a bottle, a hair comb, a canteen) were carried out into the sun with the "precisely measured care taken in moving a child."[53] Once outside, they were gently placed on cotton paper coated in cyanide salts, and the photograms were made.

Inside slavick's bottle, which drowns in a vast sea of sapphire, a spot of white light (caused by a bit of carbonized something inside) appears to shimmer at its center. Like Barthes's "delayed rays of a star" (H, 81; S, 126), the white light reaches out to us from August 6, 1945; but, we feel shame when admiring it.

Is it Hope that lies trapped in this bottle?

In the context of Hiroshima, the blue bottle with its little something left behind evokes the Greek myth of Pandora removing the lid of the jar, only for Hope to remain. Yet, Hope is not necessarily so clearly hope. As Glenn W. Most has remarked, the Greek word (or name) usually rendered as *hope* can also mean "anticipation of bad as well as of good things."[54] Accordingly, the classicist translates Pandora's seminal moment from Hesiod as follows:

> But the woman [Pandora] removed the great lid from the storage jar with her hands and scattered all its contents abroad. She wrought baleful evils for human beings. Only *Anticipation* remained there in its unbreakable home under the mouth of the storage jar.[55]

slavick has translated an A-bombed bottle into a field of blue (that duplicitous color of joy and sadness). In it, we see a trace of something that is perhaps best named Anticipation (Plate 18). With all her goodness and all her badness, Anticipation flashes an inconsolable sign to us, from within a bottle that is as unbreakable as Duras's summer marble.

The impossibility of an appropriate souvenir of Hiroshima is highlighted by Resnais by way of the postwar tour bus with the words "ATOMIC TOUR" written in bold black letters (in English) down the long side of the big bus packed with curious onlookers.

Not only do we see the bus but we also witness a series of images of perverse Hiroshima souvenirs: miniatures of the Children's Peace Monument; small replicas of the Hiroshima Prefectural Industrial Promotion Hall, bizarrely covered in faux pearls; souvenir booklets in multiple languages, like the kind you might purchase when visiting a famous pilgrimage site. This series of shots of mementos for sale is culminated by one of the Hiroshima Gift Store, a makeshift wooden hut, closed for business as it sits along the river.

The store along the river not only evokes the two rivers that wind their way through this sinuous film – the Motoyasu River, which victims of the bomb fled to in order to escape the heat; and the Loire River, the "beautiful" and "unnavigable" river of Nevers[56] – but it also brings to mind Lethe, the mythological river of forgetfulness. These objects and the little house that sells them make visible, through sad, sad satire, the impossibility of offering up something material by which to remember Hiroshima. They all fall into the depths of Lethe.[57]

## INCONSOLABLE MEMORIES

The woman from Nevers tells her Japanese lover that, like him, she too has tried with all of her might not to forget: "Like you, I wanted to have an inconsolable memory, a memory of shadow and stone" (S, 23; G, 32). Her words of the desire for an "inconsolable memory" speak to that most famous image from August 6, 1945: the shadow of someone sitting on the steps, waiting for the Sumitomo Bank to open.

In the film, when Duras's phrase, "Like you, I wanted to have an inconsolable memory," is completed with the words, "a memory of shadow and stone," the film cuts to this shadow. Two-hundred and fifty meters from

*The impossibility of an appropriate souvenir*

*closed for business*

the hypocenter, the person-in-waiting vanished, save for the trace caused by the thermal rays of the bomb.

And there are other such nuclear photographs of bodies *gone*: for instance, the shadow left of the woman crossing the bridge over the river. The imprint of this vanished body captures the movement of the woman walking at the fatal second when the bomb dropped. She, like the bank patron, is nowhere to be found, not even buried in the ground, not even as fertilizer for the earth. Vaporized with the bomb, these bodies have left nothing but surreal shadows, sometimes white, sometimes black.

The Hiroshima photograms are haunting, revolting, replays of the early days of photography, of Talbot's "art of fixing a shadow."[58] When placed side-by-side, Talbot's early nineteenth-century photograph of a ladder, coolly burning its imprint on a haystack, speaks silently with the shadow of a ladder seared onto a metal storage tank in Hiroshima. Both ladders speak to the woman whose skin was trellised by the blast.

It was Talbot who took the camera obscura elsewhere, inventing the negative–positive process, sending photography forever adrift under the spell of its binaries: not only the profundity of the play between negative and positive but also what Barthes names as "this stubbornness of the Referent" (H, 6; S, 17). In Barthes's words: "The Photograph belongs to that class of laminated objects whose two leaves cannot be separated without destroying them both: the windowpane and the landscape, and why not: Good and Evil, desire and its object: dualities we can conceive but not perceive" (H, 6; S, 17). These dualities create a spatial back-and-forth shimmering, which allows the light of the past to touch us, over and over, like those Barthesian "delayed rays of a star."

But these post-nuclear photographs from Hiroshima are an altogether different form of technology than that which was invented long ago by Talbot. His pictures were spatial, as they work between the past and the present. But there is no past and present in a body vanished. While Balzac may have feared losing thin ghosts of himself, like layers of skin, with each photograph "taken," in the case of the Hiroshima "photographs," everything is taken. These "photographs" are not spatial, like the casts of bodies lost at Pompeii or even like a beautiful photogram of poppies on blue light-sensitive paper. Their totalizing loss of the referent suggests the failure

*ladder,*

........................................

of indexicality in the post-nuclear, a different moment of forgetting that could mean the whole world will be forgotten.

Duras refers to the photographs that are seen in the Hiroshima Peace Memorial Museum (which document horrible burns to the skin, unbearable scarring, the loss of hair, melted eyes, birth defects, agony, agony) as *mensongères* (misleading) images. Richard Seaver in the English version of the script translates *mensongères* as "deceitful" (S, 8; G, 10). Deceitful is a fitting description of what these photographs hold. As earnest and as noble as the intention behind these photographs might have been, what else could these pictures be but deceiving? They tell us nothing. Like the woman from Nevers, we see nothing.

Hiroshima demands a new post-nuclear indexicality, which embraces the unimaginable: representing the immaterial.

SHE: Four times at the museum . . .
HE: What museum in Hiroshima?
SHE: Four times at the museum in Hiroshima . . . I saw the bouquet

*ladder*

*bloom of its agony . . .*

of bottle caps: who would have suspected that? Human skin
floating, surviving, still in the bloom of its agony. . . .

I was hot at Peace Square. Ten thousand degrees at Peace
Square. I know it. The temperature of the sun at Peace Square.
(S, 17; G, 24–25)

It is summer 1957. I remember the bright sunny days cut by the fear
of the Cold War, the terrible fear that the world would end. At times, I
could see it in my mother's anxious face. This memory is, of course, a "fan-
tasy with a décor almost certainly derived from film" and yellowed photo-
graphs.[59] I had just left her womb; I was six months old.

I saw nothing.

*I saw nothing.*

...........................................

ceci est la couleur
de mes rêves.

PLATE 1

*"patch of blue"*

PLATE 2

*Pecola wants nothing more than "Morning-glory-blue-eyes...*
*Alice-and-Jerry-blue-storybook-eyes" ... Her vision is as skewed as*
*Kiki Smith's upside-down Lilith (1994).*

"Suivant moi, l'hypocrisie était impossible en mathématiques et dans ma simplicité juvénile, je pensais qu'il en était ainsi dans toutes les sciences où j'avais ouï dire qu'elles s'appliquaient" (Stendhal).

même celles-là

(à un moment (les maintenant les abandonne)

l'analogie des poupées que l'on fait

Plassans

il le sait,

qui pourraient-ils tromper?

Nul, absolument, nul en maths et en logique, il n'a jamais osé manier de véritables algorithmes; il s'est rabattu sur des formalisations moins ardues : des formules de lettres/schémas, des tables, des arbres. Ces figures, à vrai dire, ne servent à rien ni à personne; ce sont des joujoux, pas compliqués, avec un mouchoir Zola, de la sorte, se fait un plan pour s'expliquer (lui-même son roman à son roman ces dessins n'ont même pas l'intérêt de placer le discours sous l'alibi scientifique : ils sont là d'une manière décorative, typographique de la même façon, le calcul — dont relevait le plaisir — était placé par Fourier dans une chaîne fantasmatique (car il y a des fantasmes de discours) (SFL. ▬ 89, 107).

on joue pour soi :)

12 Juil

PLATE 4

*An open armpit of "marten and beechnut" and "Midsummer night /*
*Of privet and the nests of angel fish"*

PLATE 5

*She holds a washcloth that is the color of the veins of her white breasts:*
*the milky blue of a Polaroid picture.*

PLATE 6

*Boudinet's bed is sheathed with the illicit Pola-blues.*

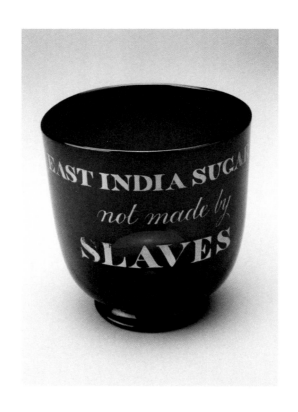

PLATE 7

*Sugar is violent, is black with history and blue with sorrow.*

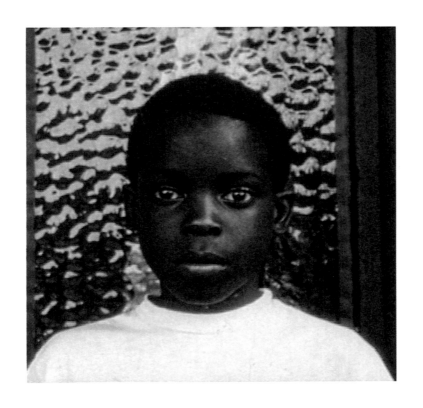

PLATE 8

*I feel the punch of "Blue Black Boy"*

PLATE 9

*Like Briar Rose, like Alexandra Stewart behind a circle of glass,*
*like the woman of La Jetée, this black and blue Beauty*
*is also near, but unreachable.*

PLATE 10

*sleeping on a ferry*

PLATE 11

*We see a ferry passenger's watch moving through the blue*

PLATE 12

"because if you paint a single color over a relief map of Western Europe and North Africa,
you thereby eliminate the boundaries between the countries with a unifying bath of blue"

PLATE 13

Klein found some hope in these terrible images. The bodies of his anthropometries are attempts at being in conversation with the unbearable "photographs on stone" from 1945.

COURTESY OF THE MENIL COLLECTION, HOUSTON

PLATE 14

*a "serving of Hieronymus Bosch" on a black and blue "slice of Ellsworth Kelly pie"*

PLATE 15

*"Japanese paper flowers, tightly folded, that blossom and develop in water"*

PLATE 16

In 1945, the American Surrealist Joseph Cornell, a fan of Proust and of the cinema,
put a blue marble at the center of a construction that looks like a book

PLATE 17

*"I am. I am. I am"*

PLATE 18

*Anticipation*

# ILLUSTRATIONS

## PLATES

All plates appear between pages 160 and 161.

graphed by Rick Gardner, Houston. Courtesy of The Menil Collection, Houston

FIGURES

Introduction

Author's Note I

## Chapter 2

## Chapter 3

courtesy of the Immogen Cunningham Trust © 1958, 2010 Imogen Cunningham Trust, www.ImogenCunningham.com

151  Ishiuchi Miyako. *Untitled*, 2007. False teeth from the Hiroshima Peace Memorial Museum. © Isiuchi Miyako "hiroshima." Courtesy of the artist and The Third Gallery

154  Alain Resnais (Director), Marguerite Duras (Screenplay). *Hiroshima mon amour*, 1959. Argos Films

154  Alain Resnais (Director), Marguerite Duras (Screenplay). *Hiroshima mon amour*, 1959. Argos Films

156  William Henry Fox Talbot. Calotype negative of *The Haystack*, c. 1842. Science and Society Picture Library

157  Photograph of a ladder seared onto a metal tank. Taken in Hiroshima, 1945. National Archives and Records Administration (NARA)

158  Alain Resnais (Director), Marguerite Duras (Screenplay). *Hiroshima mon amour*, 1959. Argos Films

159  Tsuchida Hiromi. *Damaged Lens with one frame*. From the series *The Hiroshima Collection*, 1979–82. Although the body of Moto Mosoro (54 at the time) was not found, a part of her burned head was discovered on September 6, 1945, one month after the atomic bombing, at a place 1,500 meters from the hypocenter. This was taken from an eye socket. Courtesy of the artist and Studio Equis

# NOTES

## INTRODUCTION

1. Richard Howard, "Childhood Amnesia," *Yale French Studies*, no. 43 (1969): 165. As Howard points out, the words for child and childhood in French (*enfant* and *enfance*) are also speechless at their core.

2. As Gabriel Ramin Schor writes: "The mysterious side to black has appealed to artists. For Paul Klee it was not to be rationalized: 'We do not have to understand the black, it is the primeval ground.' His comment recognized the archaic origins of black – back to the time when man had neither tamed fire nor used it to lighten the hours of darkness." See "Black Moods," *Tate Etc.* 7 (summer 2006): 2.

3. This is, of course, the famed metaphor that Sigmund Freud developed in *The Question of Lay Analysis* (1926) to describe the sexual life of an adult woman. While the womb is not necessarily sexual, it is a marker of sex. Freud left the metaphor of the "dark continent" in its original English, which, as Ranjana Khanna points out, "grants it a further aura: of colonialism and its projection of a mysterious Africa . . . The metaphor of the 'dark continent' first came into use in H. M. Stanley's explorer's narrative about Africa: *Through the Dark Continent*." See Ranjana Khanna, *Dark Continents: Psychoanalysis and Colonialism* (Durham: Duke University Press, 2003), 49.

4. Jean-Luc Nancy, *Listening*, translated by Charlotte Mandell (New York: Fordham University Press, 2007), 37. In French: *À l'écoute* (Paris: Éditions Galilée, 2002), 73.

5. Roland Barthes, *The Neutral: Lecture Course at the Collège de France (1977–1978)*, translated by Rosalind Krauss and Denis Hollier, text established, annotated, and presented by Thomas Clerc (New York: Columbia University Press, 2005), 155. In French: *Le Neutre: Cours au Collège de France (1977–1978)*, text established, annotated, and presented by Thomas Clerc (Paris: Éditions du Seuil, 2002), 198.

6. Milan Kundera, "Afterword: A Talk with the Author by Phillip Roth" in *The Book of Laughter and Forgetting*, translated by Michael Henry Heim (New York: Viking, 1981), 234–35.

7. Tobias Hill, "Impossible Things," in *The Phantom Museum and Henry Wellcome's Collection of Medical Curiosities*, edited and with an introduction by Hildi Hawkins and Danielle Olsen (London: Profile Books, 2003), 171.

8. Chris Marker, *Sans soleil*, Argos Films, 1982. Although at times the date is given as 1983, as in the Criterion Collection's American release.

9. Walter Benjamin, "The Image of Proust," in *Illuminations*, edited and with an introduction by Hannah Arendt, translated by Harry Zohn (London: Fontana, 1973), 210.

10. "Nostology" is not in the *Oxford English Dictionary*. Oscar Nybakken defines "nostology" as "an unsatisfactory synonym for gerontology" in his *Greek and Latin in Scientific Terminology* (Ames: Iowa State University Press, 1994), 272.

11. For a complete study of Vladimir Nabokov's life as a serious lepidopterist, see Kurt Johnson and Steve Coates, *Nabokov's Blues: The Scientific Odyssey of a Literary Genius* (Cambridge, Mass.: Zoland Books, 1999).

12. Not all Blues are blue — some might be "better described as brown, copper, gray, silver, or even white." Johnson and Coates, 45. As Nabokov once explained: "When a lepidopterist uses *Blues*, a slangy but handy term, for a certain group of Lycaenids, he does not see that word in any color connection because he knows that the diagnostic undersides of their wings are not blue, but dun, tan, grayish etc., and that many Blues, especially in the female are brown, not blue." See ibid.

13. Toni Morrison, *The Bluest Eye* (New York: Plume, 1993), 23. First published in 1970.

14. Morrison, 213, author's "Afterword."

15. Ibid., 46.

16. Ibid., 23.

17. Ibid., 50.

18. Susan Sontag, *On Photography* (New York: Farrar, Straus and Giroux, 1973), 20.

19. Barthes, *The Neutral*, 69. In French: *Le Neutre*, 102.

20. Rainer Maria Rilke, from his journals, as discussed in Erica Togersen, *Dear Friend: Rainer Maria Rilke and Paula Modershon* (Evanston, Ill.: Northwestern University Press, 1998), 71. E. M. Butler quotes the journal passage in full, in *Rainer Maria Rilke* (Cambridge: Cambridge University Press, 1946), 98–99: "The milk was black. Although we were all surprised, no one dared to mention his discovery, and each one of us thought: 'Well after all, it's night. Never yet have I milked a goat at night. Evidently their milk gets darker and darker from twilight onwards, and now, two hours after midnight, it's still quite black. But don't let me think of that now. Every one of us will have to face the fact alone. To-morrow.' And we all drank of the black milk of the twilight goat and became strangely wakeful after this mysterious beverage."

21. Roland Barthes, "Leaving the Movie Theater," in *The Rustle of Language*, translated by Richard Howard (Berkeley: University of California Press, 1989), 346. In French: "En sortant du cinéma," in *Œuvres complètes*, new rev., corr. ed. presented by Éric Marty (Paris: Éditions du Seuil, 2002), 4:778. First published in French in 1975.

22. I have used Victor Burgin's translation here, rather than Richard Howard's. In Howard's translation of this passage, perhaps in some sort of Proustian asthmatic

moment, he leaves out the cat, *"un chat dormi"*; see "Leaving the Movie Theater," in *The Rustle of Language*, 345. For Burgin's translation, complete with the all-important sleeping cat, see Victor Burgin, *The Remembered Film* (London: Reaktion Books, 2004), 30. In French: *Œuvres complètes*, 4:346.

23. Jean Cocteau, "Plain Song" ("*Plain-chant*"), in *Modern French Poets: Selections with Translations, Dual-Language Book*, edited by Wallace Fowlie (New York: Dover Publications, 1993), 131.

24. William Gass, *On Being Blue: A Philosophical Inquiry* (Jaffrey, N.H.: David R. Godine, 1997), 3–4.

25. Rebecca Solnit, *A Field Guide to Getting Lost* (New York: Penguin Books, 2005), 29.

26. Gass, 34.

27. Ibid., 9.

28. "The Rustle of Language" is the translated title of an essay by Barthes from 1975, as well as a collection of essays.

29. *Toward the Blue Peninsula (For Emily Dickinson)*, circa 1953, is one of many, many blue-schemed boxes by Joseph Cornell. The Dickinson poem, circa 1862, from which the title of the box comes, is particularly utopian in its impossible longing, ending with the lines: "It might be easier / To fail – with Land in Sight – / Than gain – My Blue Peninsula – / To perish – of Delight – "

30. The turning of black eyes into blue eyes as an erasure of Jewish identity was brought to my attention by Alice Kaplan and through further discussions with Andrew Hennlich.

31. This famous quotation by Antoine de Bibesco is often cited as part of the Orientalizing of Proust's Jewishness. As Diana Fuss writes: "At a time when Jews in France were viewed as foreign and exotic, Proust's lovers and friends were forever Orientalizing Proust, comparing his 'huge Oriental eyes' (Daniel Halévy) to 'Japanese lacquer' (Antoine de Bibesco)." See *The Sense of An Interior: Four Writers and the Rooms that Shaped Them* (London: Routledge, 2004), 167.

32. For example, when Albertine childishly and revoltingly claims: "I'm not allowed to play with Israelites" (K, II, 659; P, II, 256–57).

33. Janet Harbord makes a similar reading when she describes the narration of the film as embodying "the childhood voice of bedtime stories." See Chris Marker, *La Jetée* (London: Afterall Books, 2009), 87.

34. This is from the voice-over of Marker's *Sans soleil*.

35. Scarry, 85.

36. Michel Pastoureau, *Blue: The History of a Color*, translated by Markus I. Cruse (Princeton: Princeton University Press, 2001). Originally published in French as *Bleu: Histoire d'une couleur* (Paris: Éditions du Seuil, 2000). Michel Pastoureau, *Black: The History of a Color*, translated by Jody Gladding (Princeton: Princeton University Press,

2009). Originally published in French as *Noir: Histoire d'une couleur* (Paris: Éditions du Seuil, 2000).

37. Pastoureau, *Black*, 12.

38. *Roland Barthes by Roland Barthes*, translated by Richard Howard (New York: Noonday Press, Farrar, Straus and Giroux, 1977), 101. In French: *Roland Barthes par Roland Barthes* (Paris: Éditions du Seuil, 1975), 95.

39. The fictional town of Combray is based on the real town of Illiers. Illiers was later renamed Illiers-Combray in honor of Proust's great work.

40. Chris Marker, *Immemory*, a CD-ROM (Cambridge, Mass.: Exact Change, 2002). Originally produced in French in 1998, under the same title, by Éditions du Centre Pompidou. This line of Marker's can be found in the liner notes that accompany the CD-ROM.

41. My approach here is fuelled by Fredric Jameson's lecture, "The Historical Novel in Postmodernity," presented at Between History and Narrative: A Colloquium in Honor of Hayden White, University of Rochester, Rochester, New York, April 2009.

42. Roland Barthes, *The Pleasure of the Text*, translated by Richard Miller (New York: Hill and Wang, 1975), 18. In French: *Le Plaisir du texte* (Paris: Éditions du Seuil, 1973), 31.

43. This phrase is from Malcolm Bowie's enchanting essay that proves that for all his bulk and length, Proust also has a talent for brevity. See Malcolm Bowie, "Postlude: Proust and the Art of Brevity," in *The Cambridge Companion to Proust* (Cambridge: Cambridge University Press, 2001), 219.

44. This useful comment is from the art historian Sarah Turner, in response to my lecture "Love in Black and Blue: The Bruising of Roland Barthes's *Camera Lucida*," presented at York University, U.K., February, 2009.

45. Chris Marker, *La Jetée*, Argos Films, 1962. This line is a near repetition of the first line spoken in the film, only the subject has been changed from male to female. The text from *La Jetée* in French and in English translation can be found in Chris Marker, *La Jetée, ciné-roman* (Cambridge: MIT Press, 2008). This book is unpaginated. All further translations of *La Jetée* are taken from this book.

### AUTHOR'S NOTE I

1. Roland Barthes, *Empire of Signs* (New York: Hill and Wang, 1982), 6. In French: *L'Empire des signes*, in *Œuvres complètes*, new rev., corr. ed. presented by Éric Marty (Paris: Éditions du Seuil, 2002), 3:352.

2. Nicholas Abraham, "The Shell and the Kernel: The Scope and Originality of Freudian Psychoanalysis," in Nicholas Abraham and Maria Torok, *The Shell and the Kernel*, edited, translated, and with an introduction by Nicholas T. Rand (Chicago:

University of Chicago Press, 1994), 79–98. In French: *L'Écorce et le noyau* (Paris: Flammarion, 1987), 203–26. Through capitalization, Abraham creates a shell around his use of the word "Kernel," just as Freudian psychoanalysis *shells* "Pleasure." In Abraham's own contributions to psychoanalysis he often, but not always, capitalizes Kernel. In the interest of consistency, I have capitalized Kernel throughout this book, whenever I am referring to the mystery of Abraham's *meaningful* theory.

3. James Clifford, *Routes: Travel and Translation in the Late Twentieth Century* (Cambridge: Harvard University Press, 1997), 12.

4. Ibid.

5. This is how Barbara Johnson describes Nicholas Abraham. See her translation of Jacques Derrida's "Foreword" to Nicholas Abraham and Maria Torok, *The Wolf Man's Magic Word: A Cryptonymy*, translated by Nicholas Rand (Minneapolis: University of Minnesota Press, 1986), translator's note, xii.

6. Ibid., 83. In French: 207.

7. Some readers will also be picking up an echoing of not only Abraham, but also Jean-Luc Nancy, especially his use of the word "sense" (*sens*) in his *Listening*, translated by Charlotte Mandell (New York: Fordham University Press, 2007). In French: *À l'ecoute* (Paris: Èditions Galilée, 2002). As Mandell writes in her Translator's Preface to *Listening*: "*Sens* means meaning, and it means sense – in all the meanings of that word in English, as in the senses five, feeling, intuition – as well as direction" (xi–xii).

8. Ibid., 82. In French: 207.

9. Ibid.

10. Gaston Bachelard, *The Poetics of Space*, translated by Maria Jolas (Boston: Beacon Press, 1994), 232. In French: *La Poétique de l'espace* (Paris: Quadrige/Presses Universitaires de France, 2009), 209.

11. Abraham, 88. In French: 214.

12. This is in Nicholas Rand's "Editor's Note" to Abraham, "The Shell and the Kernel," 77. This "Editor's Note" is not in the French edition.

13. Abraham, 80. In French: 205.

14. Abraham, 85. In French: 210.

15. Ibid.

16. Abraham, 86. In French: 212.

## 1. ELEGY OF MILK

1. André Breton, "Free Union," in *Poems of André Breton, A Bilingual Anthology*, translated and edited by Jean-Pierre Cauvin and Mary Ann Caws (Boston: Black Widow Press, 2006), 93. The title of the poem in French is "L'Union libre."

2. Ibid.

3. Ibid., 95.

4. The particular blue of the Polaroid picture was pointed out to me by Esther Teichmann.

5. Paul Celan, "Todesfugue" ("Deathfugue"), in *Selected Poems and Prose of Paul Celan*, in German and in English, translated by John Felstiner (New York: W. W. Norton, 2001), 30–31.

6. The British publication of *Camera Lucida* mysteriously and problematically leaves out the Boudinet photograph, which is part of the original French edition and also the American translation. See *Camera Lucida* (London: Vintage, 1993).

7. Diana Knight, "The Woman without a Shadow," in *Writing the Image after Roland Barthes*, edited by Jean-Michel Rabaté (Philadelphia: University of Pennsylvania Press, 1997, 138.

8. Helmut Newton, *Pola Woman* (Munich: Schrimer/Mosel, 1992), 10.

9. Bianca Abraham, an undergraduate in my class "Art since 1945" at the University of North Carolina, Chapel Hill, 2006, has helped me to think through the Polaroid bed and its relationship to daylight.

10. Roland Barthes, *A Lover's Discourse*, translated by Richard Howard (New York: Hill and Wang, 1977), 14. In French: *Fragments d'un discours amoureux*, in *Œuvres complètes*, new rev. corr. ed. presented by Éric Marty (Paris: Éditions du Seuil, 2002), 5:42.

11. This translation is mine. For a variant rendition in English, see Roland Barthes, *The Pleasure of the Text*, translated by Richard Miller (New York: Hill and Wang, 1975), 5. In French: *Le Plaisir du texte* (Paris: Éditions du Seuil, 1973), 12.

12. Jacques van Ginnken, as quoted in Tzvetan Todorov, *Theories of the Symbol*, translated by Catherine Porter (Ithaca, New York: Cornell University Press, 1982), 234. For the original passage in French, see Jacques van Ginnken, *La Reconstruction typologique des langues archaïques de l'humanité* (Amsterdam: Noord-Hollandsche uitgeversmaatschappij, 1939), 63.

13. Hélène Cixous, in "The Laugh of the Medusa," translated by Keith Cohen and Paula Cohen, *Signs: Journal of Women in Culture and Society* 1, no. 4 (1976): 881.

14. Lawrence Sterne, *The Life and Opinions of Tristam Shandy, Gentleman and A Sentimental Journey Through France and Italy* (New York: Modern Library, 1995), 497.

15. The complications of reading Van der Zee's documentation of the African American middle and upper classes is best attended to by the leading critic on the photographer: Deborah Willis, who writes: "Since the rediscovery of James VanDer-Zee's photographic archive in 1969, when his photographs were included in the Metropolitan Museum of Art's controversial exhibition, *Harlem on My Mind*, VanDerZee's images of the people of Harlem have been celebrated as an important and beautiful historical document. If in the years since, critics and historians have come to value them primarily as a visual record of the emergence in America of the African middle and upper classes, we should not be surprised, but we should not let this

judgement limit our responses to the photographs themselves." See her ground-breaking *VanDerZee* (New York: Abrams, 1993), 8. Willis published this early book under the name Deborah Willis-Baraithwaite. There are several variations on the spelling of VanDerZee. Willis's "VanDerZee" is the most accurate, but in this book I use Barthes's spelling.

16. Shawn Michel Smith, "Race and Reproduction in *Camera Lucida*," in *Photography Degree Zero: Reflections on Roland Barthes's Camera Lucida*, edited by Geoffrey Batchen (Cambridge: MIT Press), 246. Smith, as she graciously acknowledges, is working from David C. Hart's M.A. thesis, "Differing Views: Roland Barthes, Race and James Vanderzee's Family Portrait" (University of North Carolina, Chapel Hill, 1996), 111.

17. Willis-Baraithwaite, 73.

18. I began thinking more seriously about Barthes's handling of the Van der Zee photograph through discussions with José Esteban Muñoz. I shared José's reading with my own students, particularly David C. Hart.

19. Walker describes her often-used character of the "nigger wench" as "a receptacle — she's a black hole, a space defined by things sucked into her." See Gwendolyn DuBois Shaw, *Speaking the Unspeakable: The Art of Kara Walker* (Durham: Duke University Press, 2004), 19.

20. This was pointed out to me in an essay by one of my former undergraduate students, Grayson Limer, for my class "Art since 1945" at the University of North Carolina, Chapel Hill, 2006.

21. Shaw, 133.

22. Ibid., 5.

23. Hans Christian Andersen, "The Ugly Duckling," in *Hans Christian Andersen, Fairy Tales*, new translation by Tiina Nunnally, edited and introduced by Jackie Wullschlager (New York: Viking, 2004), 157.

24. William Henry Fox Talbot, "Some Account of the Art of Photogenic Drawing" (1839), published in *Photography: Essays and Images, Illustrated Readings in the History of Photography* (New York: Museum of Modern Art; and Boston: New York Graphic Society, 1980), 25.

25. See Shaw, 20–27. For a history of Lavater, see Victor I. Stoichita, *A Short History of the Shadow*, translated by Anne-Marie Glasheen (London: Reaktion Books, 1997), 156–71.

26. These are the words of Baroness Bodild Donner, "whose estate Andersen often visited at Christmas," as quoted by Wullschlager in the introduction to *Hans Christian Andersen*, xl.

27. Translation is mine. Howard translates this passage as "sting, speck, cut, little hole," 27.

28. From an interview with François Truffaut, as cited by the writer and musi-

cian Peter Blegvad (guitarist, lyricist, and vocalist for the band The Lodge). See Blegvad's website: http://www.amateur.org.uk. See also Blegvad's essay "Milk," in *The Phantom Museum and Henry Wellcome's Collection of Medical Curiosities*, edited and with an introduction by Hildi Hawkins and Danielle Olsen (London: Profile Books, 2003), 104–41.

29. Http://www.amateur.org.uk.

30. Luce Irigaray, "And the One Doesn't Stir without the Other," translated by Hélène Vivienne Wenzel, *Signs: Journal of Women and Culture and Society* 7, no. 1 (1981): 60. In French: *Et l'une ne bouge pas sans l'autre* (Paris: Les Éditions de Minuit, 1979), 7.

31. "Négresse nourricière" is used here by Barthes to describe the person who nursed and raised the child. The word "nègre" or "négresse" has been used in French to describe someone who works hard and does all the work (the person being of color or not). Like the American "Mammy," the use of the words "nègre" and "négresse" comes from the time of slavery and the words have kept their pejorative connotation. Yet the word "négresse" as a pejorative term is then troubled by Barthes's expression of "ô négresse nourricière," suggesting that the author is paying homage to what Howard names for us as the "solacing Mammy." I thank Anne Calvignac and Allison Connolly for helping me with the difficulties and subtleties of this translation.

32. As even Barthes himself knows, you cannot take Barthes at his word. He loves to contradict himself, because it is contradiction that fuels him. Consider just one of thousands of examples: how he posits "Japan" as a fictive in *L'Empire des signes*, but nonetheless fills it with history, with facts, with concrete observations.

33. Hardly known today, Savorgnan de Brazza was once one of France's greatest legends. As Edward Berenson begins to explain: "During the summer and fall of 1882, no French man or woman was more visible than the explorer Pierre Savorgnan de Brazza. At a time when France confronted armed resistance to its imperial efforts in North Africa and Indochina, Brazza's 'pacific conquest' of extensive lands across the Congo River made him a national hero. Parisian journalists crowned Brazza a 'conquérant pacifique' and lauded him for winning the Congo 'without spilling a drop of blood.'" See Berenson's essay "Unifying the French Nation: Savorgnan de Brazza and the Third Republic," in *French Music, Culture, and National Identity, 1870–1939*, edited by Barbara L. Kelly (Rochester, N. Y.: University of Rochester Press, 2008), 17.

34. In *Black Skin, White Masks*, translated by Charles Lam Markman (New York: Grove Press, 1967), 109. In French: *Peau Noire, Masques Blancs* (Paris: Éditions du Seuil, 1952), 88.

35. It is important to note that this series of images speaks at once to both darkness and desire and their variations in the fantasies of both white and black culture. These "imaginaries" necessarily include the appetite for lighter skin as it is produced within the black community, as well as the feeding on darkness by whites.

36. Toni Morrison, *The Bluest Eye* (New York: Plume, 1993), 51, 58.

37. Fanon, *Black Skin, White Masks*, 112. In French, 90.

38. See Alison and Helmut Gernsheim, *The History of Photography* (Oxford: Oxford University Press, 1955), 258. For an excellent analysis of the concept of the appetite of the eye, see Olivier Richon's "A Devouring Eye," in *Olivier Richon: Fotografie 1989–2004* (Milan: Silvana Editoriale, 2004), 25–33.

39. Morrison, *The Bluest Eye*, 153.

40. Roland Barthes, "Wine and Milk," in *Mythologies*, selected and translated by Annette Lavers (New York: Hill and Wang, 1972), 61. In French: "Le Vin et le lait," in *Œuvres complètes*, new rev. corr. ed. presented by Éric Marty (Paris: Éditions du Seuil, 2002), 1:730.

41. Ibid.

42. Roland Barthes, "The Blue Guide," in *Mythologies*, selected and translated by Annette Lavers (New York: Hill and Wang, 1972), 74–77. In French: "Le 'Guide bleu,'" in *Œuvres complètes*, new rev. corr. ed. presented by Éric Marty (Paris: Éditions du Seuil, 2002), 1:765–67.

43. Toni Morrison, *Playing in the Dark: Whiteness and the Literary Imagination* (New York: Vintage Books, 1992).

44. I am making use of the final lines of Morrison's *Playing in the Dark*, in which she concludes, in response to the racism in some of our greatest literature: "But it would be a pity if the criticism of that literature continued to shellac those texts, immobilizing their complexities and power and luminations just below its tight, reflecting surface. All of us, readers and writers, are bereft when criticism remains too polite or too fearful to notice a disrupting darkness before its eyes." See Morrison, *Playing in the Dark*, 91.

45. Rosalind E. Krauss and Denis Hollier, "Translator's Preface" in Roland Barthes, *The Neutral: Lecture Course at the Collège de France (1977–1978)*, translated by Rosalind E. Krauss and Denis Hollier, texts established, annotated, and presented by Thomas Clerc under the direction of Éric Marty (New York: Columbia University Press, 2005), xiii.

46. Robert Louis Stevenson, "My Shadow," first published in 1885 in *A Child's Garden of Verses*, reprinted in *The Norton Anthology of Children's Literature: The Traditions in English*, edited by Jack Zipes, Lissa Paul, Lynne Vallone, Peter Hunt, and Gillian Avery (New York: W. W. Norton: 2005), 1185–86. The poem in full is as follows:

I have a little shadow that goes in and out with me,
And what can be the use of him is more than I can see.
He is very, very like me from the heels up to the head;
And I see him jump before me, when I jump into my bed.

The funniest thing about him is the way he likes to grow—
Not at all like proper children, which is always very slow;

For he sometimes shoots up taller like an india-rubber ball,
And he sometimes goes so little that there's none of him at all.

He hasn't got a notion of how children ought to play,
And can only make a fool of me in every sort of way.
He stays so close behind me, he's a coward you can see;
I'd think shame to stick to nursie as that shadow sticks to me!

One morning, very early, before the sun was up,
I rose and found the shining dew on every buttercup;
But my lazy little shadow, like an arrant sleepy-head,
Had stayed at home behind me and was fast asleep in bed.

47. Peter Stallybrass, "Worn Worlds: Clothes, Mourning and the Life of Things," *Yale Review* 81, no. 2 (1993): 36.

48. See Alice Walker, "Uncle Remus, No Friend of Mine," *Southern Exposure* 9 (summer 1981): 29–31.

49. Margaret Olin, "Touching Photographs: Roland Barthes's 'Mistaken' Identification," *Representations* 80 (fall, 2002): 104. Olin's carefully nuanced essay has been instrumental in my writing and teaching.

50. Barthes begins his little essay as follows, setting up the white petit bourgeois as a straw dog: "*Match* has printed a story which has a good deal to say about our petit-bourgeois myth of the Black: a young couple, both professors, have made an expedition into Cannibal country to do some painting; they have taken with them their months-old baby, Bichon. *Match* goes into ecstasy over the courage of all three." See Roland Barthes, "Bichon and the Blacks" (1979), in *The Eiffel Tower and Other Mythologies*, translated by Richard Howard (Berkeley: University of California Press, 1997), 35. In French: "Bichon chez les Nègres," in, *Œuvres complètes*, new rev. corr. ed. presented by Éric Marty (Paris: Éditions du Seuil, 2002), 1:719.

51. Juníchirō Tanizaki, *In Praise of Shadows*, translated by Thomas J. Harper and Edward G. Seidensticker (Stony Creek, Conn.: Leete's Island Books, 1977), 30.

52. *Roland Barthes by Roland Barthes*, translated by Richard Howard (New York: Noonday Press of Farrar, Straus and Giroux, 1977), among the unpaginated images at the beginning of the book. In French: *Roland Barthes par Roland Barthes* (Paris: Éditions du Seuil, 1975), 20.

53. Eve Kosofsky Sedgwick, "How to Bring up Your Boys Gay: The War on Effeminate Boys," in *Tendencies* (Durham: Duke University Press, 1993), 157.

54. Morrison, *The Bluest Eye*, 133.

55. Roland Barthes, *A Lover's Discourse*, translated by Richard Howard (New York: Hill and Wang, 1978), 14. In French: *Fragments d'un discours amoureux*, in *Œuvres complètes*, new rev. corr. ed. presented by Éric Marty (Paris: Éditions du Seuil, 2002), 5:42.

56. Barthes, *The Neutral*, 72. In French: *Le Neutre*, 106.

57. Barthes, *Michelet*, trans. Richard Howard (Berkeley: University of California, 1992), 153. In French: *Michelet*, in *Œuvres complètes*, new rev. corr. ed. presented by Éric Marty (Paris: Éditions du Seuil, 2002), 1:394.

58. Jules Michelet, preface to the 1869 edition of *The History of France*. See Edward K. Kaplan, *Michelet's Poetic Vision: A Romantic Philosophy of Nature, Man and Woman* (Amherst: University of Massachusetts, 1977), xii.

59. Barthes, *Michelet*, 157. In French: *Michelet*, 1:398.

60. Barthes, *Mythologies*, 9. In French: *Mythologies*, *Œuvres complètes*, 673.

61. Barthes, "Wine and Milk," 60. In French: "Le Vin et le lait," 1:729.

62. Barthes, "Wine and Milk," 60. In French: "Le Vin et le lait," 1:729.

## 2. "A" IS FOR ALICE

1. Hereafter all further text from the voice-over of *La Jetée* will be noted in bold.

2. André Breton, *Manifestos of Surrealism*, translated by Richard Seaver and Helen R. Lane (Ann Arbor: University of Michigan Press, 1969), 16. In French: *Manifestes du surréalisme* (Paris: Gallimard, 1979), 26.

3. Chris Marker, from the voice-over of his film *Remembrance of Things to Come*, made in collaboration with Yannick Bellon, Les Films de l'Equinoxe, 2001.

4. Raymond Bellour and Laurent Roth, *A propos du CD-ROM de Chris Marker* (Paris: Centre Georges Pompidou, 1997), 108. The book is dual language: in English and French. The famously "reclusive, elusive, and mysterious . . . Marker was given the name Christian François Bouche-Villeneuve at his birth in July 1921, probably in Neuilly-sur-Seine, a suburb of Paris." See Nora M. Alter, *Chris Marker* (Urbana: University of Illinois Press, 2006), 3.

5. "Jet-man" is borrowed from Barthes's essay of the same title, in *Mythologies*, selected and translated from the French by Annette Lavers (New York: Hill and Wang, 1972), 71–73. In French: "L'homme-jet," in *Œuvres completes*, new rev. corr. ed. presented by Éric Marty (Paris: Éditions du Seuil, 2002), 1:742–44.

6. As Maria Tatar explains, the Grimms' story of "Sleeping Beauty" ("Dornröschen," 1812) is sometimes translated literally as "Little Briar Rose." Charles Perrault's version "La Belle au bois dormant" or "Sleeping Beauty in the Wood" was published in 1697. See *The Annotated Classic Fairy Tales*, edited by Maria Tatar (New York: W. W. Norton and Company, 2003), 95. In the Grimms' version of the story, the princess is given the name Briar Rose, after the sleep-inducing prick of her finger on the spindle causes her and the entire castle to be overgrown by a fearsome, thick, prickly, hedge of briars. There are endless variations of fairy tales. As Tatar comments in another of her anthologies: "Although many variant form of a [fairy] tale can now be found between the covers of books and are attributed to individual authors, edi-

tors or compilers, they derive largely from collective efforts. . . . The story of Little Red Riding Hood, for example, can be discovered the world over, yet it varies radically in texture and flavor from one culture to the next." See *The Classics Fairy Tales: Texts, Criticism* (New York: W. W. Norton and Company, 1999), ix.

7. Robert Coover, *Briar Rose* (New York: Grove Press, 1996), 25. Coover, an American fiction writer, retells the fairy tale, with the same unresolved circularity as Marker tells his fairyish *La Jetée*.

8. For Cornell, his starry women also included young shop girls, like the clerk that he voyeuristically watched and wrote about in his journal as the *fée aux lapins*. Her nickname is derived from the fact that she sold rabbits at a five-and-dime store.

9. I would like to thank Jenny Carlisle for pointing this out to me.

10. Jack Zipes, *Breaking the Magic Spell: Radical Theories of Folk and Fairy Tales*, rev. and expanded ed. (Lexington: University of Kentucky Press, 2002).

11. Ernst Bloch, "The Fairy Tale Moves on its Own in Time" (1930), reprinted in Zipes, 153.

12. For more on El Santo, see Anne Rubenstein's "El Santo's Strange Career," in *The Mexico Reader: History, Culture, Politics*, edited by Gilbert M. Joseph and Timothy J. Henderson (Durham: Duke University Press, 2003), 570–78.

13. Rubenstein, 578.

14. Barthes, "The Jet-man," 71. In French: "L'homme-jet," 743.

15. Ibid.

16. Jean Baudrillard, "Hot Painting: The Inevitable Fate of the Image," in *Reconstructing Modernism: Art in New York, Paris, and Montreal, 1945–1964*, edited by Serge Guilbaut (Cambridge: MIT Press, 1990), 17–29.

17. Barthes, "The Jet-man," 72. In French: "L'homme-jet," 744.

18. Ibid.

19. The film was first released in French as *Le Fond de l'air est rouge* in 1977. As Catherine Lupton writes: "*Le Fond de l'air est rouge* exists in a number of different versions. In 1988 Marker produced a three-hour version for British television as part of Channel 4's '68/88 season, with a new coda registering some of the political events that had taken place since the original release, and the English title *A Grin without a Cat*. (The original French title translates loosely as 'a touch of red in the air': a play on the expression 'le fond de l'air est frais,' meaning slightly chilly weather.) See Catherine Lupton, *Chris Marker: Memories of the Future* (London: Reaktion Books, 2005), 227n1.

20. Chris Marker, untitled essay on the Pathéorama that accompanies the liner notes for the DVD of *La Jetée / Sans soleil*, Argos Films, 2003. Unpaginated.

21. "Alicious" is a term coined by James Joyce in *Finnegan's Wake*, where he writes, "Alicious, twinstreams, twinestreams, twinestraines, through alluring glass or alas in jumboland?" (London: Penguin Books, 1992), 528.

22. Marker, untitled essay on the Pathéorama.

23. See note 22 of the introduction for the source of this quotation.

24. Chris Marker, *Staring Back* (Cambridge: MIT Press, 2007), 7.

25. Peter Collier, Anna Magdalena Elsner, and Olga Smith, "Introduction," in *Anamnesia: Private and Public Memory in Modern French Culture*, edited by Peter Collier, Anna Magdalena Elsner, and Olga Smith (Bern, Switzerland: Peter Lang, 2009), 13.

26. Marcel Proust, *Swann's Way*, translated and with an introduction and notes by Lydia Davis (New York: Viking Penguin), 47.

27. Boileau-Narcejac (Pierre Boileau and Thomas Narcejac), *Sueurs froides* (Paris: Éditions Denoël, 1958).

28. Chris Marker, *Immemory*, a CD-ROM (Cambridge, Mass.: Exact Change, 2002).

29. Ibid.

30. Brian Massumi, "Too-Blue: Color-Patch for an Expanded Empiricism," in *Parables for the Virtual: Movement, Affect, Sensation* (Durham: Duke University Press, 2002), 208–56.

31. Ibid., 210.

32. See Rebecca Solomon, *Utopia Parkway: The Life and Works of Joseph Cornell* (Boston: Museum of Fine Arts Publications, 1997), 85.

33. Ibid.

34. Ibid., 87.

35. See Louis Marin, *Utopics: The Semiological Play of Textual Space*, translated by Robert A. Volrath (Atlantic Highlands, N. J.: Humanities Press International, 1990), xvi. Originally published in French as *Utopiques: jeux d'espaces* (Paris: Édition de Minuit, 1973).

36. See Marina Warner, *Fantastic Metamorphoses, Other Worlds: Ways of Telling the Self* (New York: Oxford University Press, 2002), 93.

37. Victor Burgin, *The Remembered Film* (London: Reaktion Books, 2004), 105.

38. Barthes, "The Face of Garbo," in *Mythologies*, selected and translated from the French by Annette Lavers (New York: Hill and Wang, 1972), 57. In French: "Le Visage de Garbo," in *Œuvres completes*, new rev. corr. ed. presented by Éric Marty (Paris: Éditions du Seuil, 2002) 1:725.

39. Ibid.

40. Ibid.

41. Lewis Carroll, *Through the Looking-Glass*, in *The Annotated Alice, The Definitive Edition, Alice's Adventures in Wonderland and Through the Looking-Glass*, introduction and notes by Martin Gardner (New York: W. W. Norton and Company), 268.

42. Barthes, "The Face of Garbo," 56. In French: "Le Visage de Garbo," 1:724.

43. Carroll, *Through the Looking-Glass*, 273.

44. Bloch, 151.

45. Barthes uses this term to describe Bernard Faucon's photographs of mannequins, who appear to have been awakened, as if they escaped the department store

window. See Roland Barthes "Bernard Faucon," in *Œuvres complètes*, new rev. corr. ed. presented by Éric Marty (Paris: Éditions du Seuil, 2002), 5:472. First published in *Zoom*, 1978.

46. Lewis Carroll, *Alice's Adventures in Wonderland*, in *The Annotated Alice, The Definitive Edition, Alice's Adventures in Wonderland and Through the Looking-Glass*, introduction and notes by Martin Gardner (New York: W. W. Norton and Company), 74.

47. Hélène Cixous, "Introduction to Lewis Carroll's *Through the Looking-Glass* and *The Hunting of the Snark*," translated by Marie Maclean, *New Literary History* 13, no. 2 (1982): 240. In French: "Introduction" to Lewis Carroll's *De l'autre côte du miroir et ce qu'Alice y trouva et La Chasse au Snark*, translated by Henri Parisot (Paris: Aubier-Flammarion, 1971), 23.

48. Carroll, *Through the Looking-Glass*, 265–66.

49. Harald Wienrich, *Lethe: The Art and Critique of Forgetting*, translated by Steven Rendall (Ithaca: Cornell University Press, 2004), 4. For an illuminating discussion of the impossibility of "the art of forgetting," see Umberto Eco, "An Ars *Oblivionalis?* Forget It," *PMLA* 103 (1988): 254–61.

50. Carroll, *Through the Looking-Glass*, 177.

51. See Carolyn Burke, "Irigaray Through the Looking Glass," *Feminist Studies* 7, no. 2 (1981): especially pages 298–99.

52. Carroll, *Through the Looking-Glass*, 196.

53. Ernst Bloch, "Better Castles in the Sky at the Country Fair and Circus, in Fairy Tales and Colportage" (1959), in *The Utopian Function of Art and Literature: Selected Essays*, translated by Jack Zipes and Frank Mecklenburg (Cambridge: MIT Press, 1988), 186.

## 3. A LONG PIECE OF BLACK LEADER

1. Chris Marker, *Sans soleil*, Argos Films, 1982. Hereafter all text from the voice-over of *Sans soleil* will be noted in bold. Marker released a French version and an English version in the same year. I thank Nora Alter for sharing the text of *Sans soleil* in French with me.

2. See Michel Chion, *The Voice in Cinema*, translated by Claudia Gorbman (New York: Columbia University Press, 1999), 61. In French: *La Voix au cinema* (Paris: Éditions de le Etoile/Cahiers du cinema, 1982), 63.

3. See Jacqueline Hoefer, "Ruth Asawa, A Working Life," in *The Sculptures of Ruth Asawa: Contours in the Air*, exhibition catalog, edited by Daniell Cornell (Berkeley: University of California Press, 2006), 16–17.

4. Anatole Dauman formed Argos Films with Philippe Lifchitz. Dauman produced the first films of Chris Marker. In 1959, Argos instigated the production of *Hiroshima mon amour*.

5. And then, while still in the black, the title appears in English in violet letters: *Sunless*. And finally, while still in the black, we are presented with the title in its mother tongue, yellow letters that finally spell *Sans soleil*.

6. Sei Shōnagon, *The Pillow Book*, translated by Meredith McKinney (London: Penguin, 2006), 87–88.

7. On the use of blue in the *Recherche*, see my *Reading Boyishly: Roland Barthes, J. M. Barrie, Jacques Henri Lartigue, Marcel Proust, and D. W. Winnicott* (Durham: Duke University Press, 2007).

8. See Louis Marin, *Utopics: The Semiological Play of Textual Space*, translated by Robert A. Volrath (Atlantic Highlands, N.J: Humanities Press International, 1990), xiii. Originally published in French as *Utopiques: Jeux d'espaces* (Paris: Édition de Minuit, 1973).

9. Marin, xv.

10. Ibid., 58.

11. Ernst Bloch, "Something's Missing: A Discussion between Ernst Bloch and Theodor W. Adorno on the Contradictions of Utopian Longing (1964)," in *The Utopian Function of Art and Literature: Selected Essays*, translated by Jack Zipes and Frank Mecklenburg (Cambridge: MIT Press, 1988), 165.

12. Hayden White, "The Future of Utopia in History," from his lecture at the University of North Carolina, Chapel Hill, March 5, 2005.

13. I am playing with a lovely phrase by one of my former students, the artist Wendy Chien. In a seminar paper (University of North Carolina, Chapel Hill, Spring 2006) on the beds of the late Cuban-American artist Felix Gonzales-Torres, Chien noted, "the bed is a hatchery for dreams."

14. The physical and psychic wound of the black sun is at the heart of Julia Kristeva, *Black Sun: Depression and Melancholia*, translated by Leon S. Roudiez (New York: Columbia University Press, 1989). Originally published in French as *Soleil noir: Dépression et mélancolie* (Paris: Éditions Gallimard, 1987), which ends on Duras and *Hiroshima mon amour*.

15. Klein's wife, the artist Rotraut Uecker, as quoted in Thomas McEvilley, "Yves Klein: Conquistador of the Void," *Yves Klein, 1928–1962, A Retrospective* (New York: The Arts Publisher, 1982), 62.

16. See Nan Rosenthal, "Assissted Levitation: The Art of Yves Klein," in *Yves Klein, 1928–1962, A Retrospective* (New York: The Arts Publisher, 1982), 123.

17. In Sidra Stich, *Yves Klein* (Stuttgart: Edition Cantz, 1995), 179.

18. These are Marguerite Duras's words for describing the horrible shadows of victims vanished by the dropping of the atomic bomb on Hiroshima.

19. It is the too-muchness of it all: a point magnified by the long take of a giraffe dying.

20. Adam Phillips, *On Kissing, Tickling, and Being Bored: Psychoanalytic Essays on the Unexamined Life* (Cambridge: Harvard University Press, 1994). See especially the chapter "On Being Bored," 68–78.

21. Shōnagon, 30.

22. Roland Barthes, *The Pleasure of the Text*, translated by Richard Miller, with a Note on the Text by Richard Miller (New York: Hill and Wang, 1975), 11. In French: *Le Plaisir du texte* (Paris: Éditions du Seuil, 1973), 22.

23. Vladimir Nabokov, "Marcel Proust," in *Vladmir Nabokov, Lectures on Literature*, edited by Fredson Bowers (San Diego: Harcourt, 1982), 224.

24. While there is some disagreement as to the circumstances of its actual start, many believe that the dancing youth, the Takenoko-zoku, gathered spontaneously for the first time in Yoyogi Park in the summer of 1979. The Takenoko-zoku broke up after several years and were eventually replaced by rock bands performing in the street.

25. Joris-Karl Huysmans, *Against Nature*, translated by Robert Baldick, with an introduction and notes by Patrick McGuinness (London: Penguin, 2003), 13. In French: *À Rebours* (Paris: Gallimard), 90. As cited in Michel Pastoureau, *Black: The History of a Color*, translated by Jody Gladding (Princeton: Princeton University Press, 2009), 169. Originally published in French: *Noir, histoire d'une couleur* (Paris: Editions du Seuil, 2008).

26. Phillips, 97.

27. "Temple tourism" is a term I learned in conversation with Ranji Khanna.

28. Manny Farber, "White Elephant Art vs. Termite Art" (1962), as collected in *Negative Space: Manny Farber on the Movies* (New York: De Capo Press, 1998), 134–44.

29. Ibid., 137.

30. The metonymic workings of Manny Farber's paintings and writings have been thoroughly worked through in Kevin Parker's "Manny Farber and the Landscape," *Art Forum* (February 1985): 72–75. Parker's essay has been instrumental in my understanding of Farber's termite.

31. See Patrick Amos and Jean-Pierre Gorin, "The Farber Machine," *Rouge*, online journal, no. 12 (2008), http://www.rouge.com.au/12/farber_amos_gorin. The text first appeared in *Art in America* 74, no. 4 (April 1986).

32. Farber, 135.

33. Michael Kimmelman, "Cross Sections of Yesterday," *New York Times*, February 23, 2007.

34. Ibid.

35. Ibid.

36. See Pamela M. Lee, *Object to be Destroyed: The Work of Gordon Matta-Clark* (Cambridge: MIT Press, 2000), 169.

37. Ibid.

38. See Ernst Bloch, "Better Castles in the Sky at the Country Fair and Circus, in Fairy Tales and Colportage" (1959), in *The Utopian Function of Art and Literature: Selected Essays*, translated by Jack Zipes and Frank Mecklenburg (Cambridge: MIT Press, 1988), 186.

39. Lee, *Object to be Destroyed*, 178.

40. See Laurent Roth, "A Yakut Afflicted with Strabismus," in *Qu'est-ce qu'une madeleine: A propos du CD-ROM Immemory de Chris Marker*, edited by Yves Gevaert (Paris: Centre Georges Pompidou, 1997), 50.

41. Marker, liner notes for *Immemory*.

42. The name Krasna is withheld until the closing credits of *Sans soleil*. It appears again in Marker's *Immemory* as the filmmaker's real or fictional (or both) Uncle Anton Krasna—a photographer—as Raymond Bellour notes in Bellour and Roth, *A propos du CD-ROM de Chris Marker* (cited in chap. 2, n. 4, above), 155.

43. *Remembrance of Things to Come* sounds like an inversion of *Remembrance of Things Past*, the earlier translation of the title of Proust's great novel, before it was decided, to more accurately translate it as *In Search of Lost Time*.

44. Catherine Lupton, *Chris Marker: Memories of the Future* (London: Reaktion, 2005).

45. See Hamid Naficy, *An Accented Cinema: Exilic and Diasporic Filmmaking* (Princeton: Princeton University Press, 2001), 228.

46. Gilles Deleuze, *Proust and Signs: The Complete Text*, translated by Richard Howard (Minneapolis: University of Minnesota Press, 2000), 12. In French: *Proust et les signes* (Paris: Presses Universitaires de France, 1964), 19.

47. Deleuze, *Proust and Signs*, 12. In French: 20.

48. *Roland Barthes by Roland Barthes*, translated by Richard Howard (New York: Noonday Press of Farrar, Straus and Giroux, 1977), 78. In French: *Roland Barthes par Roland Barthes* (Paris: Éditions du Seuil, 1975), 84.

49. As Maker claims in *Immemory*, in response to the cut sequoia at Muir Woods and the cut sequoia at Le Jardin des Plantes: "The section of sequoia is still at the entrance to Muir Woods . . . it had better luck than its counterpart in the Jardin des Plantes, today buried in a basement."

## AUTHOR'S NOTE II

1. Marta Weiss's poem "1945" was published in *Hanging Loose Magazine*, no. 60 (1993).

## 4. "SUMMER WAS INSIDE THE MARBLE"

I want to thank elin o'Hara slavick, whose paintings, drawings, and photography brought me back to my earliest memories of seeing films of Hiroshima. This chapter on Hiroshima began as an essay, entitled "Blossoming Bombs," for slavick's book *Bomb after Bomb: A Violent Cartography* (Milan: Charta, 2007). I also want to express my gratitude to her for generously sharing with me a vast array of images of Hiroshima, as well as her own experiences from visiting the city.

1. Roy Armes, *The Cinema of Alain Resnais* (London: A Zwemmer, 1968), 61.

2. Ibid., 71.

3. Johann Wolfgang von Goethe, *Italian Journey, 1786–1788*, translated by W. H. Auden and Elizabeth Mayer (London: Penguin, 1970), 203.

4. Jacques Rivette, Eric Rohmer, Jean-Luc Godard, et al., "Hiroshima, notre amour," in *Cahier du cinema, the 1950s: Neorealism, Hollywood, New Wave*, edited by Jim Hillier, translated by Liz Heron (Cambridge: Harvard University Press, 1985), 69.

5. Southern California was a superb location for my apprenticeship in the art film. I studied at the University of California, San Diego, with J. P. Gorin and Manny Farber.

6. See Akira Mizuta Lippit's fine book, *Atomic Light (Shadow Optics)* (Minneapolis: University of Minnesota Press, 2005).

7. Tōge Sankichi, "The Shadow," in John Whittier Treat's *Writing Ground Zero: Japanese Literature and the Atomic Bomb* (Chicago: University of Chicago Press, 1995), 186. The steps, once fenced off from the city street with a plaque, have been removed and are now part of the Hiroshima Peace Memorial Museum.

8. Talbot, as quoted by Micheal Gray, in *Specimens and Marvels, William Henry Fox Talbot and the Invention of Photography* (New York: Aperture, 2000), 78, 77.

9. This is the title of a well-known photograph by Julia Margaret Cameron from 1872; it is, however, inscribed by an unknown hand. See Julian Cox and Colin Ford, *Julia Margaret Cameron: The Complete Photographs* (Los Angeles: Getty Publications, 2003), 388–89, figure 895.

10. Lippit, *Atomic Light*, 112.

11. Erik Barnouw, *Media Lost and Found* (New York: Fordham University Press, 2001), 215.

12. Erik Barnouw was the first chief of the Motion Picture, Broadcasting, and Recording Sound Division at the Library of Congress. The documentary was first shown in 1970 at the Museum of Modern Art in New York. The struggles that Iwasaki (who had been taken to prison for his outspoken criticism of the Japanese government's new cinema law of the 1930s) had in shooting the film and keeping it safe from both the Japanese and American governments is a complicated affair. The complications included seeing his own footage, which he had assumed had been de-

stroyed, in a broadcast of Barnouw's documentary on television Tokyo in 1970. Soon after that, Barnouw and Iwasaki would become friends and working partners for the remainder of their lives. See Barnouw, *Media Marathon: A Twentieth-Century Memoir* (Durham: Duke University Press, 1996), 193–217. I would like to thank Mara West for transcribing the film *Hiroshima-Nagasaki, August 1945* for me.

13. The words of the Hiroshima girl are read by Oshima Kazuko, who had been in Japan during the war. At the time of the filming, she was a graduate student in the department of Film, Radio and Television at Columbia University, of which Barnouw was chair. Paul Ronder, who was also a graduate student at that time, is the voice of the male narrator. Ronder, along with Geoffrey Bartz, also did the editing. See Barnouw, *Media Marathon*, 194–95.

14. Eliza Minot, *The Tiny One* (New York: Alfred A. Knopf, 1999), 13. The novel takes place over only one day. The story is written from the point of view of a young girl, who is describing the day in which her mother has died in an automobile crash. Everything changed. Nevertheless, the young girl is able to hold onto something, "the tiny one thing," amidst the incomprehensible loss of the mother: "it's like the dust of magnets or something that will pull me to her" (253).

15. Eric Barnouw, *Hiroshima-Nagasaki, August 1945*. From the voice-over (Paul Ronder).

16. John Hersey, *Hiroshima* (London: Vintage, 1989) 69–70.

17. Gilles Deleuze, *Proust and Signs: The Complete Text*, translated by Richard Howard (Minneapolis: University of Minnesota Press, 2004), 117.

18. Ibid.

19. Ibid., 11.

20. Ibid.

21. Marie Nordlinger was born and raised in Manchester, going to art school there, even studying with Walter Crane, before heading to Paris as a young woman, to study painting. She was the English cousin of Reynaldo Hahn, the pianist that Proust fell in love with. See P. F. Prestwich, *The Translation of Memories: Recollections of the Young Proust* (London: Peter Owen, 1999).

22. Roland Barthes, "Dare to Be Lazy" (1979), in *The Grain of the Voice: Interviews 1962-1980*, translated by Linda Coverdale (Berkeley: University of California Press, 1991), 339. In French: "Osons être paresseux," in *Œuvres complètes*, new rev. corr. ed. presented by Éric Marty (Paris: Éditions du Seuil, 2002), 5:764–65.

23. Barthes, "Dare to Be Lazy," 343. In French: "Osons être paresseux," 5:765.

24. Yet, poppies are also the flower of forgetting: as the source of opium, they offer up "amnesia and dreams, a sort of relief from the sleeplessness of too much memory"; see William James Booth, *Communities of Memory on Witness, Identity and Justice* (Ithaca: Cornell University Press, 2006), 72.

25. The Committee for the Compilation of Materials on Damage Caused by the

Atomic Bombs in Hiroshima and Nagasaki, *Hiroshima and Nagasaki: The Physical, Medical, and Social Effects of the Atomic Bombings* (New York: Basic Books, 1981). Originally published in Japanese (Tokyo: Iwanami Shoten Publishers, 1979).

26. William Shakespeare, *Hamlet*, edited by G. R. Hibbard (Oxford: Oxford University Press, 2008), 307.

27. Harald Weinrich, *Lethe: The Art and Critique of Forgetting*, translated by Steven Rendall (Ithaca: Cornell University Press, 2004), 3.

28. Of interest is the fact that her cruel father was a chemist, as was Resnais's.

29. While there is no direct Proustian reference in the film, there are obvious connections between the problems of memory and the struggle to translate the remembered into effective writing. Of interest is the fact that both Resnais and Proust suffered greatly from asthma and sought escape from their immobility through imagination. Resnais discovered Proust at age fourteen.

30. See Fabrice Virgili's *Shorn Women: Gender and Punishment in Liberation France*, translated by John Flower (Oxford: Berg, 2002), 6. Originally published in French as *La France 'virile' des femmes tondues à la Libération* (Paris: Éditions Payot & Rivages, 2000). Virgili is borrowing the term "obscene object," from Alain Corbin.

31. Marguerite Duras, *The War: A Memoir*, translated by Barbara Bray (Pantheon: New York, 1986), 3. Originally published in French as *La Douleur* (Paris: P.O.L., 1985).

32. Duras, *The War*, 64.

33. Ibid., 65.

34. Gaston Bachelard, *Poetics of Space*, translated by Maria Jolas (Boston: Beacon Press, 1994), 234. In French: *La Poétique de l'espace* (Paris: Presses Universitaires de France, Bibliothèque de Philosophie Contemporaine, 1957).

35. Bachelard, quoting La Fontaine, 234.

36. Herman Rapaport, "Text in a Box," *SubStance* 26, no. 1 (1997): 59.

37. Alain Resnais, *Night and Fog* (Nuit et brouillard), 1955. The text of the film can be read in Jean Cayrol's *Nuit et brouillard* (Paris: Librairie Arthème Fayard, 1997). The line in French, in both film and the published text is: "Nous ne pouvons que vous montrer l'écorce, la couleur" (24). The line might be more accurately translated as "We can only show you the bark, the color."

38. Victor Burgin, *The Remembered Film* (London: Reaktion, 2004), 16.

39. Lippit, 44.

40. Gilles Deleuze, *Cinema 2: The Time-Image*, translated by Hugh Tomlinson and Robert Galeta (London: Continuum, 2005), 117–18. Originally published in French as *Cinéma, tome 2, L'Image-temps* (Paris: Éditions Minuit: 1985).

41. Ashleigh Wells, "The Graft and the Relic," unpublished essay from my graduate seminar on Proust and the writing of history, University of North Carolina, Chapel Hill, Fall 2005.

42. Ibid.

43. Ibid.

44. Burgin, *The Remembered Film*, 15.

45. Fredric Jameson, *Archaeologies of the Future: The Desire Called Utopia and Other Science Fictions* (London: Verso, 2005), 199.

46. Guillaume Apollinaire, *Selected Writings of Guillaume Appolinaire*, translated with a critical introduction by Roger Shattuck (New York: New Directions, 1971), 171–72.

47. Lippit, *Atomic Light*, 112.

48. Barnouw and Iwasaki, *Hiroshima-Nagasaki, August 1945*.

49. Hiromi Tsuchida, *Hiroshima* (Tokyo: Kosei Publishing, 1985), 155.

50. Ibid, 5 (preface).

51. Ishiuchi Miyako, *Hiroshima* (Tokyo: Shueisha, 2008), 76. This artist's statement has been translated by Gavin Frew.

52. Ibid.

53. Roland Barthes, *Empire of Signs*, translated by Richard Howard (New York: Hill and Wang, 1982), 16. In French: *L'Empire des signes*, in *Œuvres complètes*, new rev. corr. ed. presented by Éric Marty (Paris: Éditions du Seuil, 2002), 3:363. Barthes is discussing Japan's use of chopsticks: a way to gently move foodstuff, almost maternally, unlike the piercing, stabbing Western fork.

54. Hesiod, *Theogony, Works and Days, Testimonia*, edited and translated by Glenn W. Most, Loeb Classical Library (Cambridge: Harvard University Press, 2006), 1:95, note 7.

55. Ibid., 95.

56. ELLE says of the Loire: "It's a completely unnavigable river, always empty, because of its irregular course and its sand bars. In France, the Loire is considered a very beautiful river, especially because of its light . . . so soft, if you only knew" (S, 54; G, 87).

57. For an excellent study on forgetting, as held by the writings on and metaphors of Lethe, see Weinrich's *Lethe: The Art and Critique of Forgetting*.

58. William Henry Fox Talbot, "Some Account of the Art of Photogenic Drawing" (1839), published in *Photography: Essays and Images, Illustrated Readings in the History of Photography* (New York: Museum of Modern Art; and Boston: New York Graphic Society, 1980), 25.

59. Burgin, 15.

# INDEX

CAROL MAVOR is Professor of Art History and
Visual Studies at the University of Manchester. She is the author
of *Reading Boyishly: Roland Barthes, J. M. Barrie, Jacques Henri Lartigue,
Marcel Proust, and D. W. Winnicott* (2007), *Becoming: The Photographs
of Clementina Viscountess Hawarden* (1999), and *Pleasures Taken:
Performances of Sexuality and Loss in Victorian Photographs* (1995).

.......................................

Library of Congress Cataloging-in-Publication Data
Mavor, Carol
Black and blue : the bruised passion of Camera lucida, la Jetée,
Sans soleil, and Hiroshima mon amour / Carol Mavor.
p. cm.
Includes bibliographical references and index.
ISBN 978-0-8223-5252-5 (cloth : alk. paper)
ISBN 978-0-8223-5271-6 (pbk. : alk. paper)
1. Black. 2. Blue. 3. Barthes, Roland. Chambre claire.
4. Jetée (Motion picture) 5. Sans soleil (Motion picture)
6. Hiroshima mon amour (Motion picture) I. Title.
BH301.C6M38 2012
700.1 — dc23
2011053303